ADVENTURES IN ROSÉ WINE IN PROVENCE

ADVENTURES IN ROSÉ WINE IN PROVENCE

TEXT FRANÇOISE PARGUEL
PHOTOGRAPHY CAMILLE MOIRENC

ABRAMS I NEW YORK

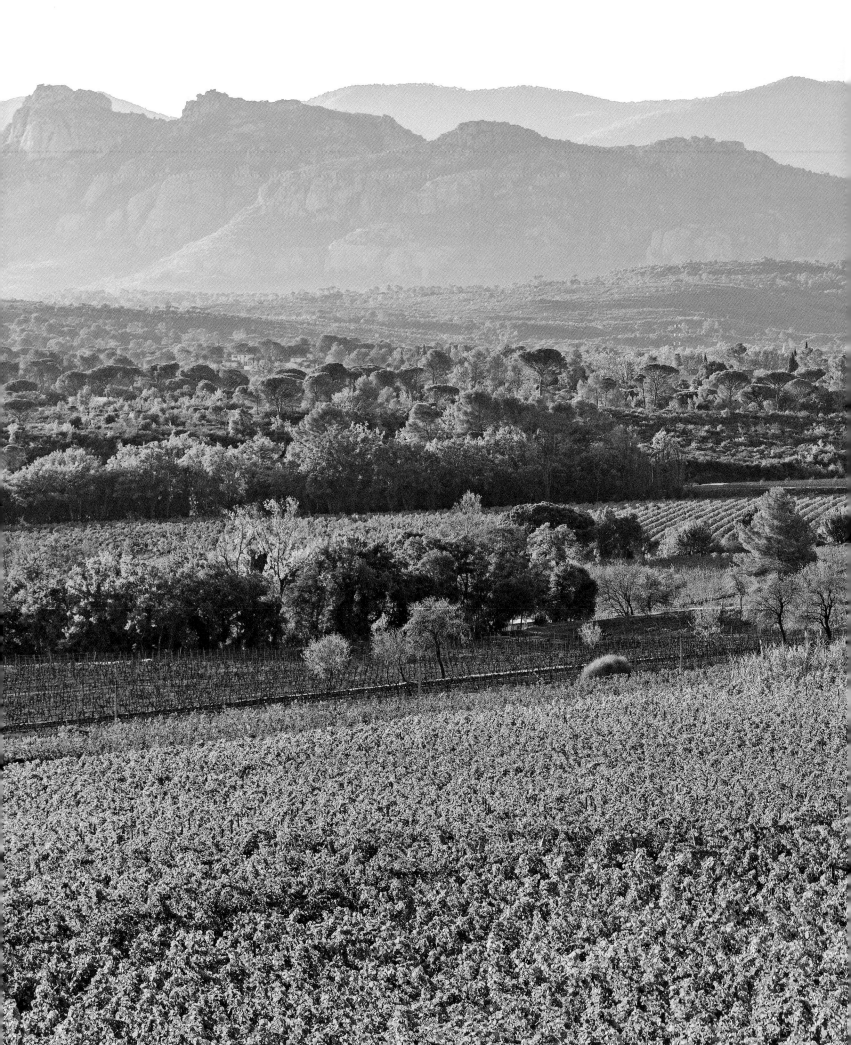

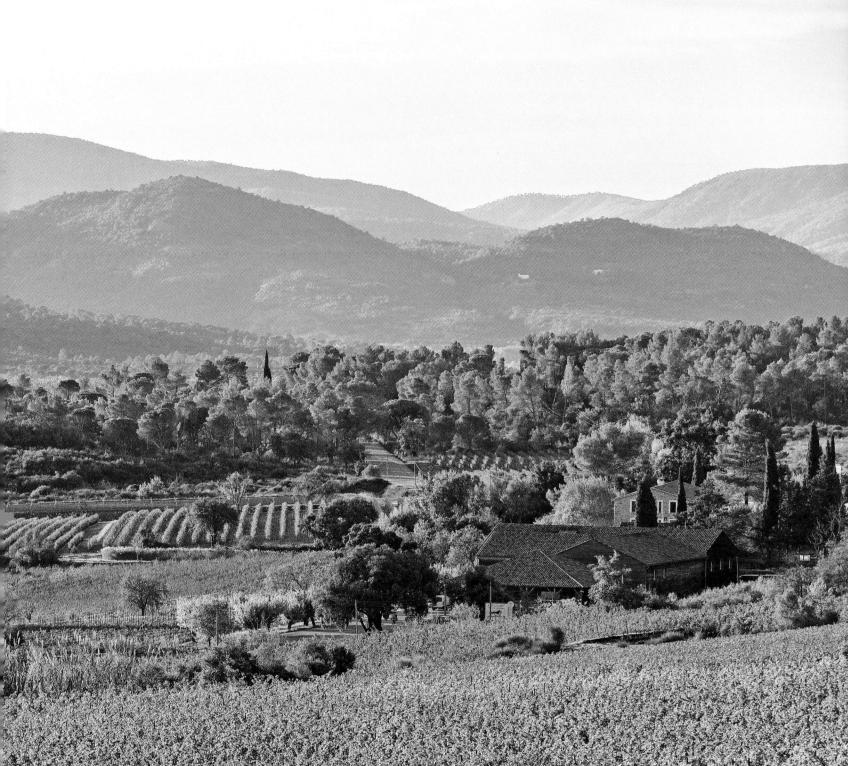

CONTENTS

IN THE PINK

Provence. Authentic, idyllic and secretive one moment, noisy and flashy the next. Looking from west to east, the region includes the cities of Arles and Aix-en-Provence, the Montagne St Victoire, the Massif des Maures, and the red rocks of the Estérel Mountains. To the south is the Provence coastline, with its headlands and coves, turquoise-blue waters, islands and peninsulas… the French Riviera, Cannes, Nice. How we picture Provence has a lot to do with memory and imagination. For many people it's a "must". The ultimate destination.

Unfailing sunshine, magical light and dreamy landscapes. Lavender fields, one hundred-year-old olive trees and maritime pines alive with cicadas. Hill-top villages, architectural ruins and a sky of infinite blue that dives into the sea. Provence is a place of enchantment with an art of living all its own: recreated in the writings of Pagnol, Daudet, Mistral, Giono and Rostand; captured in the brushstrokes of the Impressionists and the Fauves; glorified in the works of Provençal painter Cézanne.

Prohibition then saw the start of a craze for summering on the French Riviera. Fleeing their straitlaced homeland, Gertrude Stein, Hemingway, Picasso and Cole Porter came to live it up with the Fitzgeralds at their Villa Saint Louis on Cap d'Antibes – a place where the ghosts of *Tender is the Night* seem to float amid the glamor of the Roaring Twenties. The Americans have been coming here ever since.

Some years later Cannes held its first festival, and a certain Roger Vadim "created" Brigitte Bardot, who in turn created Saint-Tropez. Pampelonne beach took off with the opening of Club 55, its iconic sands attracting the legendary Princess Grace of Monaco plus those few Parisians who like French writer Françoise Sagan drove down the plane-tree lined RN7 highway all the way to the Midi. Hyped to the skies by famous artists and influencers before their time, Provence became a magnet for tourists.

Fast forward to the dawn of the new millennium and Provence does it again. Only this time the attraction is wines – rosé wines. Unassuming little wines traditionally served drowning in ice at barbecues and games of *pétanque*. Who could have imagined that Provence rosé would one day unleash a revolution in taste?

Yet their pale color has become the global standard, symbolizing wines in a category of their own that are not afraid to rattle the complacency of red and white. Quite an achievement for a region traditionally known for its aromatic whites and characterful, long-lived reds. But then people have been making wine here for 2,600 years – generation after generation of earthbound wine-growers making wines that celebrate the diversity of their terroirs.

Today, France's oldest wine region can also claim to make award-winning rosé wines – relaxed, unfussy but increasingly honest wines that hit the sweet spot every time. Nothing preachy, just come-hither elegant pinks with the smell of friendship. Versatile too. Paired with appetizers or paired with a meal, Provence rosé will flatter any dish no matter how elaborate – hence its appeal for leading chefs. Women love Provence rosé and before you know it millennials will be posting Provence rosé on Instagram – rosé flowing all day and all night on the private beaches of the Côte d'Azur, Ibiza, Mykonos, Porto Cervo, Miami, Dubai…

No wine region in France has enjoyed such spectacular growth in so little time. In less than 40 years, Provence has made rosé its own. With the help of committed winegrowers and great family estates such as Ott*, Farnet-Minuty and Barbeyrolles, the vineyards of Provence have inspired equal commit-ment in the rich entrepreneurs who came calling, some of them visionaries like Sacha Lichine. After them came key players in the luxury goods market – LVMH, Pernod Ricard, Roederer, Chanel, watchmaker Richard Mille – together with the actor Brad Pitt and even a British lord.

This is the story of the people who made it happen: great names forever linked with the history of those phenomenally successful rosés, branded and estate-bottled wines alike, that keep Provence in the pink.

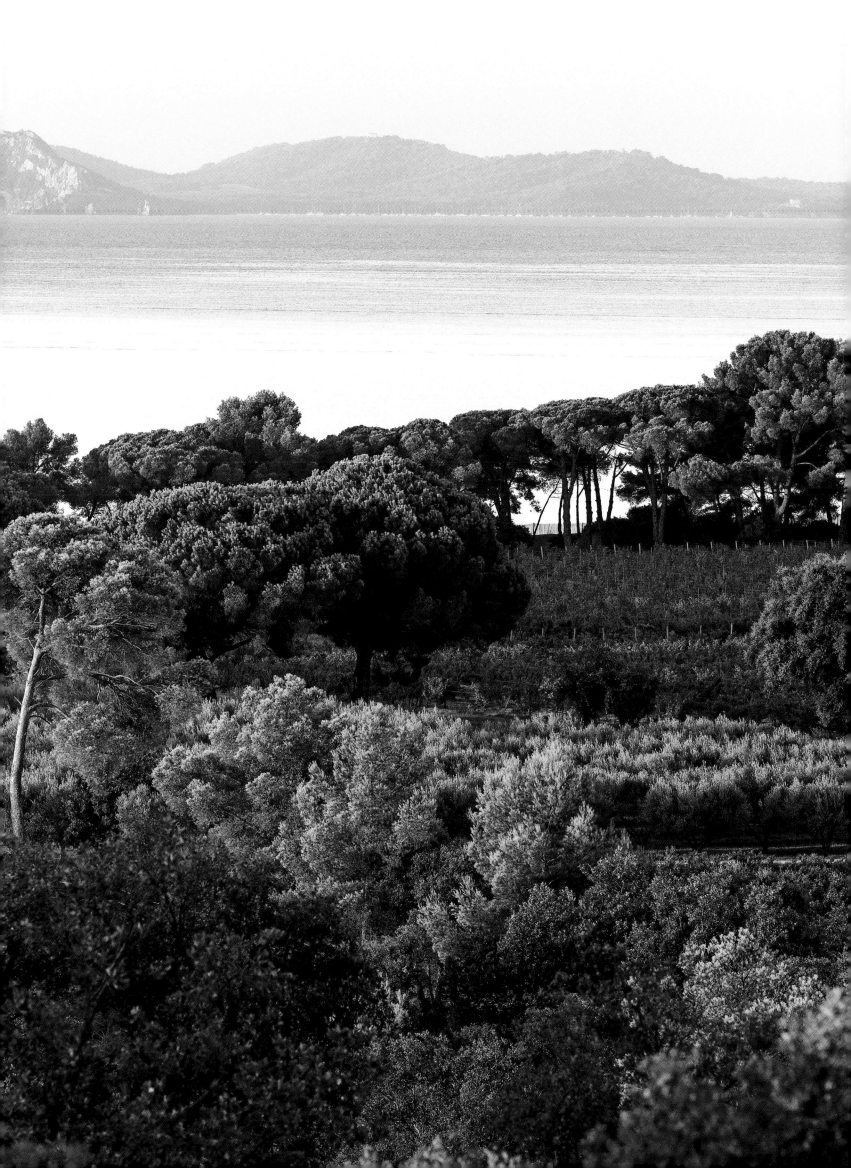

OUR GREAT ADVENTURE BEGINS

OTT, FARNET/MATTON, FOURNIER/LE BER, RIGORD, SUMEIRE, PASCAUD – THE LANDSCAPES OF PROVENCE HAVE BEEN SHAPED BY SUCCESSIVE GENERATIONS OF GREAT, LANDOWNING FAMILIES WHO LEFT THEIR MARK ON THE HISTORY OF ROSÉ WINE. VISIONARY PIONEERS FROM DIFFERENT ERAS WHO SAW THE POTENTIAL IN THE REGION AND WERE NOT AFRAID TO INNOVATE. THESE WERE PEOPLE WITH PASSION – BOLD WINEMAKERS OF BOTH SEXES WHO EMBRACED UNCERTAINTY AND TOGETHER GAVE BIRTH TO A LEGEND.

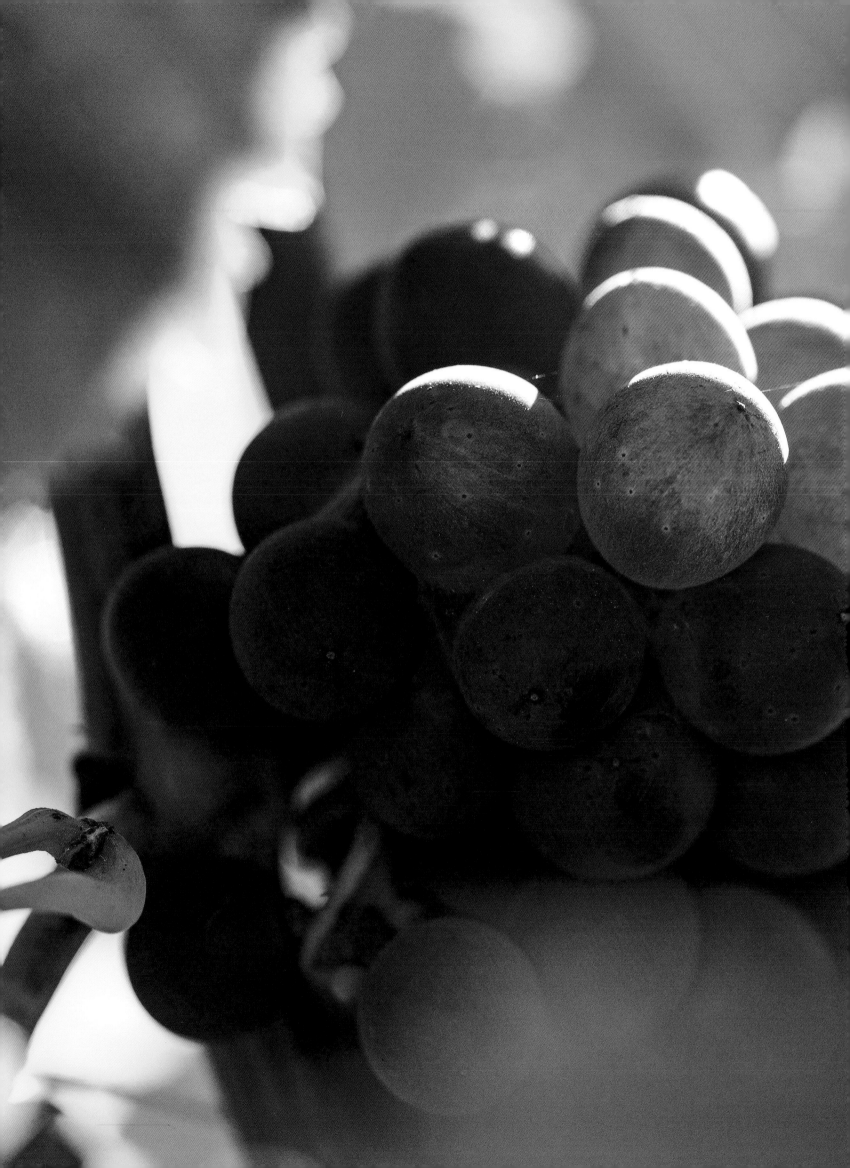

GREAT
FAMILIES

WHO BROKE
NEW GROUND

DOMAINES OTT*: MAKERS OF HISTORY

Domaines Ott, les vins de l'élite* – these are the words displayed on the lovingly preserved wooden boxes on show in the Clos Mireille cellar. A slogan that might raise a few eyebrows today but a testament nonetheless to the estate's uncompromising standards. Today fourth generation scion Jean-François Ott salutes his passionate forebears for daring to follow the path carved out in 1896 by their visionary predecessor: Marcel Ott, the founder of this Var wine estate and a prime mover in the development of Provence wines. Nearly 130 years later, Domaines Ott* with its three vineyards in two appellations (Château de Selle and Clos Mireille/Côtes de Provence and Château Romassan/Bandol), is known all over the world for its superior wines… and its distinctive bottle.

Looking back to the early 20th century, we find a young agricultural engineer from Alsace leaving home in search of a wine estate. With high hopes for the future, Marcell Ott scoured France's vineyards from Bordeaux to Algeria before being eventually persuaded by his wife to join her in Provence. So it was that the couple acquired Château de Selle in Taradeau, near Draguignan in the Centre-Var area: a property located in sunny Provence, a historic French province rich with olive groves, lavender plants and mulberry trees. But in 1912 when Marcel acquired the property this once thriving region was in tatters. Blighted by phylloxera, the vineyard had to be entirely replanted – a task he undertook with gusto, knowing that the terroir was intact and ripe for innovation. From the very beginning our visionary winegrower insisted on the very highest standards of care throughout the lifecycle of the vine. Working in harmony with nature, restricting yields, planting vines of superior quality – Marcel's every move revealed his determination to coax out great wines from this terroir of argillaceous limestone.

By the twenties, he was ready for new adventures and took over management of the Clos Mireille, a magnificent estate minutes from the coast, facing the Ile de Porquerolles. With its pine groves and hundred-year-old coconut palms, its stone buildings and rows of vines right down to the sea, the property was a paradise on earth. Marcel applied himself with his customary zeal to rebuilding the vineyard, working the same way as before but this time with schists, clays and quartzite. And in 1936, Marcel Ott, founder of the Ott dynasty and an entrepreneur to his fingertips, acquired ownership of the Clos Mireille.

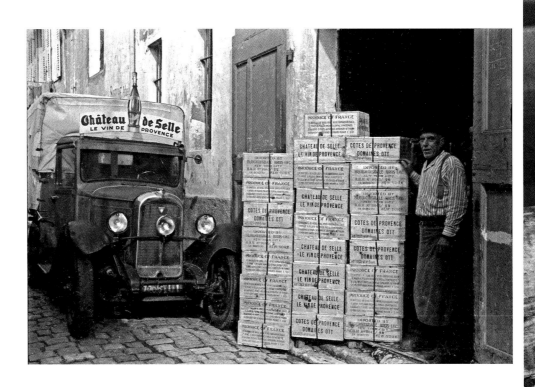

The arrival of his three sons proved a boon to business. This was in the 1930s, at a time when Bordeaux and Burgundy had the market pretty much cornered and Provençal wine producers were looking for a way to make their wines stand out. The obvious answer was an unusual bottle shape – easier said than done when your business is wine, not glassmaking… Nothing daunted, Marcel's son René came up with a design for a tall, slender bottle – like an amphora but minus the handles – which he then submitted for the industry's consideration. It was thrown out on grounds of cost. Piqued but no less sure of himself, René went ahead with his idea anyway. Ott's trademark bottle was born and is still in use today for small and large volumes alike. Next, equally unique and instantly recognizable, came the star-shaped symbol alongside the two "t's" in Ott intertwined – a graphic device that turned the family name into a logo. Simple and effective. Marketing before its time.

The man behind the amphora-shaped bottle was also an exceptional salesperson. Leaving it to his two brothers to look after the production side of the business, he concentrated on promoting their two estates at the global level. His first step was to put together a sales team in charge of taking France's restaurant world by storm, building a reputation for Ott wines that eventually extended from the Côte d'Azur to major towns in France and ultimately beyond. By 1938 Ott wines were being shipped to the United States, positioning Domaines Ott* among the leading exporters of rosé wine. It was then that the business established its headquarters in Antibes, a busy port town complete with a warehouse ideally located to receive the *demi-muids* of wine (600-liter capacity oak barrels) that arrived from Provence for bottling.

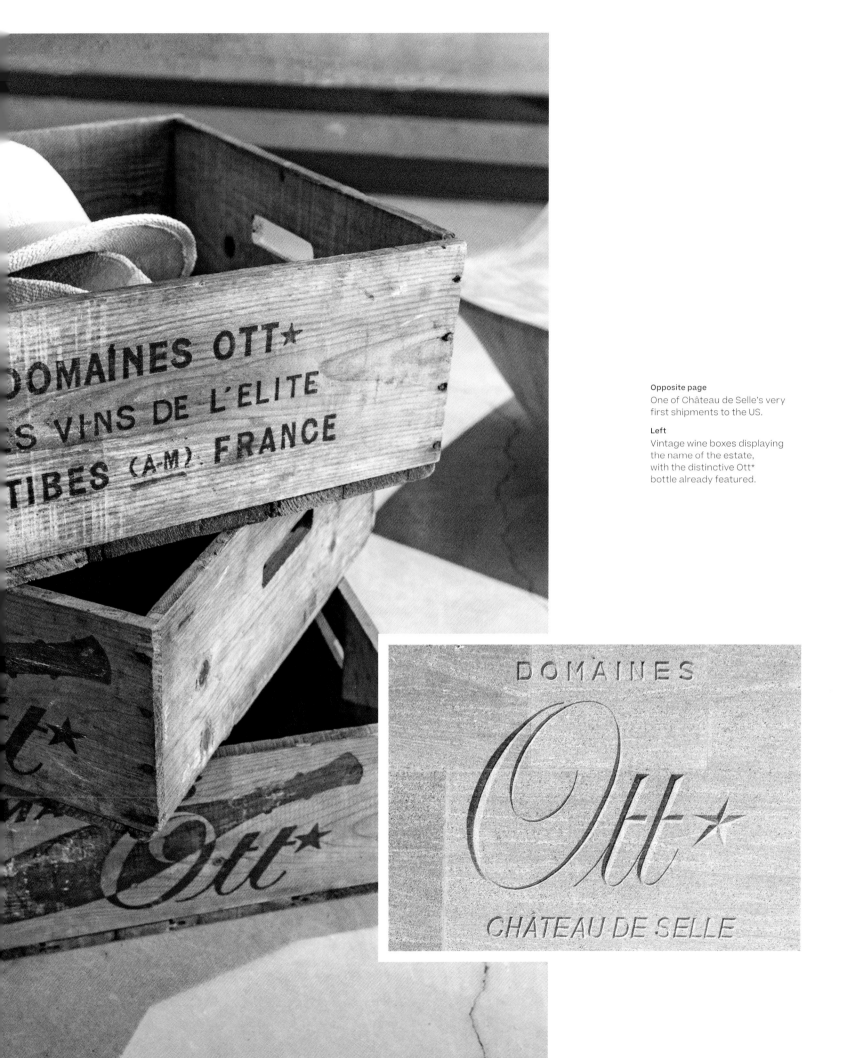

Opposite page
One of Château de Selle's very first shipments to the US.

Left
Vintage wine boxes displaying the name of the estate, with the distinctive Ott* bottle already featured.

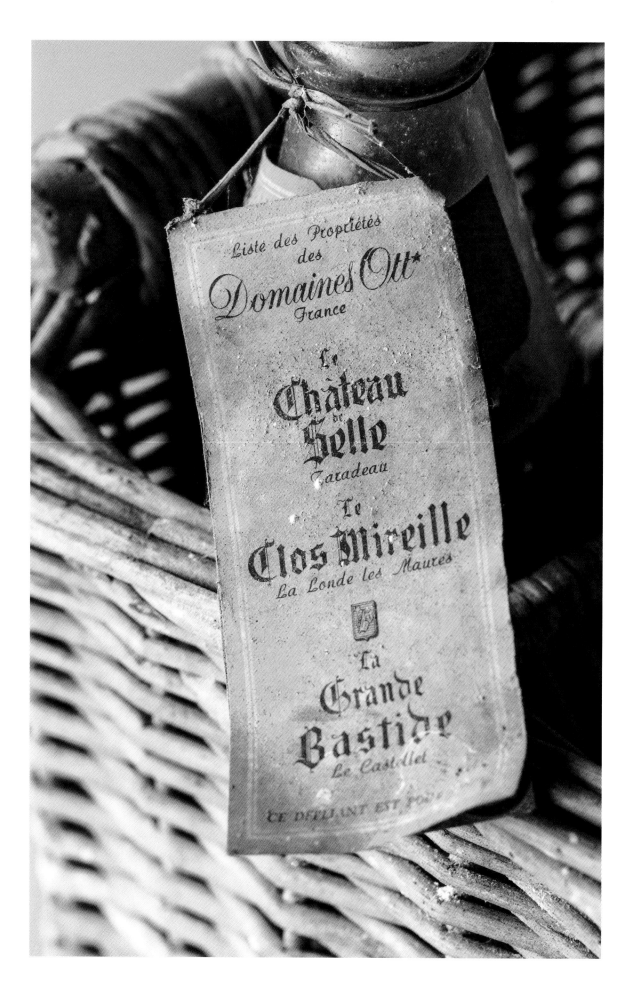

Right
Period label listing the estates, complete with La Grande Bastide (the former name of Château Romassan).

Opposite page
Three generations of bottles: the original sandstone mold (left), a famous bottle of rosé with the old-style label (right) and its contemporary counterpart (center).

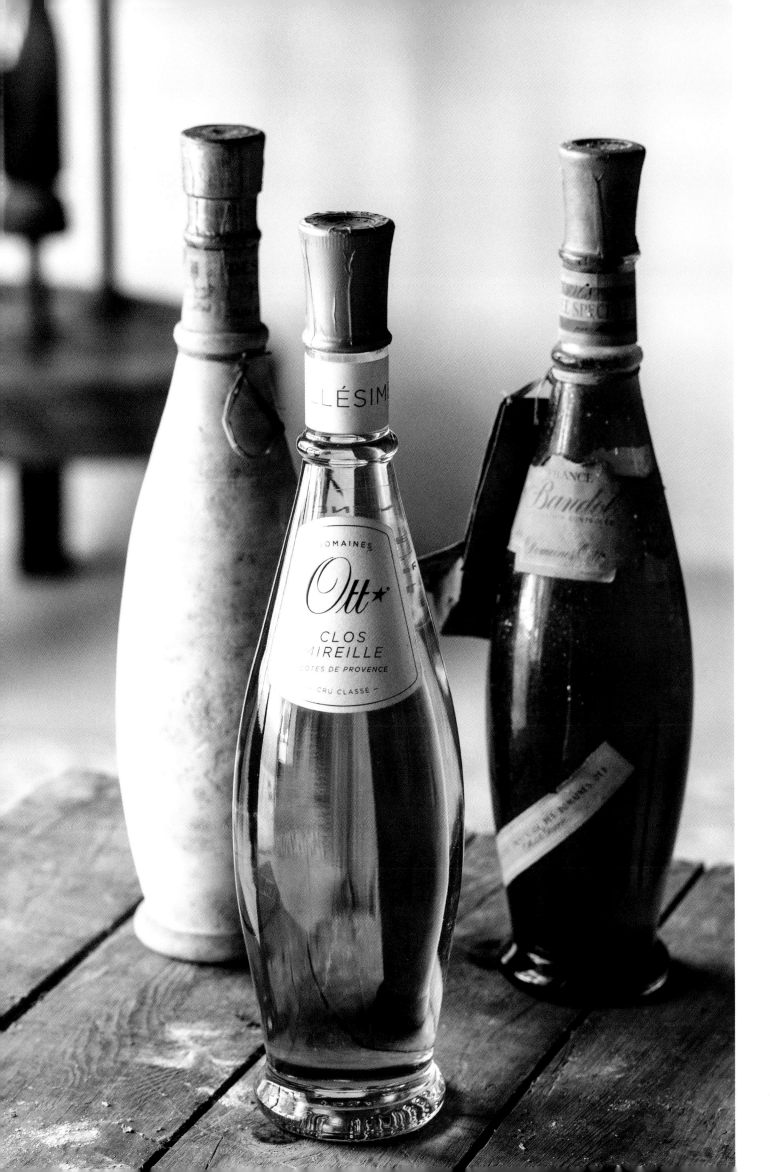

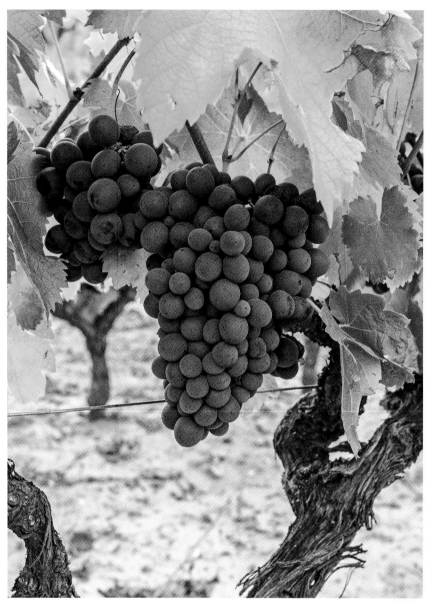

Left
Fine clusters of cinsault
growing in the Clos Mireille.

Opposite page
Château Romassan and
its chapel in the heart
of the Bandol appellation.

Following pages
A Clos Mireille vineyard
parcel overlooking
the Mediterranean Sea.

After World War II, the third generation arrived on the scene. Château de Romassan, a little jewel of an estate in the Bandol appellation was acquired in 1956, with brothers and cousins galore pulling together to work the vineyard, sell the wines and organize the logistics. The period 1960-1970 then saw major works to improve the family holding, starting with a complete restructuring of the vineyards and the acquisition of additional plots. Next came an equipment overhaul and a concerted drive for excellence. With increasing recognition came new opportunities for Clos Mireille Blanc de Blanc to shine, earning its place on the best wine lists in France. Rosé meanwhile (which had yet to turn pale) became the family specialty. As Jean-Jacques, company director since 1984, remembers today: "We always believed in rosé – always believed that a delicate forerunner of organic rosé would quickly find takers worldwide." Turns out he was right.

By the eve of the new millennium rosé wine was well on its way and producers were struggling to keep up with demand. Domaines Ott*, by contrast, was way ahead of the game and rose effortlessly to the occasion.

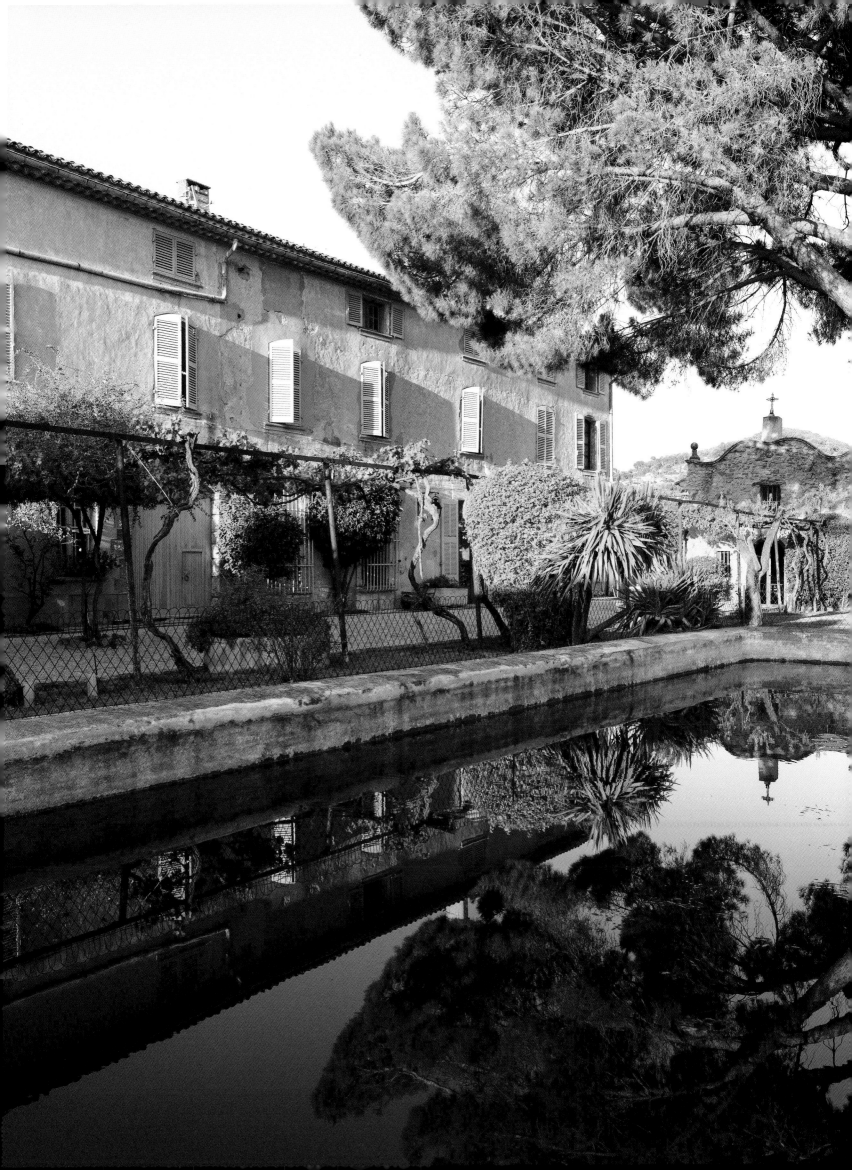

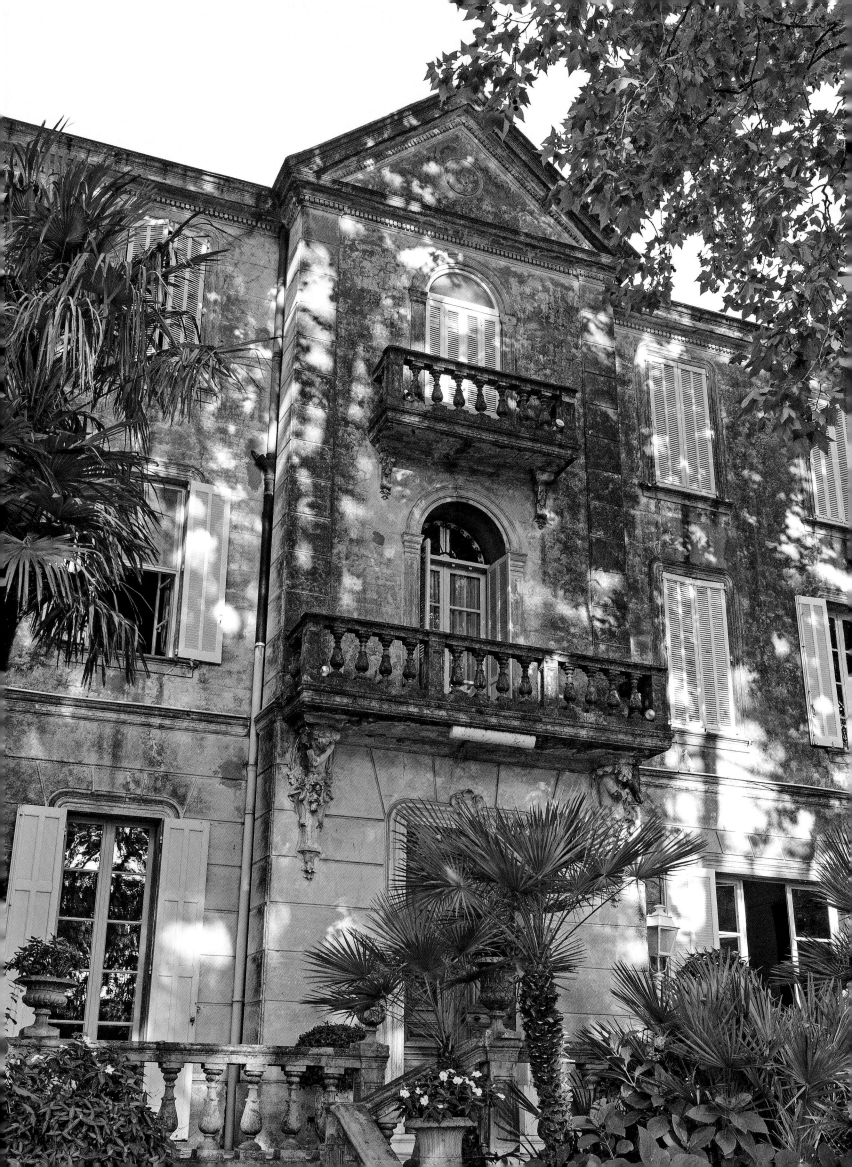

MINUTY, FROM THE CHÂTEAU TO THE BRAND

It all began in 1936 with family patriarch Gabriel Farnet, the first of three generations of Farnet-Mattons who gave their all to making this chateau one of the biggest names in fine wine, not to mention a global brand. This is the story of a family venture in which everyone did their bit, first the founder then his descendants, all of them helping to build, reinforce and eventually promote the brand. Together they passed on a legacy of passion that is still going strong today.

Gabriel Farnet, like so many boys from good families back then, practiced law – in Grimaud, near the family property in Vidauban, heart of the Centre-Var. Located by the Route Nationale 7 highway, Vidauban was a place brimming with business opportunities. The Farnet family house stood alongside some of the finest properties in the region, many of them owned by local worthies and members of the middle classes who grew vines as a sideline. Gabriel, for his part, took a fancy to a delightful little chateau with a pediment in the Second Empire style and adjoining chapel. It stood hidden among trees in the *lieu-dit* of Minuty: 20 hectares of vines nestling at the foot of the village of Gassin, with a breathtaking view over the Bay of Saint-Tropez (then a tiny fishing port). This was a rare natural haven and a real find for a man ever fascinated by the rugged beauty of the coast. A smitten Gabriel quickly struck a deal and after the necessary renovations were made, the family moved in.

While continuing to practice law, he took over supervision of the vineyard, which produced red and rosé wines for merchants who mainly sold to cafés in the surrounding towns and cities. Yet this was a vineyard that had ranked as a Cru Classé since the 1955 classification of Provence wines – a passport to fame granted to just 23 properties, among them the Minuty *Lieu-dit*.

A new chapter unfolded with the arrival of Gabriel's daughter Monique and her husband Etienne Matton, an established lawyer in Paris. They came for good, not just for the outdoor life but fully determined to manage Minuty full-time, starting with a major overhaul of the winery buildings and vineyard alike. Etienne Matton meanwhile applied his legal skills to acquiring new lands. As his youngest son François recalls: "Being a complete beginner in this area, my father quickly surrounded himself with the right people – in this case a winery engineer/consultant and a top-ranking INAO official. They taught him a lot but his stroke of genius was to put his money in real estate while it was still affordable, increasing production by purchasing the 20-hectare Saint-Elme vineyard, also in Gassin."

Opposite page
Château Minuty: home
to three generations
of the Farnet-Matton family.

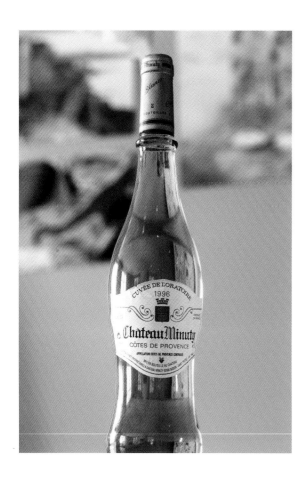

Left
The *flûte à corset* – Minuty's
iconic hourglass bottle
designed by Monique Matton.

With his wines now ever better made thanks to advances in enology, Etienne concentrated on developing sales – an area where everything remained to be done. It was his wife who came up with the idea of the *flûte à corset*: Minuty's iconic hourglass bottle, which would see dozens of iterations by producers everywhere before becoming the standard for Provence. Monique's new bottle opened doors for the brand – to Côte d'Azur restaurants and to the trendy bars and private beaches that were starting to take off in the late seventies. Minuty, like its counterpart Domaines Ott*, built its reputation in the region's top restaurants where success hinged on fine wines. But it didn't stop there. With sales booming, Etienne Matton had the idea for a product at the other end of the scale, also tailored to the needs of restaurants. "This was a more affordable entry-level rosé," remembers François, "made with grapes bought in from wine cooperatives and neighboring producers but entirely vinified in-house. It was a real hit and did great things for our reputation." And with that, Minuty became one of the first to make premium rosé blends, so increasing its product offering and breaking into new markets – a winning formula when rosé sales exploded on the eve of the new millennium. Other producers likewise took the plunge, adding one or more branded wines to their estate-bottled offerings. Another big development was the move to pale colored rosé, borrowing from Régine Sumeire's recently launched Pétale de Rose like so many other producers in the region. This was at the end of the 1980s, shortly after Gabriel's two sons, Jean-Etienne and François, joined the business and immediately made three important changes. "We stopped including dark-skinned grapes like carignan and syrah; we went for direct pressing with little or no maceration; and we cut down on sulfites." The result was a fresh and translucent rosé of exceptional delicacy – fresh, fruit-forward and uncommonly elegant. Henceforth grenache would be the grape of choice when replanting existing vineyard sites.

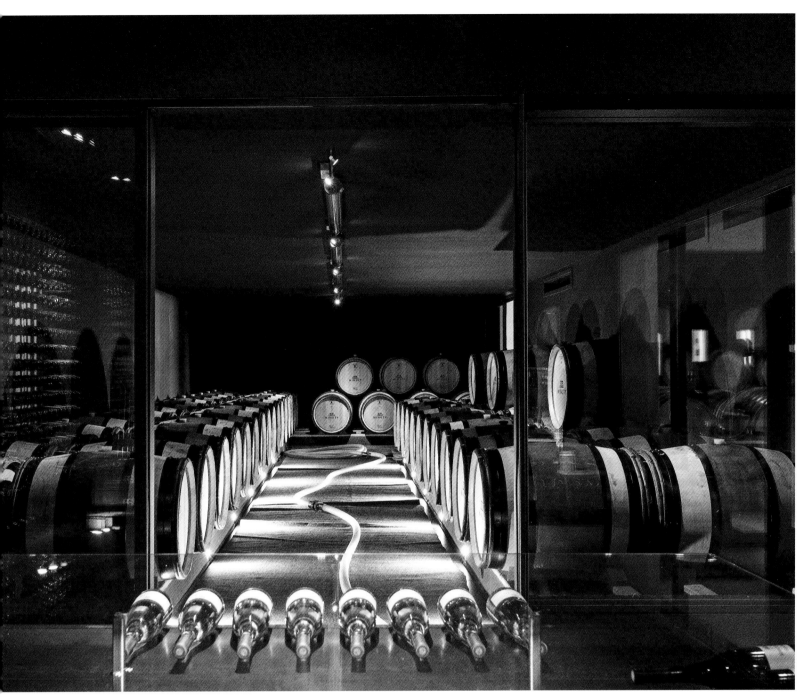

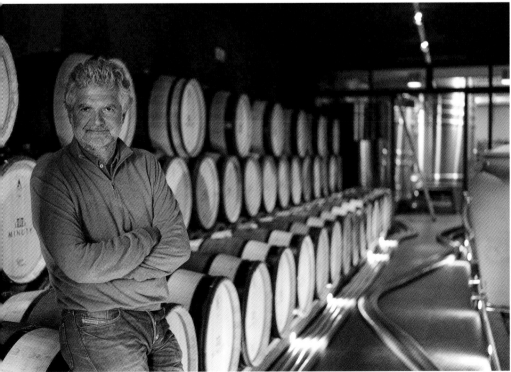

Above
The handsome barrel hall where Minuty red wines are aged.

Left
François Matton and brother Jean-Etienne. Together they transformed Château Minuty into a world-class brand.

The new millennium saw the brothers invest in their production facilities together with marketing, François Matton's particular area of expertise: "The important thing was to offer a consistent range that would support our strengthening position in premium rosé blends, and empower our brand identity." The range today hinges on estate-bottled wines and brand wines, with product visibility increasing every year. In less than a decade, the Or range has become the face of Chateau Minuty, with the exclusively pink Chateau Minuty cuvee 281 standing as the epitome of its rosé offerings. Its brand wines feature the Cuvee Prestige, and M Minuty: a rosé wine presented in a customized bottle, available since 2018 as a Limited Edition Rosé designed by an artist.

Gone are the days when it was the Côte d'Azur that served as a showcase for Minuty wines. "Now France is by far and away our number one market," says François Matton "and we have also grown our international sales. These days every other bottle is sold abroad, operating in more than 100 countries and focusing on rosé wine." The entire range is marketed by SAS Minuty, which unlike some producers, regards reputation as inversely proportional to public relations. François Matton continues: "our sales promotions are strictly for distributors, importers and members of the press. We make it a rule never to host any events at the chateau – soirees, dinners or anything else." Advertising and a strong social media presence, on the other hand, are considered essential to increase brand awareness.

Two major investments left their mark on the 2010s: the acquisition of the 60-hectare Chateau de Verrez vineyard in Vidauban; and the building of a winery and bottling plant in Brignoles (for blended wines only). Work is currently underway to convert 15 hectares of vineyards in Pampelonne to organic practices, with the remainder of the vineyard sporting the Haute Valeur Environnementale label (HVE or high environmental value).

Faced with a complex inheritance, the Matton brothers passed the baton having put Minuty on the map in less than 40 years and established its credentials as a leading exponent of Provence's new style rosés.

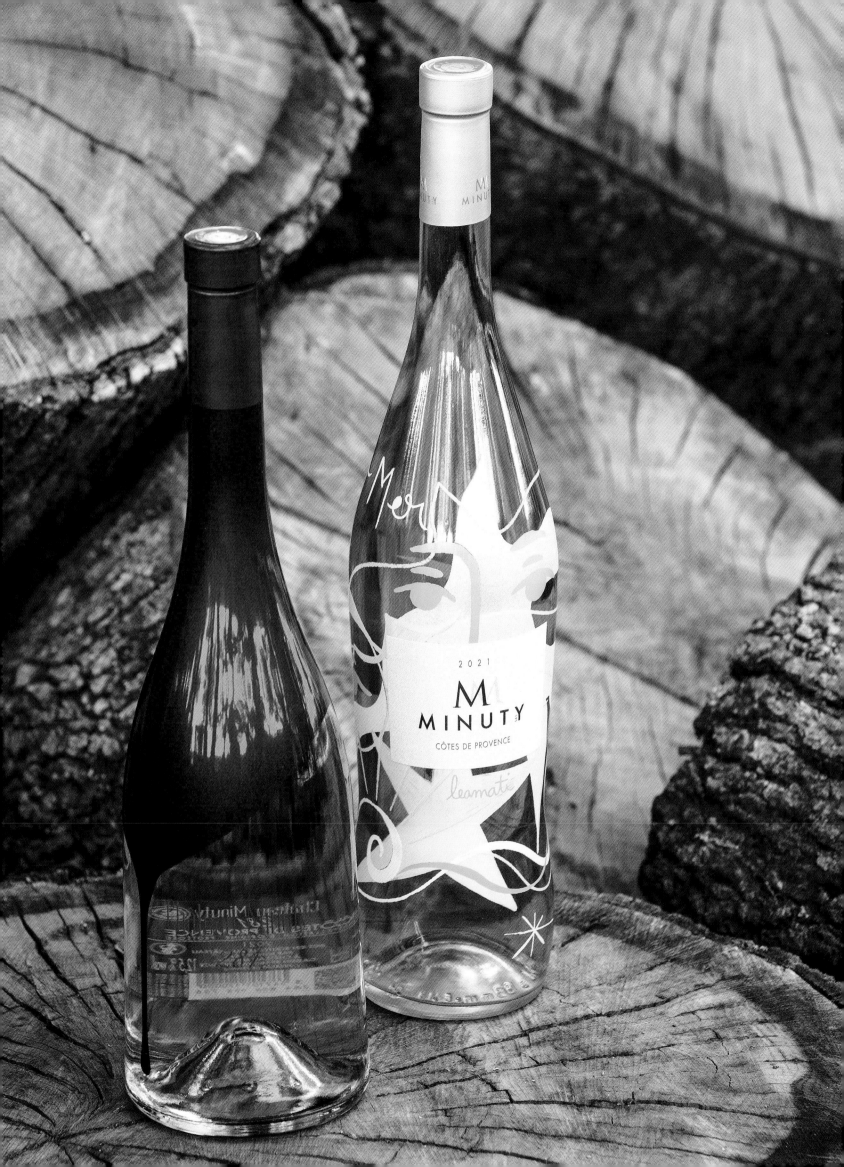

THE COMMANDERIE DE PEYRASSOL – A LEGEND HANDED DOWN FROM MOTHER TO DAUGHTER

Women have always been given charge of the Commanderie de Peyrassol. Not by chance but according to a family ritual that began in 1789 and endured until 2001. Throughout that time, this spectacular, relic-strewn stronghold built by the Knights Templar was under the ownership of the Rigord family. It nestles in the foothills of the Massif des Maures, in a secluded valley stretching across the hills of the Var near Brignoles – a location so remote that that for many years the property remained vacant, with crops and herds of sheep as its only neighbors. Vineyards did not appear until the early 20th century, tended by generation after generation of wives and daughters whose menfolk were in professional practice.

In 1967 the Commanderie passed down to Dr Rigord, who took up residence with his wife Françoise as the Lady of Peyrassol. In the years that followed Françoise Rigord would devote her unusual energies to bringing the estate back from the brink. She put an end to the renting out of vine plots (what's known in French as *fermage*); overhauled the vineyard; invested in a fermentation room so she could vinify on the premises; and invested in large oak vats for her *chai* (barrel hall). She also began work on restoring the habitable part of the *bastide* (a Provençal manor house).

Ten years later she was quick to grasp the quality and marketing challenges arising from the birth of the Côtes de Provence appellation in 1977. That year she was one of the first women to pioneer the change to chateau bottling. Peyrassol in those days extended over 260 hectares, of which 65 hectares of vineyards planted in meagre, hard-packed soils of clay and limestone – a terroir as austere as the property itself. Yet it was from this unpromising terrain that Françoise Rigord conjured her two legendary red cuvees, Le Chateau and La Commanderie. While rosé wines were still waiting in the wings, Peyrassol's red templar cross was busy conquering markets far beyond Provence.

Armed with good people skills and energy aplenty, the Lady of Peyrassol continued to develop her estate and promote her wines for many years to come. Like her winegrowing friends on the coast, she also jumped on the rosé bandwagon. But as the new millennium approached, adapting to changing market conditions meant huge investments in the vineyard and winery alike. She had put the Commanderie on the map, but now it was time for the Lady of Peyrassol to relinquish the estate she had worked so hard to create.

Opposite page
A venerable oak tun dating from the time of Françoise Rigord, opposite a work by French artist Cat Loray from the present owner's collection.

Above
Remains of the Templar stronghold in the heart of the Commanderie.

Below
Françoise Rigord, future *Dame de Peyrassol*, and her husband.

Opposite page
A very old vine with clusters of grapes at different stages of ripening.

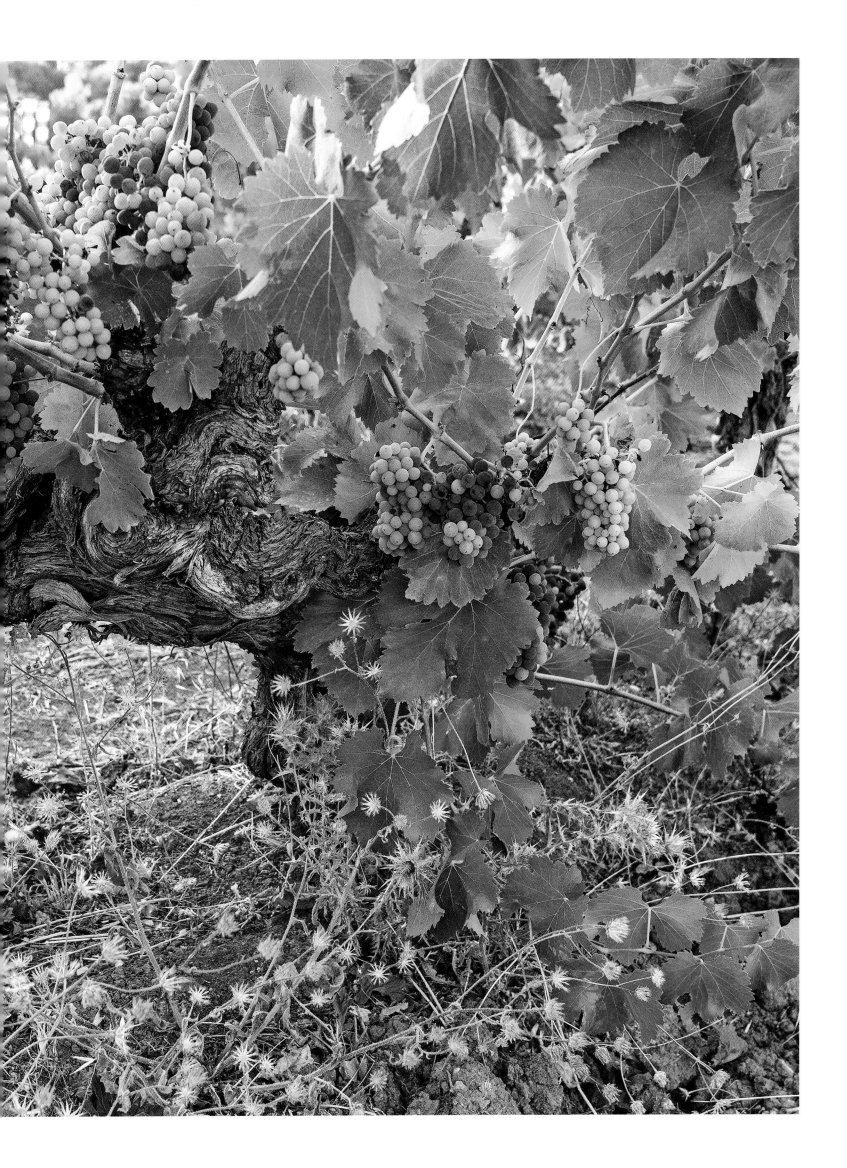

CHÂTEAU DE PAMPELONNE: CULTIVATING AUTHENTICITY

Framed by pines, *garrigue* and tamarisk trees, the Pampelonne vineyard overlooks the magnificent Bay of Pampelonne with its array of private beaches dotted with bars and restaurants: Tahiti, Bora-Bora, Moorea, Nikki-Beach, Bagatelle and Club 55 and other unmissable resorts for the summer jetsetter. With a name like Chateau Pampelonne, this estate was inevitably destined for greatness.

It has been owned by the same family for 200 years: 160 hectares of unspoiled countryside set at the foot of the charming village of Ramatuelle, dowry handed over to her future husband by a local heiress who married into the Gasquet family. In the Second Empire, her son Adrien transformed what was then a large "villa" into a chateau that he eventually bequeathed, together with the grounds, to his wife Amance de Gasquet. In those days these were uncultivated grounds, and so they remained until the family planted two hectares of vines here after World War I. More followed, slowly at first then picking up speed under the direction of Edgar Pascaud's aunt, followed by Edgar himself and eventually his daughter, Marie Pascaud who runs the estate today.

Edgar took over in 1974 on the eve of the "rosé revolution". As chateau bottling became more common, he also arranged for his own vineyard offerings to be sold by the Maîtres Vignerons de la Presqu'île de Saint-Tropez: a wine cooperative founded in 1965 of which he was a member. This remained the case for some 40 years, Edgar meanwhile focusing on quality and technological innovation like other enterprising winegrowers in the region. Given the name of his estate and its location on the road to the beaches, he knew he was onto a winner: "what started out as nothing more than a few glorified beach huts quickly developed into something altogether more sophisticated, with as many as 35 private beaches open for business by the year 2000." Determined to turn his estate into a household name, Edgar rode the wave of rosé first in France then abroad by increasing his international sales, particularly in the Caribbean and the USA. Having a shop in prime position on the road to the beach was another big advantage.

Opposite page
The chateau surrounded by tall palm trees as featured on the label of the cuvée Prestige.

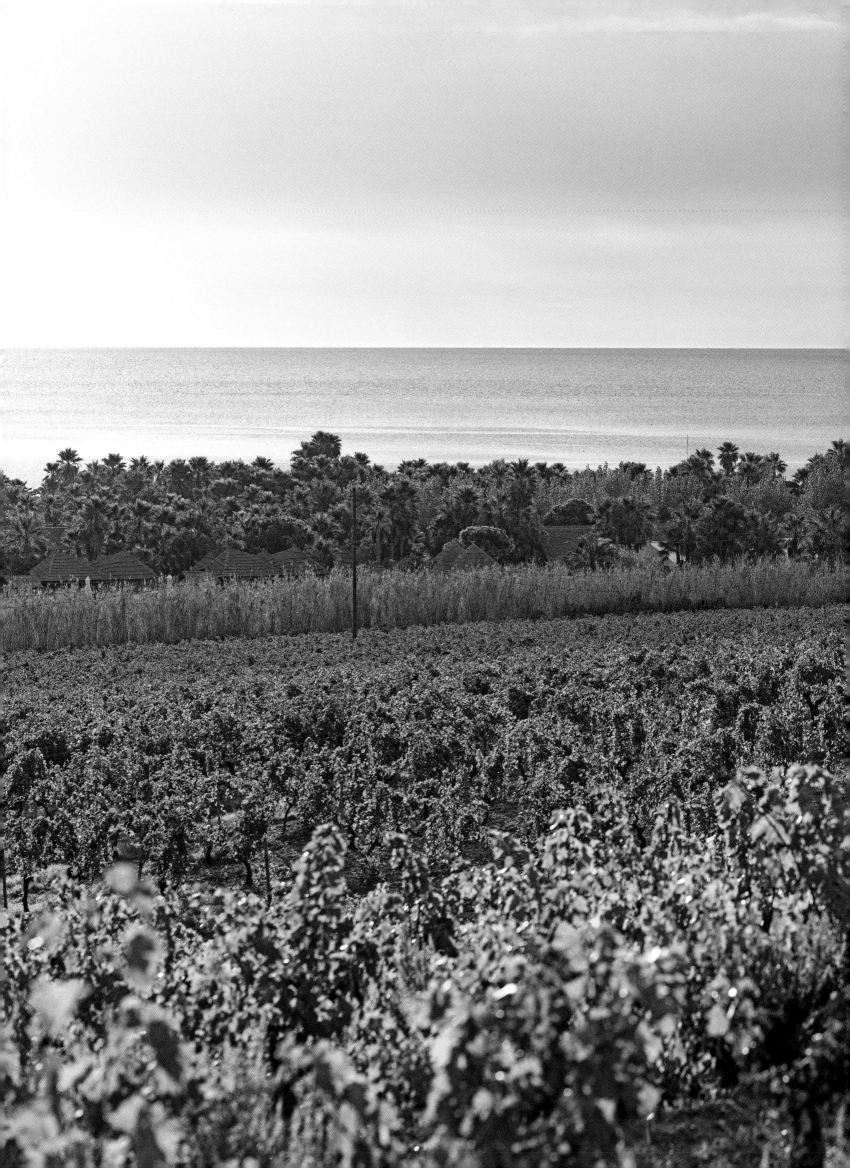

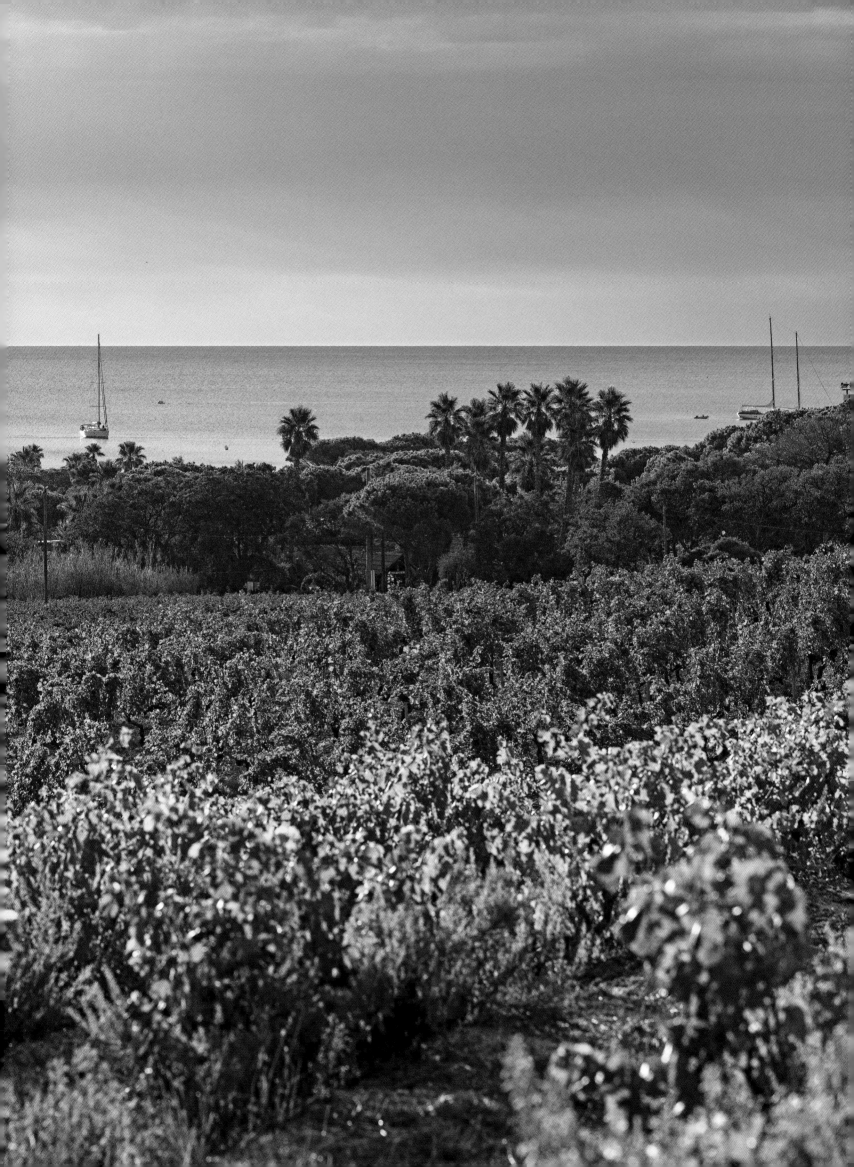

In 2003, following five years of study and with an enology degree in her pocket, Edgar's daughter Marie set off for a decade-long tour of the world. Australia, New Zealand, South Africa, Chile – different countries with as many different cultures and different takes on winegrowing. "I wanted a more modern approach, wanted to discover the world's great vineyards and learn about the culture of wine working alongside winegrowers in different countries. But I returned to Pampelonne every year to help with the harvest and winemaking." Just as well really, because on her return to France in 2014 her father greeted her with the words, "It's over to you now!" Fascinated by vines and with specialist knowledge at her fingertips, Marie immediately shifted to new, environmentally friendly growing practices in harmony with the history of the vineyard. By buying out agricultural leases (French: *fermages*), she turned the vineyard into a 50-hectare holding, planted to the nine grape varieties approved by the appellation, some of them 100-year-old vines.

Marie and her husband are committed to an overall approach founded on respect for natural resources (soil and water) and careful vineyard management. "We're fighting to protect biodiversity, prevent the destruction of our unique natural habitat by using methods that steer clear of pollutants." The vineyard was granted HVE status in 2018 but for now our young *vigneronne* has no plans to convert to organic production. "Organic has become a catch-all for a whole bunch of stuff that doesn't speak to me. It's not the only solution to our environmental problems. Then there are the economic realities facing an estate like ours – lower yields for instance and the need for manual labor. Finding employees willing to hand-till 50 hectares of vineyard isn't easy and it isn't cheap." Duly noted. In the meantime our staunch advocate for the environment has switched to 100% recyclable cardboard wine boxes, bottles exclusively made in France and paperless marketing – innovations not to be sniffed at.

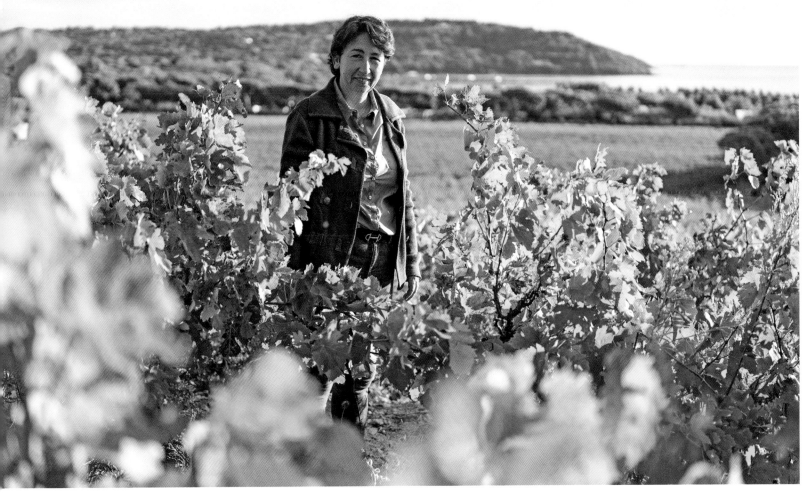

The wines that now bear Marie's signature faithfully reflect their very particular vineyard, combining good roundness with a slightly briny finish. Légende for instance, Pampelonne's prestige, old vines rosé, strikes just the right balance of structure and finesse required to go with food. Its screen-printed bottle was also Marie's idea: a black chateau and palm trees that contrast with the salmon pink hue of the wine. Another big decision of hers, particularly for a woman who claims to have no appetite for business or finance, was to part company with the Maîtres Vignerons in 2020. "With my husband in charge of sales, we wanted to go it alone and handle distribution ourselves." A bold step that meant building a new sales network and starting again from scratch – just when the world went into lockdown, restaurants, bars and wine merchants included. "The only good thing about it was that we were finally on an equal footing with all the other estates," says this lady winegrower who always tries to see the positive side of things.

For the moment her plan is to scale up the business gradually, marketing just 50% of production and bulk selling the rest. "What we want is to make wines that reflect the Pampelonne terroir, not blended wines." Since she took over less than 10 years ago Marie Pascaud has embarked on a brand repositioning and equipped her business to confront changing markets and the arrival of big groups with big money – a success born out of passion but also humility. As she says herself: "Chateau de Pampelonne is a rare gem. We have to carve out a place for ourselves by making good quality wines and cultivating authenticity."

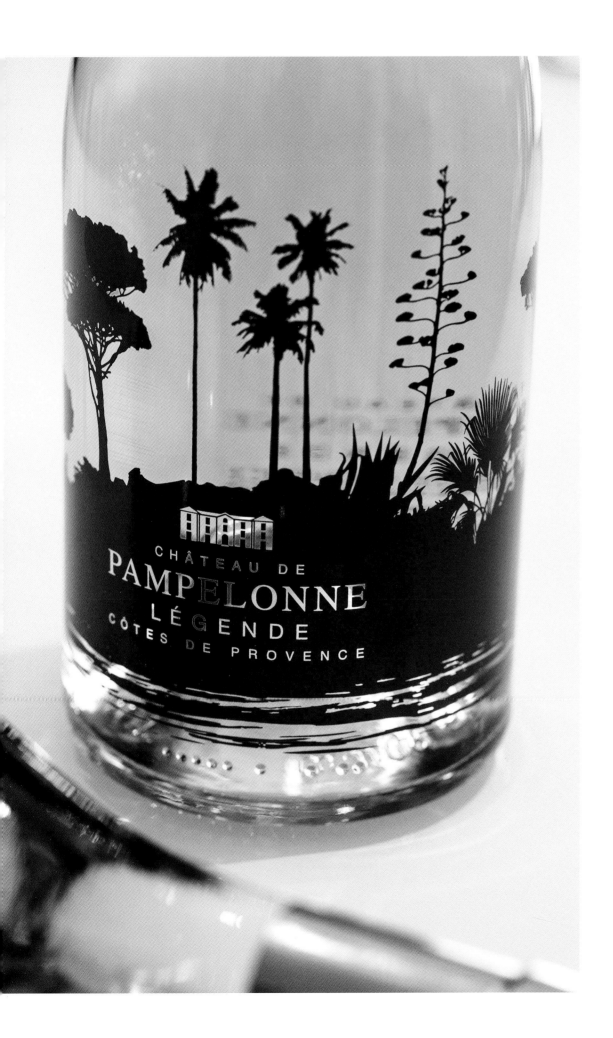

Opposite page
Château de Pampelonne,
the estate's first wine,
combines roundness with
just a touch of salinity.

Left
Légende, the prestige cuvee
created by Marie Pascaud.

CHÂTEAU DE
PAMPELONNE
LÉGENDE
CÔTES DE PROVENCE

AND BARBEYROLLES

CREATED PALE PINK...

We are in the year 1985 and, following a sun-blessed vintage, the whole of France basks in the warmth of a particularly mellow Indian summer. At this point Chateau Barbeyrolles' owner Régine Sumeire has no idea just how much this vintage will count in her life as a winegrower. She does not know that her new cuvee, Pétale de Rose, will set the tone for an entire region; that within three decades her paler-than-pink rosés will have established a reputation extending from the Saint-Tropez Peninsula to the rest of France and eventually the entire planet.

When the time came to choose her career, Régine Sumeire put away her newly acquired certificates (political science, history and Spanish) and opted to uphold the tradition of one of Provence's premier winemaking dynasties. Her life would be lived on the Mediterranean, surrounded by nature like her father before her, with one foot in the vineyards and the other in the tank room.

She discovered Barbeyrolles in 1977: a magical slice of unspoiled land encompassing 12 hectares of vineyards nestling at the foot of the village of Gassin, overlooking the Bay of Saint-Tropez. For Régine, it was love at first sight, never mind that the whole place was in dire need of renovation. Five years of monumental works later, with part of her vineyard replanted, she was ready for business. First came reds, then rosés, all of them made by a young woman with a deep-seated commitment to environmental protection. Curious about everything, Régine made it a point of honor to experiment, explore and share her love of nature with her winegrowing friends. She would have two "spiritual fathers", two great men of wine as mentors: in Provence, René Rougier of Château Simone fame; and Jean-Bernard Delmas, then manager and technical director of Château Haut-Brion, the only Bordeaux First Growth located in Graves. Indeed, it was a visit to Haut-Brion in the winter of 1985 that proved the turning point for Chateau Barbeyrolles. "In the cellars I noticed they had a Coq hydraulic grape press just like mine – a machine some people said was outdated but Jean-Bernard recommended using to press whole white grapes and bring out the best in the fruit."

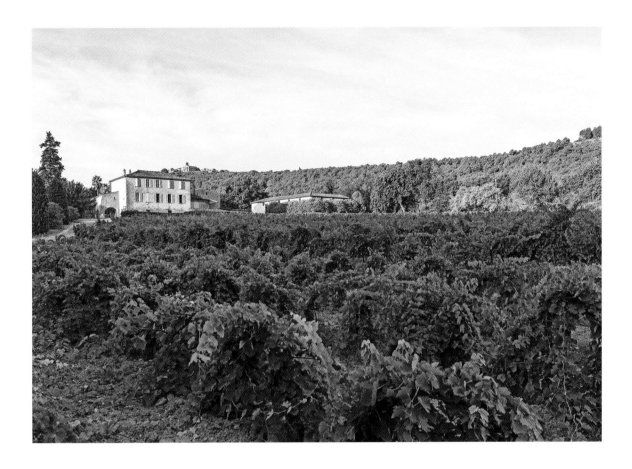

Left
The chateau, with the winery
on the right, overlooked
by the village of Gassin.

NEW WAVE ROSÉ

On her return to Provence, Régine remembered Jean-Bernard's advice and decided to put it into practice at harvest time – but to press black grenache grapes, not white. What she saw and tasted then left her dumbfounded: "The musts flowing out of the press were a translucent color, with a lovely length on the palate and exceptional freshness."

Simply explained, pressing whole grapes as gently as possible largely avoids any contact between the musts and the pigments in the grape skins – hence the ultra-pale color.

This was something entirely new and Régine was thrilled. Like any sensible winegrower however, she was careful to keep the tank in question quite separate from the others and start with a limited edition of just 6,000 bottles. And with that, the first "Pétale de Rosé" cuvee was born, named by a close friend of hers. Truth is however that while Régine's "new wave" rosé proved a hit with some Saint-Tropez restaurants, wine professionals found it altogether too pale... Then again, by the end of the summer there was not much left of those 6,000 bottles.

The following vintage saw Pétale de Rose spread its wings, sparking a craze among restaurants and local holidaymakers alike. People staying in Ramatuelle and Saint-Tropez would visit the chateau's tiny cellars to stock up on Régine's pale, exquisitely delicate rosé – a discerning clientele of faithful fans who remain just as important today.

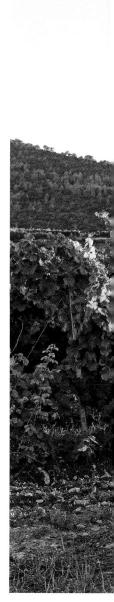

Right
Régine Sumeire checks
grape ripeness to decide
when to harvest.

Opposite page, top
Sunrise over the Tour
de l'Evêque vineyard.

Opposite page, bottom
Pierre-François de Bernardi,
Régine Sumeire's nephew.

A VINEYARD CONNECTION
SPANNING FOUR GENERATIONS

The head of this great Provençal dynasty was Gabriel Sumeire, Régine's grandfather, a wine merchant by trade who acquired three large wine estates in the Var and Bouches-du-Rhône departments before the outbreak of World War II, joined by the end of the fifties by Château La Tour de L'Evêque in Pierrefeu. So it was that Gabriel Sumeire gradually built up his winemaking empire, pursuing a life in rhythm with the vineyard that had fascinated him since childhood. It is as his proud descendant that Régine oversees the family holdings today, which now include some of the buildings and vineyard plots adjoining Chateau La Tour de l'Evêque (bequeathed to Régine's father in 1977 as part of her grandmother's estate).

Since 2019 the estate has been managed by Pierre-François de Bernard, Régine's nephew by marriage and the fourth generation to take up the baton. With support from Régine (following her father's example) he heads up the group farming business (GFA, *groupement foncier agricole*) that she established that year for her eleven nephews and nieces – a move designed to keep the property in the family, so honoring the promise she made to her grandfather.

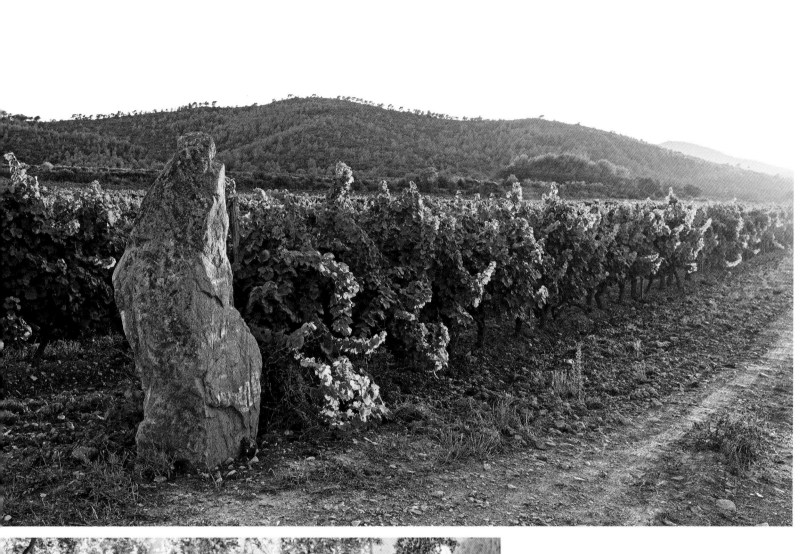

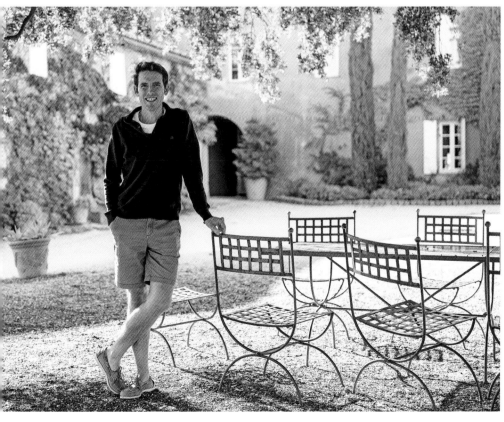

Right
Arriving at the Château
de La Tour de l'Evêque.

Opposite page
Château Barbeyrolle's famous
Pétale de Rose cuvee – the first
ever pale pink Provence rosé.

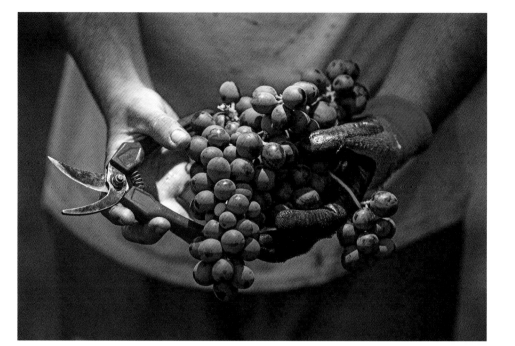

RÉGINE SUMEIRE, ONE OF THE PIONEERS OF ORGANIC FARMING

For nearly 40 years, our passionate lady winemaker gave her all to modernizing and building up her two estates. She juggled production and marketing with a seemingly inexhaustible energy, meanwhile turning Barbeyrolles into a gourmet eatery for anyone who came calling – friends, importers, sommeliers, chefs or members of the press.

In 1985, with La Tour de L'Evêque keeping her increasingly busy, she took the plunge and released her first estate bottled offerings – dynamic wines that reflected her high ambitions for this lovely 83-hectare property. Shortly afterwards came a cuvee along the same lines, 100% estate-grown-and-bottled like its predecessors but with a different label. This one was decorated with rose petals and it became a huge success, most notably in Canada where Régine still goes on a regular basis to boost sales – that, and to spend an agreeable weekend cross-country skiing or snowshoeing in the Laurentians. Sold in 40 countries worldwide, Régine's Chateau La Tour de l'Evêque now accounts for 80% of her production – a success that speaks for itself.

Both estates have seen considerable improvements in terms of equipment and winemaking but always with the environment in mind. Nature for Régine is not so much a priority as an invaluable asset worthy of her "love and respect", to quote the words used by her father and grandfather. Going organic was therefore an obvious next step: In 2008, both her properties were granted organic certification, building on the biodynamic principles she holds dear.

Today, with Pierre-François at her side, she continues to experiment in the cellars and vineyards alike – a lady winemaker driven by a quest for excellence, embodied in the pale pink rosé she gave to Provence.

THE ROUTE DU ROSÉ
SAINT-TROPEZ TO ST BARTS

It was a winning idea just waiting to be discovered. An offshore race linking two fairytale destinations, exclusively reserved for famous sailing boats from the other side of the Atlantic loaded with cases of rosé wine. In 1987 they made it happen: a handful of energetic winegrowers launched the first-ever Rosé de Provence racing event, proud to showcase their wines and already convinced that rosé was the way to go.

It all started when Sébastien Le Ber, then owner of the Domaine de l'Ile on Porquerolles and an accomplished sailor himself, introduced a skipper friend of his to the notion of shipping Porquerolles wines all the way to St Barts. The idea quickly caught on, as so often in the course of agreeable luncheons attended by two leaders of men: American skipper Gil Frei and Patrice de Colmont, president of the dynamic Yacht Club de Saint-Tropez, and owner of Pampelonne's iconic Club 55 beach.

By that time the much-awaited Nioulargue race had been going for several years, its multi-day regattas and racing events attracting gleaming racing yachts to the Bay of Saint-Tropez every September. After summering in the Mediterranean, they sailed across the Atlantic to winter in the Caribbean.

With the boats already in place, it only remained for a few enterprising winegrowers to launch the Route du Rosé: an offshore race reserved for famous sailing boats over 60 feet, for the most part beautifully restored classic craft. The idea quickly took root, championed by winemakers on the Saint-Tropez Peninsula, most notably Régine Sumeire and Edgar Pascaud, and Sébastien Le Ber in Porquerolles, with seasoned sailor Jean-Jacques Ott, president of the Association des Amis de la Route du Rosé, keeping them motivated right up to the last edition of the race in 1992.

Naturally, the race had its own set of rules – flexible for skippers, rather more challenging for the crew – and its own set of rewards – such as the "Esprit du Rosé" and the Ruban du Rosé for the fastest contender.

The originality of the idea quickly attracted the attention of journalists, who were invited to the great day of loading or, in the case of the lucky ones, to St Barts – coverage that put the spotlight on the participating estates and on Provence rosé itself. With successive editions of the event, French people gradually came to see Provence rosé in a different light.

It was the same success story in St Barts where a week-long promotional program awaited the winegrowers who travelled out to welcome the sailboats in December, complete with tastings in hotels, restaurants and on the island's private beaches. Product positioning, sales development, brand awareness… the project achieved all of its objectives, no doubt helped by the fact that Americans who visit St Barts tend to be strongly pro-Provence.

Commercial objectives aside, the Route du Rosé with its festive atmosphere and trips aboard dreamy sailboats would forever be lodged in the memories of its founders – that little group of bold, pioneering winegrowers, henceforth and forever bound together by an endeavor that succeeded beyond their wildest expectations.

Above
Route du Rosé flags blowing in the wind on the masts of the sailboats.

Opposite page, top
The pioneering winegrowers behind the Route du Rosé, waiting to welcome the boats' arrival in St Barts.

Opposite page, bottom
Loading rosé wine in the port of Saint-Tropez.

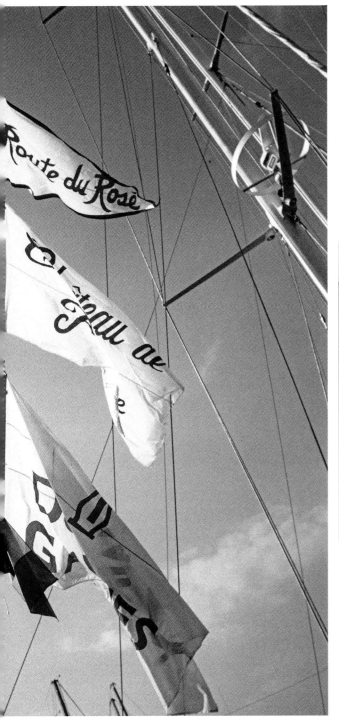

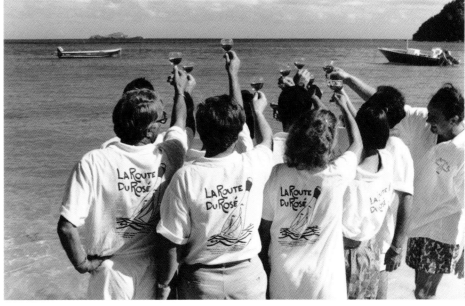

THE FAMOUS TWELVE

(11 OWNERS REPRESENTING 12 ESTATES)

Château Barbeyrolles and La Tour de L'Evêque

Château de Rasque

Château Real Martin

Commanderie de Peyrassol

Domaine de La Croix

Domaine des Escaravatiers

Domaine Gavoty

Domaine de L'Ile

Domaines Ott*

Domaine de Saint Baillon

Les Maîtres Vignerons de la Presqu'île de Saint-Tropez

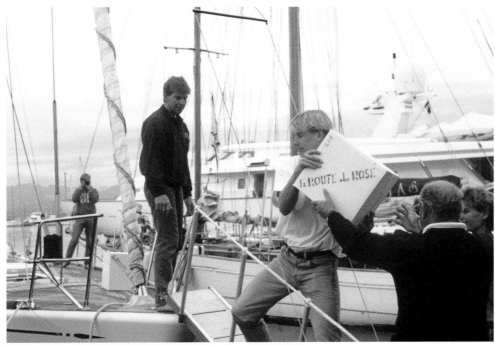

THE LE BER FAMILY

HEIRS TO AN ISLAND

Born on the paradise island of Porquerolles, off the southern tip of Provence, Sébastien Le Ber has always been torn between land and sea. Wine or waves, vines or sailing – his was not an easy choice but then every choice is a renunciation. In the end he opted for wine-growing, following his head as he meanwhile followed his heart sailing to the four corners of the Earth. So it was that he took this family-owned island estate to a whole new level, placing its wines among the finest of all the Côtes de Provence offerings.

The island was his kingdom, says the family history. In 1912 his grand-father François Fournier, an engineer and great adventurer who made his fortune in Mexico, bought Porquerolles at a government auction. This little gem of a Mediterranean island would be his wedding gift to his wife Sylvia. It lies off the coast of the French Riviera, a tiny crescent-shaped island measuring barely four square miles. A small island certainly, but with a long and turbulent history: for 2000 years Porquerolles was the butt of invasions by raiders of all cultures – Celtic, Phoenician, Greek, Italian – and pirates of all types. Hence the Fort Ste Agathe built here in the 16th century by Francis I of France, the oldest fortifications on the island. The early 20th century then saw Porquerolles transformed by a massive program of works that enjoyed the support of the French government. Crops, greenhouses, canals, electricity and workers' housing came to Porquerolles. Eventually however, courtesy of a catastrophic fire and mismanagement, this little garden of Eden was put up for auction.

For 20 years François and Sylvia Fournier drove an agricultural boom on Porquerolles, their most notable legacy being four flat fertile plains covering an area of 200 hectares that also serve as firebreaks. In the 1930s the intrepid Sylvia transformed an abandoned factory on the island's western tip into a hotel. So was born the iconic Mas des Langoustiers: a property named for the beach, nestling amid pine trees and facing two breathtakingly beautiful coves.

François Fournier's death in 1935, followed by World War II, hastened the island's inevitable decline. Everyone moved away except for the lighthouse keeper; most of the buildings were destroyed and the farmlands fell into disuse.

Right
Perfect clusters of mourvèdre.

Opposite page
Vines, cypress trees and pines
on the plain of Brégançonnet,
in the west of Porquerolles.

FROM VESSELS TO VINES

Unravelling the deceased's estate was a complicated business for four of François' six daughters. Each of them was left a plain, the Plaine du Brégançonnet in the west of the island going to daughter number four, the headstrong Lelia. In the early 1960s she and her husband Dominique Le Ber then developed the property: They renovated the Mas, replanted some 20 hectares of vines, built a wine cellar, and in 1964 their newly born Domaine de l'Ile released its first vintage. They also had a son, Sébastien. In 1971 the French government bought the major part of the island and turned it into the Parc National de Port Cros, but the family held onto their land. The Plaine du Brégançonnet was one of three areas to remain in private ownership.

Sébastien Le Ber, apart from a few seasons when he worked in the hotel, spent his youth sailing the seven seas and regatta racing. A friend of professional skippers, he has seven transatlantic crossings to his credit. On the first, in 1981, he stopped at the island of Saint Barthélemy to sell some of his wines. "I would always take advantage of an island stopover to make a sale, even if it meant venturing out by boat," says this man who would later spearhead the Route du Rosé race.

In 1974, aged 34, he stowed his sails and spent six months in the vineyards alongside his father – a head-before-heart decision triggered by a stint at the agricultural college in Hyères and visits to wine estates. Swapping the sea for the soil but with the wind ever in his hair, he embarked on life as an island winegrower. Easier said than done when everything depended on the sea link to the mainland – equipment, construction materials, provisions, even accommodation for harvesters!

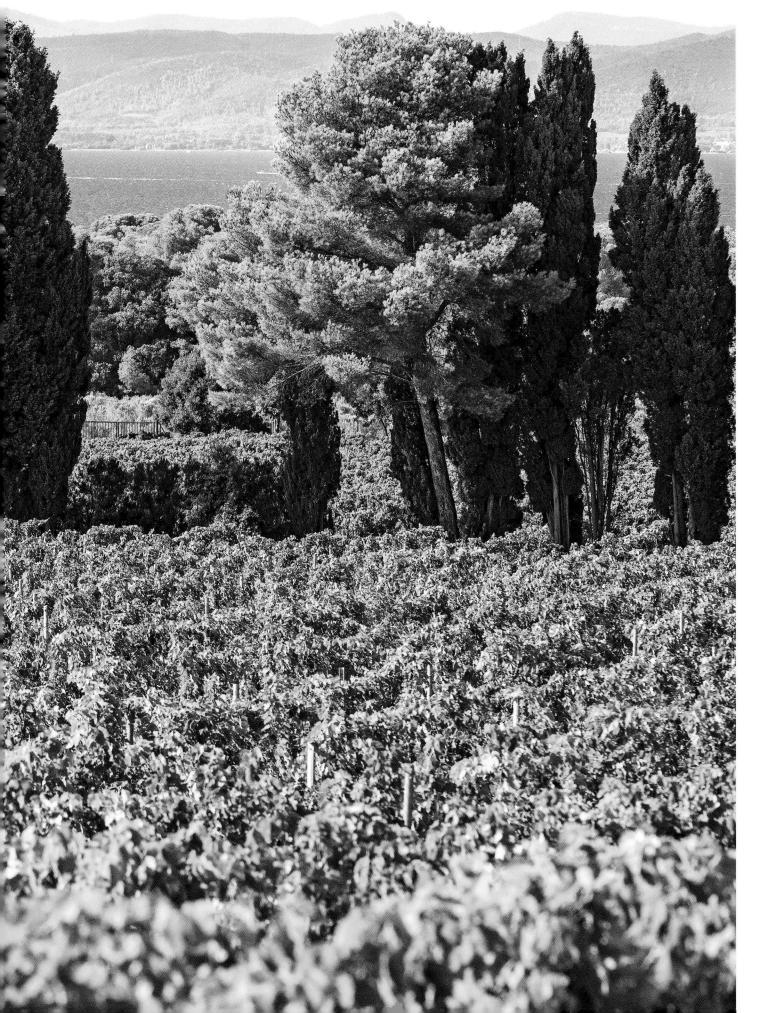

Above
A parcel of vineyard
surrounded by nature
as far as the eye can see.

Opposite page
A shady path under
a natural dome of age-old
Umbrella pines.

Within ten years, he had taken out a long-term lease on 40 hectares of state-owned land, which he then partly replanted. Realizing that he needed to catch the wave of rosé, he was soon focusing on pink wines (70% of production) with white wines making up the rest. But these weren't thirst quenchers. His style, as he says himself, was "based on texture and finesse; on late-harvest, over-ripe grapes producing orange-colored rosés with 13 percent to 13.5 percent alcohol."

Sébastien Le Ber remains a yachty, with his boat always moored at the quayside. In 1981, as a newly fledged winegrower, he founded the Yacht Club and successfully relaunched the Porquerolles Cup. A few years later came the Semaine de Porquerolles then the Classique.

Today he has hung up his secateurs but is still president of the Yacht Club. "The children weren't interested in the vineyard business but it was time to hand over anyway." There was no shortage of takers, all of them rich and famous, including a Chinese businesswoman. But only the vineyard was for sale. "My aunts all sold up but my mother kept and operated the Mas Des Langoustiers, the Restaurant de la Plage and the St Anne Hotel in the village, which all remain family-owned." In 2019 he sold his holding to Chanel. He himself still lives on the island.

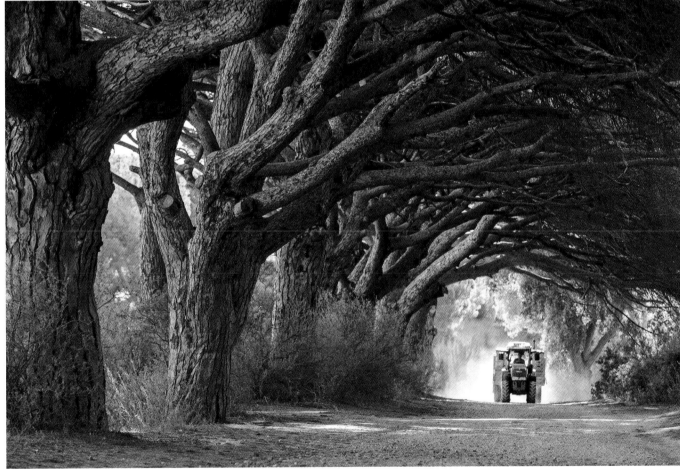

PROVENCE CLASSIFIED GROWTHS

In 1955, almost 20 years before the Côtes de Provence appellation was established in 1977, the French Ministry of Agriculture granted classified growth status to 23 Provence properties. Eighteen of those retain that status today (the remaining five have since disappeared).

The story goes back to the turn of the 20th century when a small group of visionary winery owners set out to win recognition for their terroir and the quality of their wines. In 1930 they banded together to form the Association Syndicale des Propriétaires Vignerons du Var: an association of like-minded individuals fueled by their determination to obtain a wine classification of their own.

A list of eligible properties was drawn up by the Prefect (an official who stands between central and local government) and then assessed by experts under the auspices of the INAO (national institute for quality and origin). Twenty-three properties qualified for classified growth status (French *Cru Classé*), on the basis of broad criteria spanning soil geology, terroir, climate, grape varieties, wine-making facilities, awards and chateau bottling.

The 18 growths that remain today are the only rosé wines in the world with *Cru Classé* status – a distinction that members of this exclusive club are proud to show off outside France, especially on the bottle labels.

THE CLUB MEMBERS

Château de Brégançon

Clos Cibonne

Château de Galoupet

Domaine du Jas d'Esclans

Château de La Clapière

Domaine de La Croix

Château de l'Aumérade

Château de Mauvanne

Château Minuty

Clos Mireille

Domaine du Noyer-Clos Mistinguett

Domaine de Rimauresq

Château Roubine

Château de Saint Martin

Château Saint Maur

Château Sainte Marguerite

Château Sainte Roseline

Château de Selle

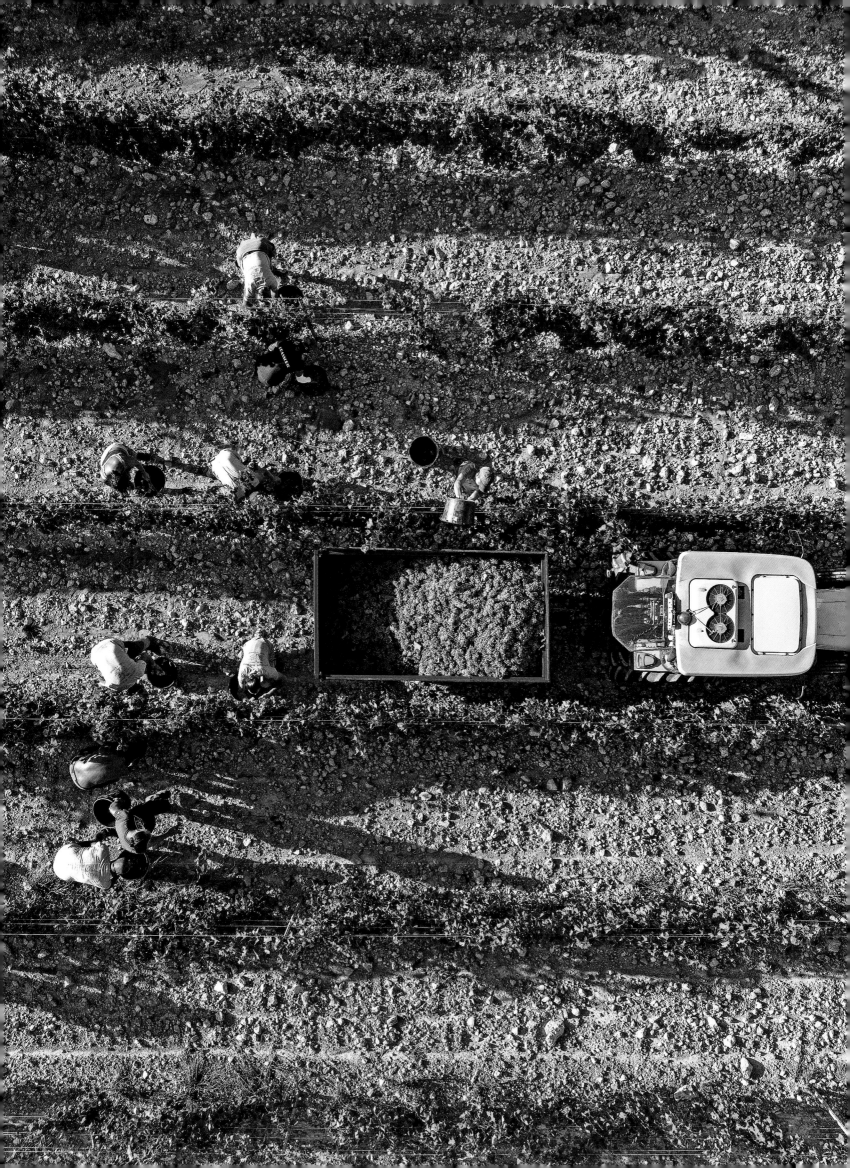

PASSIONATE NEO-WINE GROWERS

FOR MANY NEO-WINEGROWERS IN SEARCH OF A PROPERTY IN PROVENCE, ALL IT TOOK WAS ONE LOOK. NEVER MIND THE PRICE AND THE COLOSSAL TASK THAT AWAITED THEM, THEIR MINDS WERE MADE UP. UNTAMED NATURE, UNDULATING VINEYARDS, ONE-HUNDRED-YEAR-OLD OLIVE TREES: WHAT THEY SAW BEFORE THEM SET THEIR PULSES RACING AND PUT STARS IN THEIR EYES. THE CLOSING YEARS OF THE 20TH CENTURY SAW A FIRST WAVE OF WEALTHY, ENTERPRISING INDIVIDUALS SET OUT TO TRY THEIR LUCK AT WINEMAKING. SOME MANAGED IT ALONE, INSPIRING THEIR CHILDREN TO FOLLOW THEIR EXAMPLE, OTHERS DID IT WITH THE HELP OF PROFESSIONALS. WHATEVER THE CASE, THEIR DOGGED PERSISTENCE EVENTUALLY PAID OFF AND THEY FOUND THEMSELVES ON THE THRESHOLD OF FAME JUST AS ROSÉ WINE WAS TAKING OFF. IT WAS AN OPPORTUNITY TOO GOOD TO MISS.

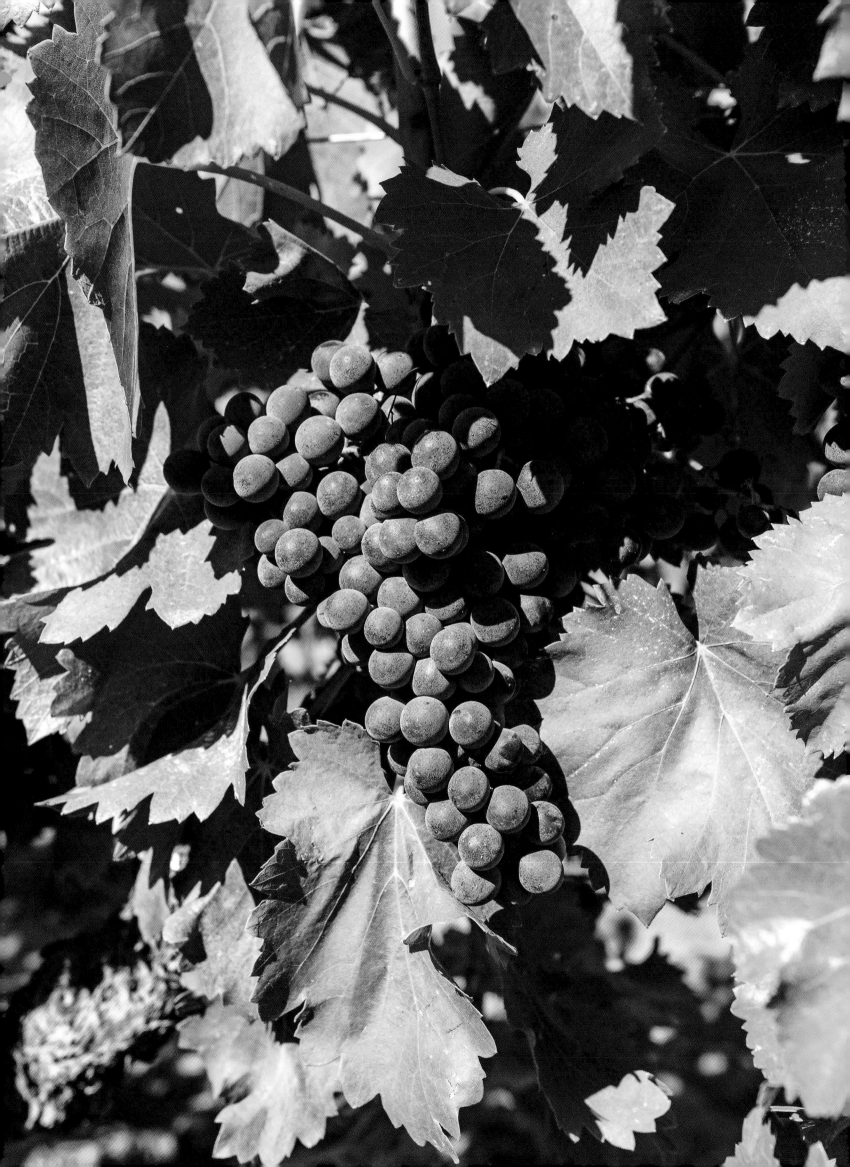

CHÂTEAU ROUBINE

A FAMILY SPIRIT

Valérie Rousselle sits on the shady terrace of her chateau, facing a magnificent one-hundred-year-old lime tree and commenting on the plans for a new solar-powered building destined to come on stream in 2024. With her is Victoria, her daughter and the person in charge of this ambitious project. It represents another major step in Château Roubine's rise to stardom among Provence rosés, not least because its completion is scheduled to coincide with Valérie's thirtieth vintage – an achievement she intends to celebrate with the opening of a new cellar wine shop.

Valérie certainly wasn't destined to be a winemaker, even if she was born in Saint-Tropez and remains firmly attached to her roots. She originally trained as a hotel manager at the Lausanne school of hospitality management in Switzerland. In fact she was thirty by the time she decided to quit her job at a Groupe Barrière Hotel in Deauville and return home to join her father, the man who back in the sixties had established the first "glampsites" on the beaches of Saint-Tropez (Pampelonne, Bora-Bora, Kontiki, La Toison d'Or…). So commenced a new career working alongside her father in real estate. Her first encounter with Château Roubine was when she was viewing the property on behalf of a client. One look at this wooded, single-block estate was all it took. "It was clearly meant for me. I don't believe in accidents. Sometimes you just have to let life show you the way." The property became hers just after the 1994 harvest: a magnificent, classified growth, located in gently rolling countryside.

A go-getter by nature, Valérie steamed ahead, disregarding doubts and uncertainty. She hired a vineyard manager and began by rebuilding the vineyard parcel by parcel, replanting to mourvèdre, rolle and tibouren, the flagship Provence grape. "In three years, we went from 57 to 72 hectares planted to the 13 regional grape varieties." The next stage in this concerted pursuit of excellence was to upgrade the winery: out with oak vats and old-fashioned machinery, in with stainless steel tanks and state-of-the-art presses. Within a decade, Château Roubine was on course for victory as a producer of Provence's then-fledgling rosés.

VALÉRIE ROUSSELLE, A PASSION FOR WINEGROWING

Between times, Valérie gave the chateau a facelift, turning it into a family home with "the soul of a Provençale dwelling". Her three young children would grow up there, in rhythm with the seasons of the vineyard and the excitement of the harvests.

She also excelled as an ambassador for Château Roubine. Tastings, meeting and greeting customers, wine fairs, business trips – Valérie was quick to grasp the importance of networking and building good working relationships. Pretty soon her calendar was full of events, which included hosting the first lunches at the chateau for sommeliers, distributors and journalists.

After Roubine, Valérie's other great area of expertise is business relations. As president of the Crus Classés de Provence from 2005 to 2008, she founded "Les Eléonores de Provence": an organization that brings together women CEOs in the lifestyle business, with the spotlight on wine, gastronomy, local products and hotels. Future years would see her nominated vice-president of "Femmes de Vin", a nationwide women's circle of key importance in France's wine landscape.

In 2008, following a course at the University of Wine in Suze-la-Rousse, she embarked on a new, green crusade: "Quite apart from learning more about winemaking, I realized that going green would become even more important in years to come. So of course I wanted to protect the environment, particularly since I firmly believed organic farming would one day be the norm." Her first step was to phase out vineyard treatments and replace them with suitable alternatives – a long and difficult process that earned the estate the EU's organic label for its 2017 vintage, followed three years later by Demeter certification (the quality mark for products grown biodynamically). "But we were in it for the long haul, the whole team - cellar master, enologist, vineyard manager – pulling together in pursuit of our shared vision," says the lady who set the ball rolling. Her two eldest children Adrien and Victoria have since joined the business – a turning point that marked the arrival of new technology, tanks and barrels aimed at making and aging wines with even greater precision.

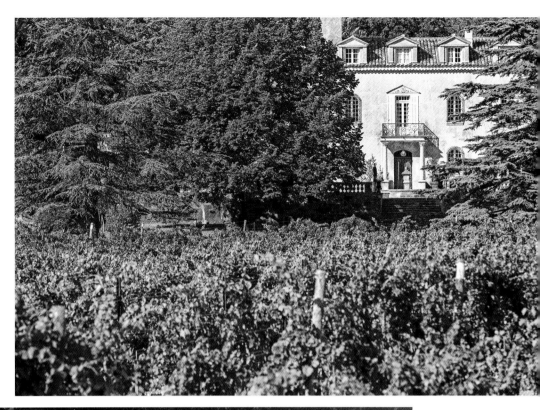

Opposite page
Valérie Rousselle
and daughter Victoria.

Right
Château Roubine and its
hundred-year-old lime tree
at the edge of the vineyard.

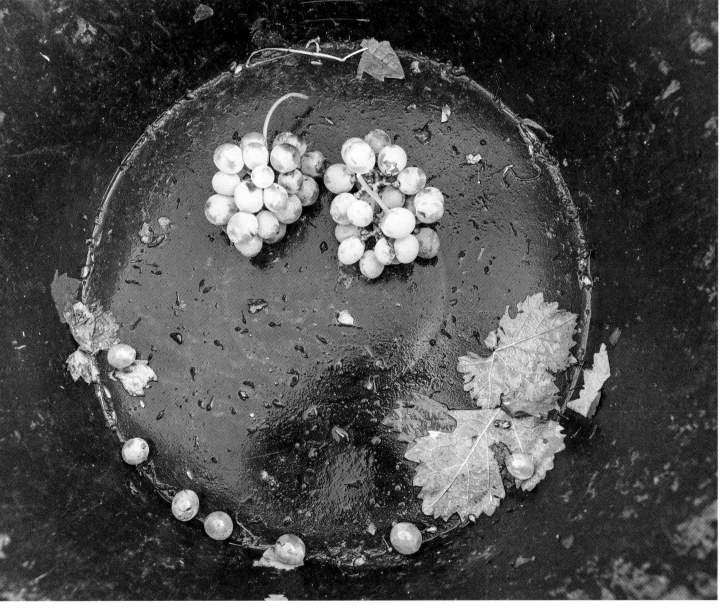

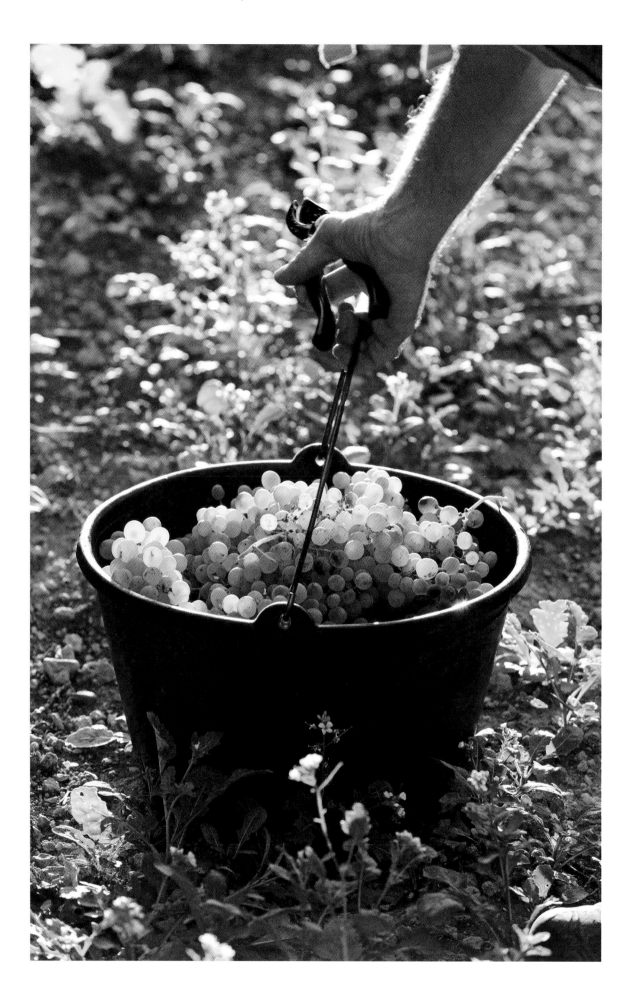

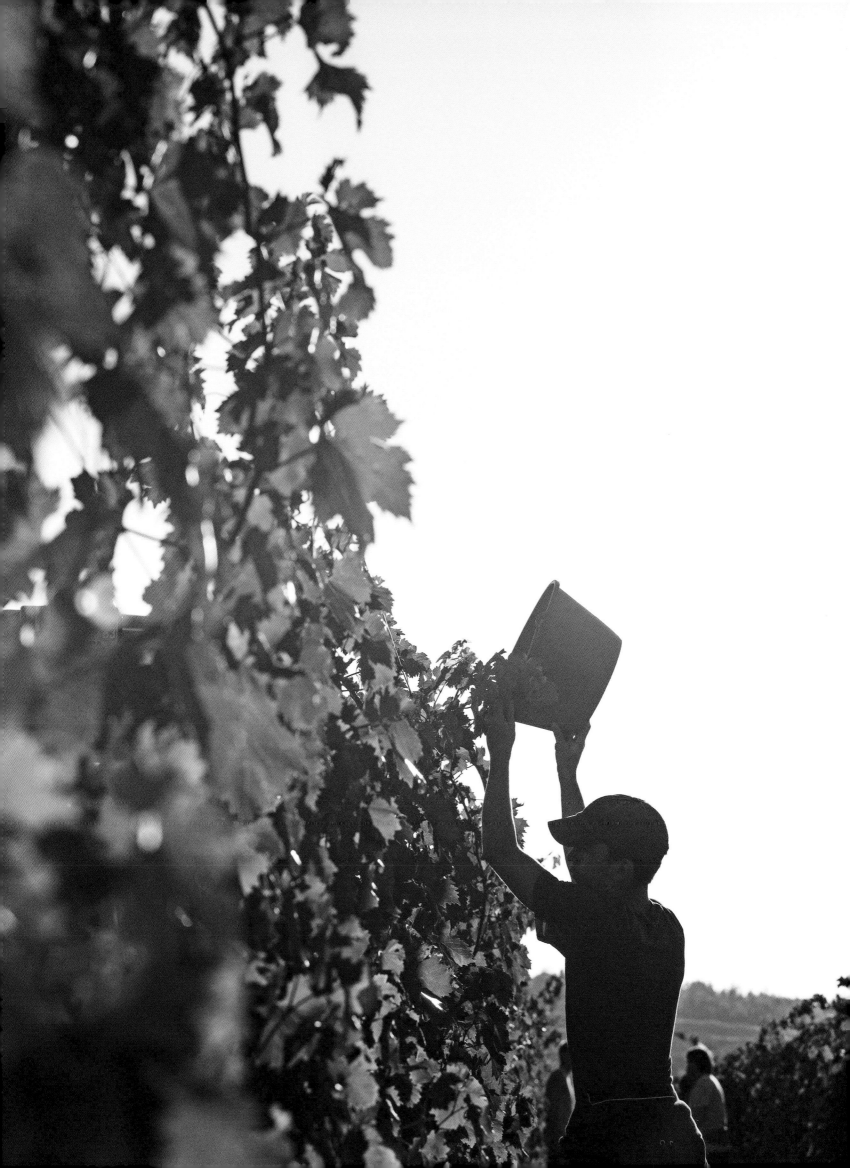

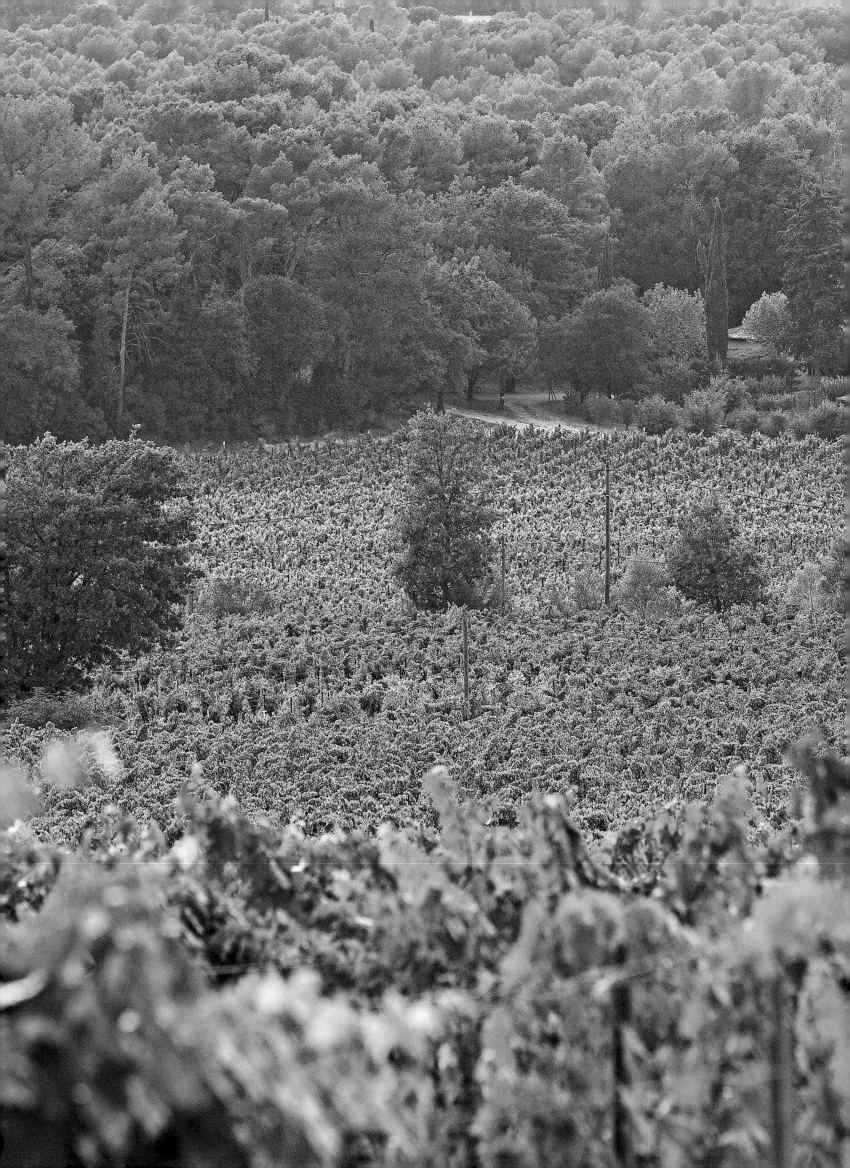

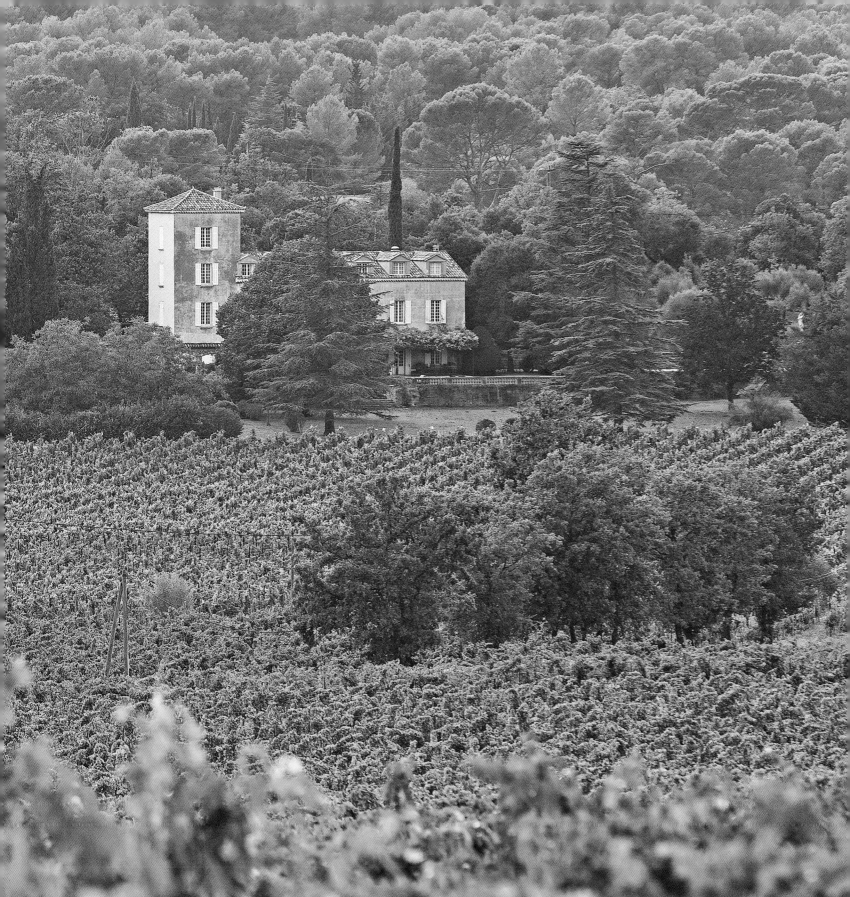

Above
Inspire and Lion et Dragon,
the estate's two main
rosé wines.

Right
Hippy, a light rosé that
expands Roubine's rosé
wine repertoire.

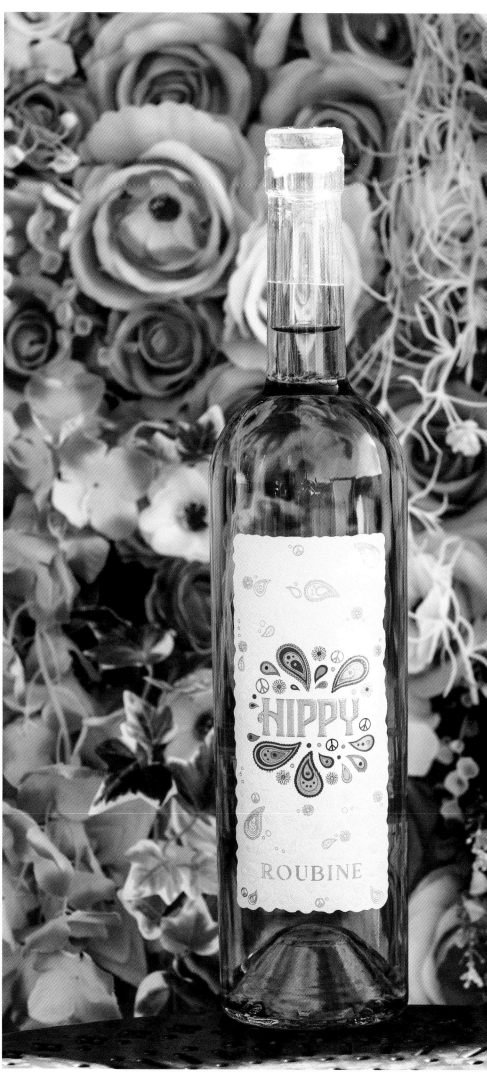

UNUSUAL BOTTLES AND
A BROAD RANGE OF OFFERINGS

In 2015, product presentation became a priority, particularly now with Valérie's son in charge of marketing. The aim was to come up with a new look that would meet changing customer expectations. Mission accomplished with the development of a customized bottle designed to bring consistency to the estate's three cuvees, Premium, Lion et Dragon and Inspire (available in red, white and rosé), and show off their *cru classé* pedigree. Elegantly designed, the bottle combines a bulbous body with a tapered neck, each of the three cuvees being distinguished by an embossed label. Large format bottles came next, mainly for rosé offerings.

The Lion et Dragon bottle is impossible to miss with its motif in relief representing a lion and dragon protecting a climbing vine under the rays of the Provence sun. The cuvee is named in honor of the estate, the lion symbolizing Lorgues and the dragon symbolizing Draguignan. Its big sister, Inspire, features a serigraph of a filiform sculpture by local artist Corinne Vue – a vibrant recreation of an original work inspired by a vine found on the property. The first in a limited series, the original takes pride of place in the chateau's grand salon.

Roubine's new-look bottles coincided with the expansion of its product line to include branded wines. "With the rosé market now booming, the time was ripe to develop our offering and pursue growth," remembers our mother and son team. They kicked off with La Vie en Rose, available only as rosé, and followed up a few years later with Hippy – light, fruit-forward wines, not as complex as their chateau counterparts but carefully made and bearing the family seal of approval…

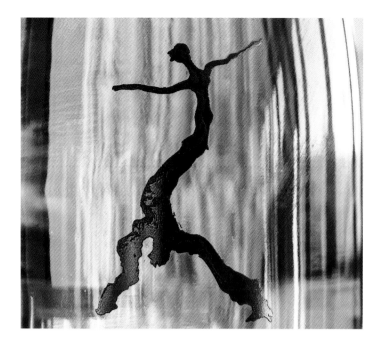

A DIFFERENT TAKE
ON A RESORT

Château Roubine rosé now accounts for more than two thirds of production and has a presence in 40 countries. Europe is its number one market, with France at the top of the list and the USA as its primary target market. The original holding is still the flagship property but has expanded over the years to include a few hectares of woodland on the edge of the property and the neighboring 50-hectare St Béatrice estate. Ever on the lookout for new opportunities, Valérie has also gained a foothold in the Côtes du Rhône appellation with the acquisition of Domaine de Chante Bise near Suze La Rousse. The result is a property portfolio that can support product diversification while also bolstering grape supply – no small advantage.

For some years now, Valérie's strategy of regular, hefty investment has been paying off handsomely. So much so indeed, that our seasoned businesswoman now has plans for a project that would draw on her background in hospitality. "My heart is set on making Roubine a resort like no other – new reception facilities, visits, wine-themed events, everything required for an unforgettable vacation experience. We've hired architect Lina Ghotmeh, a lady famous for her groundbreaking architecture, to come up with drawings for a completely new sort of hotel complex." She has in mind some thirty bedrooms in all and hopes to open in 2025.

In the meantime, she plans to celebrate her thirty years as owner of Château Roubine in characteristic style. On the agenda for 2024 are the opening of a vineyard restaurant (Fada, which is southern French slang for "nutcase") and the complete refitting of her tasting-cum-sales cellar. The drive to develop wine tourism is a return to her roots for Valérie Rousselle, albeit with one eye firmly on the future. Now that two of her children have joined the business, she relishes the prospect of making Roubine a family estate that counts in Provence.

LÉOUBE

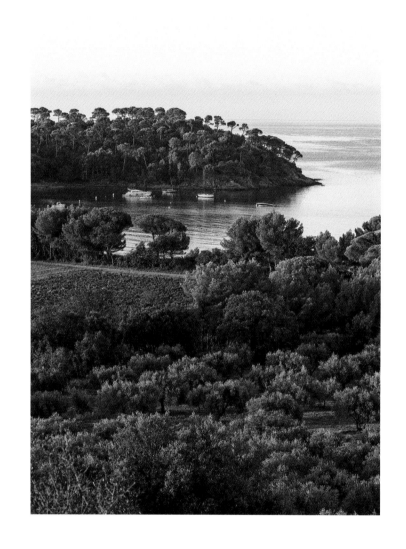

A GARDEN
OF EDEN ON THE
FRENCH RIVIERA

Lord and Lady Bamford originally came to the south of France in search of a property, not a vineyard. Wide open spaces, an endless blue sky and nature everywhere. A pristine wilderness, with the sea off in the distance perhaps but not a soul in sight. And lo, there it suddenly was! A vision of wild beauty straight out of their dreams. One of those moments that lasts forever.

Running alongside Léoube is a narrow, winding road bordered by olive groves, vines and pine trees, with glimpses of empty hillsides visible in the distance. Around the property extends Cap Bénat, one of the Côte d'Azure's best kept secrets, facing the Iles d'Or. From the chateau itself, all we see is the sea, with Pellegrin beach in the foreground, famous for its four-kilometer-long ribbon of golden sand and small inlet; and in the background, the Fort de Brégançon, standing on its rocky promontory. At the time of purchase, this 560-hectare estate consisted of grasslands and wooded hillocks interspersed with olive trees and garrigue, scattered vines for a vineyard, the ruins of stone buildings and a former *poste de douane* (customs post) at the water's edge. Nevermind, the place worked its magic anyway, say Lord and Lady Bamford: "What started out as love at first sight became a passion; 1997 was the year of an exceptional meeting with the estate of our dreams."

In the early 1900s Léoube was acquired by the Auberts, a family that made its fortune in Argentina. It was then left in the hands of an estate manager but gradually fell into decline due to years of neglect and shoddy maintenance. Eventually it was put up for sale, mortgaged to the hilt and no longer profitable but with one priceless advantage: the conservation of the coastal area lying between Bormes-les-Mimosas and Brégançon. Thanks to a landmark decision in 1975 by the Conservatoire du Littoral (coastal protection agency), there was not a building anywhere to be seen – no doubt because the nearby Fort de Brégançon is the official summer retreat of the President of France.

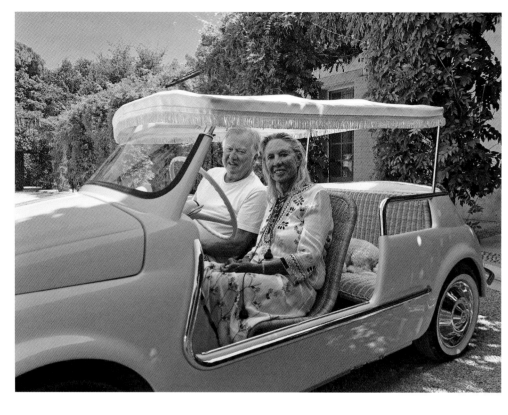

A STRONG IDENTITY

In 1998 it was destiny, not chance, that led the couple to seek advice on winemaking and wine marketing (among other things) from Jean-Jacques Ott, then CEO of Ott holdings that included the adjoining Clos Mireille vineyard. A whole bevy of specialists soon followed. In 2000 fledging winemaker Romain Ott was asked by his father to take charge of the Léoube winery. Twenty-three years later, he manages 70 hectares of vines, 22 hectares of olive groves (that's 5,000 trees) and supervises winemaking and olive oil production. He is the creator of every Léoube vintage, and the man behind the property's revival and brand identity. His credo is "Let things take their course", always looking at the property from all angles and always working closely with the owners. "Bringing the property back to life meant taking account of everything that makes this place unique – its classified status, size, microclimate, east-west exposure, diversity of soils and environmental friendliness. We needed a brand identity that worked across our entire product line."

Lord and Lady Bamford wished to apply the same organic principles here as at Daylesford Organic: their large farm in the United Kingdom long renowned as a pioneer of organic farming, with a wellness center, spa treatments and cottages as part of the package. Léoube's organic conversion began immediately, though taking it gently, one step at a time. The Bamfords completed organic certification of their estate in 2011 – a testimony to two champions of biodiversity whose vineyard, huge vegetable garden and orchard have developed in tandem with nature. Every winter, natural grazing by hundreds of sheep plays a pivotal role at Léoube, stimulating biodiversity and enriching and fertilizing the soil until spring.

Above
Owners Lord and Lady Bamford in their electric car.

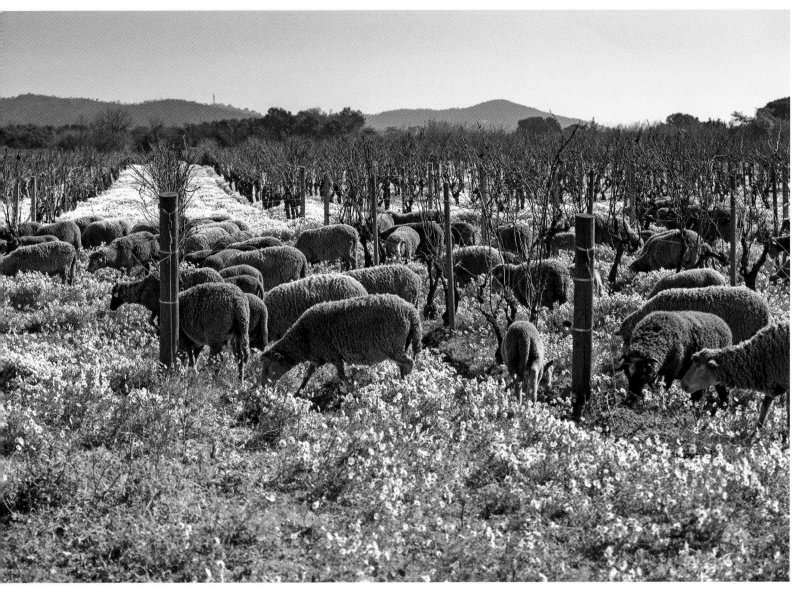

Above
Natural grazing by
hundreds of sheep continues
from winter to spring.

Left
Romain Ott – the man
behind Léoube wines since
his arrival in 2000.

FEMININE ELEGANCE

Terroir and plot selection; planting to new grape varieties; extending the olive groves; refitting the tank room and winery… Léoube's restoration has been a colossal undertaking spanning many years, weighing up the priorities and acting accordingly. As estate manager Romain Ott points out, it was 2007 before the first Léoube-labelled bottles appeared. "That's how long it took to find our own personal style and adapt to a changing market with rosé wines fast becoming the new craze."

So what is Léoube's personal style? Crowd-pleasing, with fruity finesse and more body in the case of their prestige cuvees. The range started out small and gradually grew bigger – wine with a feminine touch that is accented by the enamel screen-printing on the bottles, red, white and rosé wines alike. It was Provence architect Jacqueline Morabito who came up with the idea of using a handwritten font for the name Léoube – a minimalist, unpretentious approach that works well for all the different bottle sizes, even when displayed vertically as on in the magnum cuvee prestige rosé 2020. Other names meanwhile appear here and there: Love, Secret and Léoube La Londe, a homage in pink to the terroir. Nothing showy, either inside or outside the bottle.

Léoube wines have a strong brand presence in France's top restaurants and are also becoming known in English-speaking countries, with distributors in 50 markets worldwide. Since 2023 the wine portfolio has grown to include four ranges, each with their own distinct flavor profile while maintaining a consistent house style: Love by Léoube, Origine, Secret and Collecto.

Their uncluttered design style was largely inspired by Carole Bamford, with the focus on whiteness, lightness and sober lines – a breeziness that informs the décor of her large gift store and elegant seaside restaurant, Café Léoube. Not forgetting the labels on her little pots of tapenade, jam, honey and bottles of extra virgin olive oil…

Untamed garrigue, manicured olive groves, undulating vines and hillsides bristling with oaks… Léoube exudes authenticity and integrity. For more than 20 years now, Lord and Lady Bamford have been giving their all to restoring its fortunes and crafting its identity, patiently imprinting their own personal style on a property that is now a jewel among jewels. A secret Garden of Eden on the French Riviera.

Right
The entrance to the estate, overlooked by the now fully renovated chateau.

Opposite page
The magnum prestige cuvee and its little sister.

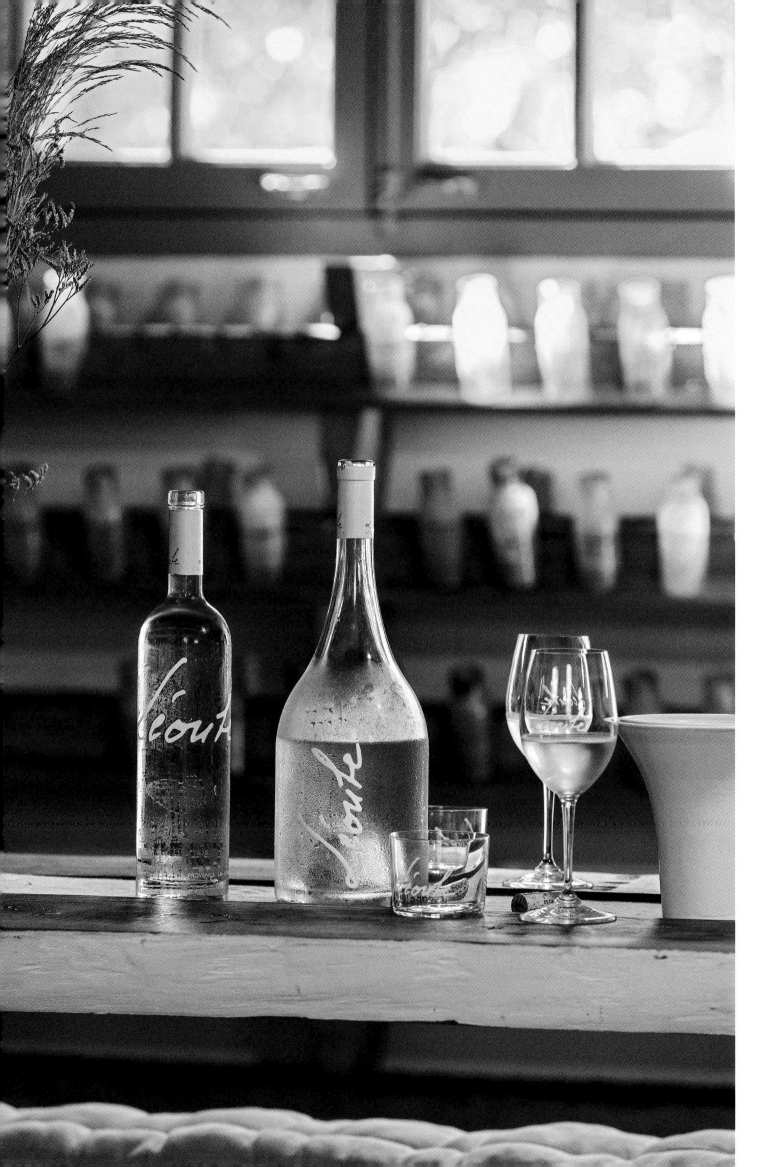

Opposite
Léoube's beautifully
screen-printed bottle,
with the signature
writ large.

LA COMMANDERIE DE PEYRASSOL

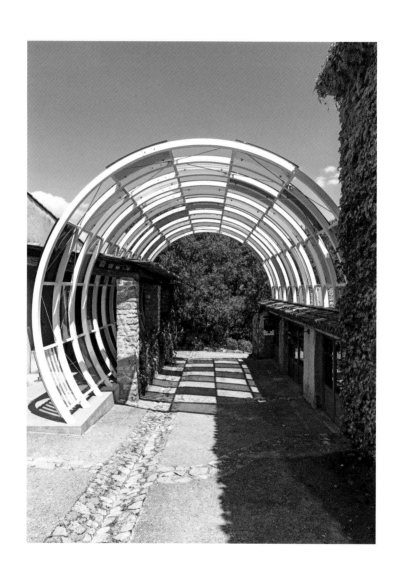

MODERN TIMES

When Philippe Austruy bought the Commanderie de Peyrassol in 2001 he fully understood the magnitude of the task he was taking on. For all its austere charm, this immense property represented a colossal undertaking. It was however exactly the impulse buy that he had been looking for, not in the Bordeaux region as originally planned, but in Provence, where he went looking following a tasting of the region's wines that led him to cast his net wider. One visit was enough. He bought the Commanderie there and then.

It was the oldest of the four properties that he had acquired to-date, but it was now all set to become the flagship of the Austruy wine empire. "Entrepreneur, builder and esthete" is how his nephew Alban Cacaret describes him. The two men have worked together since the very beginning – well almost. At his uncle's request, Alban supervised the start of the works while he was staying at the property to attend a pharmacy course nearby. Site meetings, monitoring vineyard replanting with the vineyard manager – everything about the project fascinated him. Two years later, having completed his pharmacy studies together with an enology course, he took over as manager of the estate.

The grapes grow at an altitude of 200 meters above sea level (658 feet), planted in a multitude of different parcels including some on winding vineyard terraces at an altitude of 350 meters (1148 feet). "There hasn't been a single year without works since the property was first acquired" says Alban. Twenty years later, the cellars have been renovated, the winery buildings revamped, and the vineyard replanted and extended through the purchase of neighboring lands. In short, the property looks nothing like it used to.

Within two years of its acquisition, the Commanderie was ready to start winemaking – rosé winemaking, in its newly equipped, state-of-the-art winery. "With rosé sales about to take off, it didn't take us long to realize that we had to get serious about equipping our winery if we wanted to make the best rosé wines possible." On the vineyard side, new plantings were selected on the basis of soil analysis calculated to match plant, plot and aspect. The boundaries of the property were meanwhile redefined through the acquisition of adjacent woodlands and the neighboring 20-hectare vineyard estate, La Bernarde. Pulling all of this off without ever missing out on an opportunity was a herculean achievement.

The property today extends over 850 hectares, of which 92 hectares of vineyard divided into 65 different parcels. Its 13 kilometers of terraces have been entirely rebuilt and refurbished, "always taking care to safeguard the authenticity of the location and its historical legacy," says Alban. Philippe Austruy is a lover of fine things with a keen eye for detail; but he is neither a marketing man nor a salesman. As he himself likes to put it, "when it comes to winemaking, I just issue directives. In the case of rosé, I wanted a pale-colored, easy-drinking wine – elegant but playful, nothing too showy." And he makes it a point of honor to attend every blending.

* AUSTRUY VINEYARD HOLDINGS

Château Malescasse, a Médoc Cru Bourgeois

Quinta Da Corte, Porto Appellation, Douro Valley, Portugal

Tenuta Casenuove, Chianti, Italy

La Bernarde, Provence, adjoining La Commanderie de Peyrassol

Opposite page
Daniel Buren's *Cylindre ouvert et aux couleurs* (2017), at the entrance to the estate.

BRANDED WINES:
THE GREAT TURNING POINT

As rosé production picked up speed, the range of offerings broadened to include new prestige cuvees. Among them, Le Clos, from a venerable vineyard plot at the entrance to the estate; and 1204, a parcel selection exclusively vinified as rosé. The estate's iconic Château Peyrassol label remained the engine behind it all – La Commanderie's beating heart, available in all three colors – later joined by La Bastide, an exclusively rosé wine produced to celebrate Austruy's 20 years of ownership.

New distribution channels created opportunities to reach new customers: In 2010 Peyrassol was one of the first rosés to gain a foothold on the ski slopes following the signing of an agreement with La Folie Douce restaurant in Val d'Isère. Sales outside France also developed, mainly to European countries but also more recently to the USA where imports of rosé wine have taken off thanks to a new distributor who puts the accent on reputation building. America is now Peyrassol's largest market after France. "On the wine trade side, we only woke up to the fact that we needed to change tack in 2017," admits the owner. But having made that decision, they invested in a new winery with 3000 square meters of floor space (32,000 square feet) and a built-in, ultra-modern tank room. All of their bought-in grapes and juice are exclusively sourced from Côte de Provence vineyards, with rosé wines accounting for the lion's share of wine production across two flagship brands: Lou and Les Commandeurs. "We currently produce twice as much rosé as anything else, so reinforcing rosé performance is pivotal to the development of the business," says Alban Cacaret.

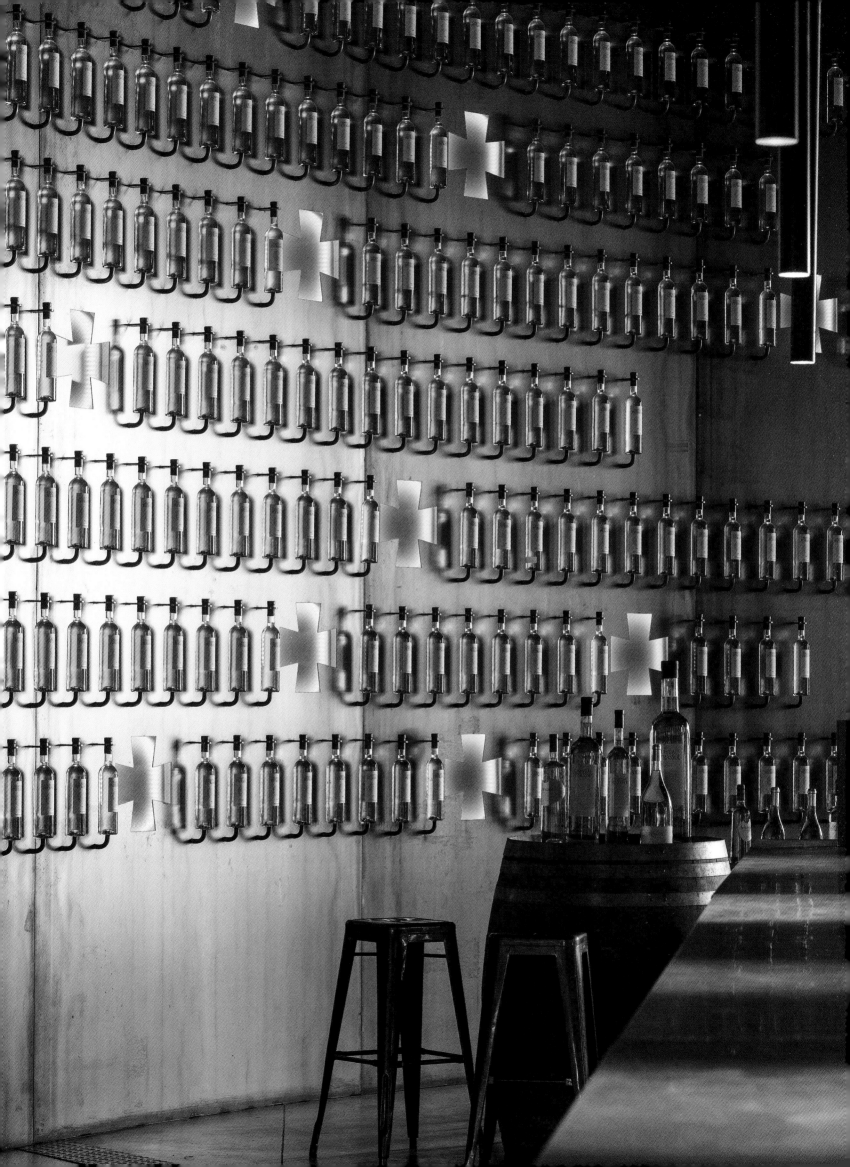

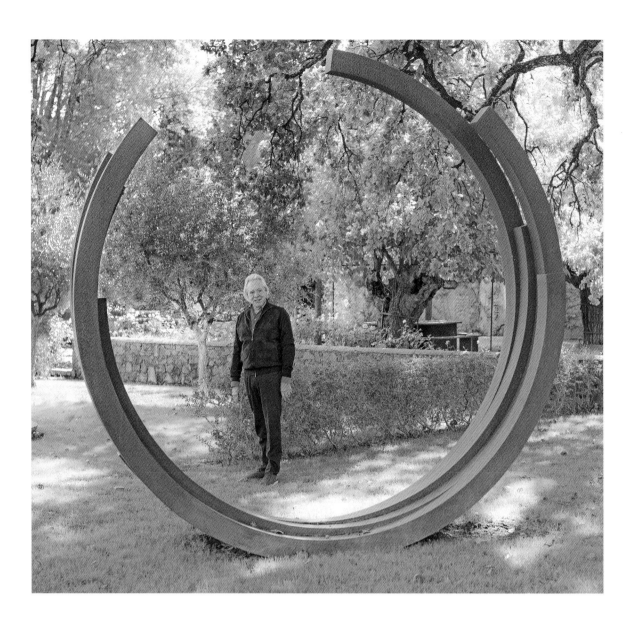

Above
Owner Philippe Austruy,
a lover of fine
wine and fine art.
226,5° ARC x 5 (2002),
Bernar Venet.

Left
Alban Cacaret,
the owner's nephew.

Opposite page
The prestige cuvee
– a tribute to a Templar
vineyard founded in 1204.

THE 2022 VINTAGE, PEYRASSOL WINES AND CERTIFIED ORGANIC BRANDS

The second major turning point was going organic – a more recent development certainly but many years in the making. How could it be otherwise when everything you see around you commands respect for nature and all living things? Truffle oaks, olive trees, herbs and wildflowers, *garrigue*… this is a richly biodiverse ecosystem teeming with wildlife. The Commanderie has long been home to all of the region's protected species: tortoises, bats, various insects, rare butterflies and assorted animals including a few feral pigs. The 2022 vintage marked the completion of the vineyard's conversion to organic certification – a commitment to nature shared by the whole team, says Alban: "We plan to follow up with our own yeasts and essential oils, and build boxwood gardens and nesting boxes for wild birds."

The year 2022 also saw Phillipe Austruy take the bold decision to transition to organic for all of his branded wines, going the extra mile to guarantee ethical sourcing. This makes him an exception among Côtes de Provence and Vins de Provence producers as one of the few local vintners who have taken the organic plunge. But then things have moved on since 2001. Today, spectacularly revived as a powerhouse of rosé wine production but with its soul intact, this former Templar stronghold has resolutely entered modern times.

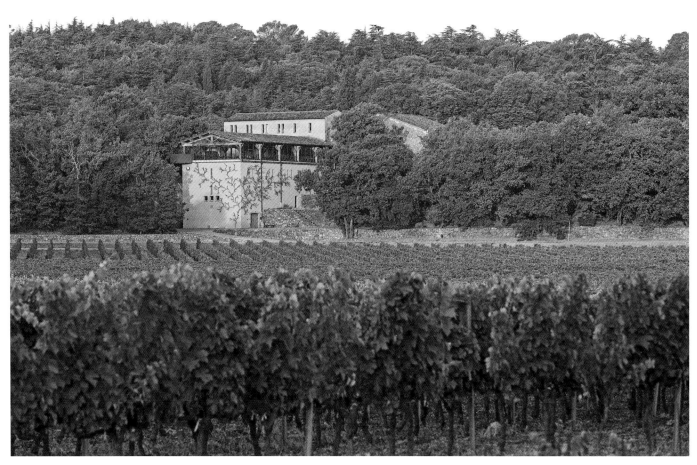

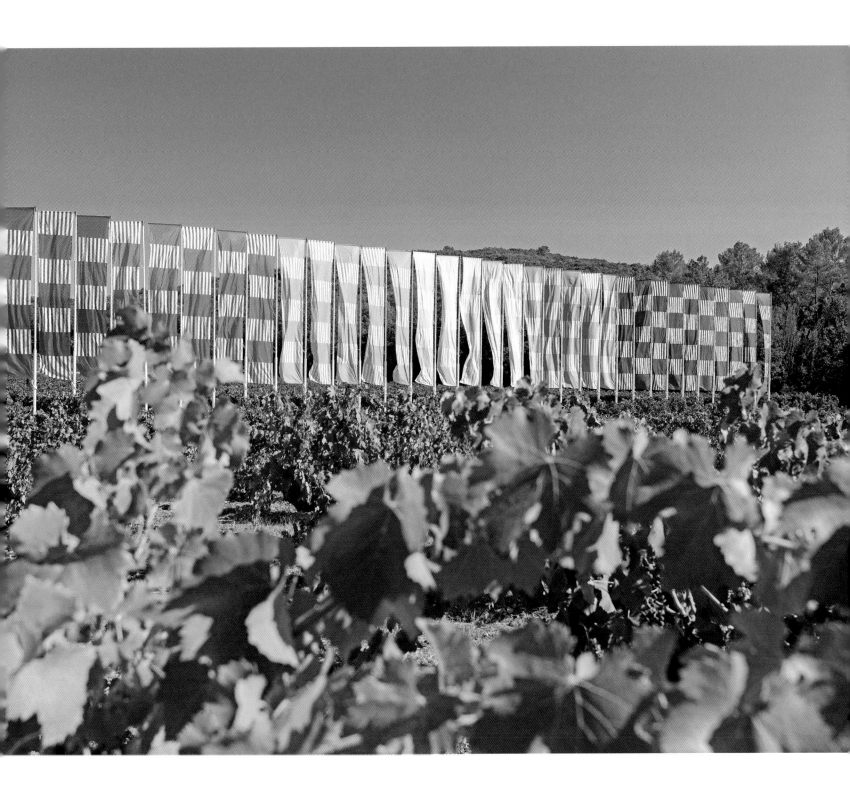

Left
The newly renovated
winery building stands
guard over the vines.

Above
Daniel Buren's *Le Damier
flottant arc-en-ciel*
– centerpiece of one
of the vineyard parcels

EARNING CREDENTIALS

THE 2000S WOULD MARK A BIG STEP FORWARD IN THE QUALITY OF PROVENCE ROSÉ. PROGRESS WAS MADE IN THE VINEYARD THANKS TO THE UNFLAGGING COMMITMENT OF THE INDUSTRY PIONEERS, FOLLOWED BY EARLY-STAGE FUNDING AND ADVANCES IN TECHNOLOGY AND ENOLOGY. AND PROGRESS WAS ALSO MADE AT THE INSTITUTIONAL LEVEL, THANKS TO PROFESSIONAL AUTHORITIES THAT STEERED A COURSE TOWARDS INNOVATION, QUALITY AND FAME, SUCCESSFULLY JUGGLING RESEARCH AND THE BEGINNING OF APPELLATION MARKETING. THE CENTRE DU ROSÉ MEANWHILE CONTINUES TO FULFILL ITS DESTINY AS A GLOBAL CENTER OF EXPERTISE, INSPIRING EXCELLENCE IN THE INDUSTRY AS A WHOLE AND SWELLING THE RANKS OF ROSÉ PRODUCERS. THAT, AND ESTABLISHING THE CREDENTIALS OF PROVENCE ROSÉ.

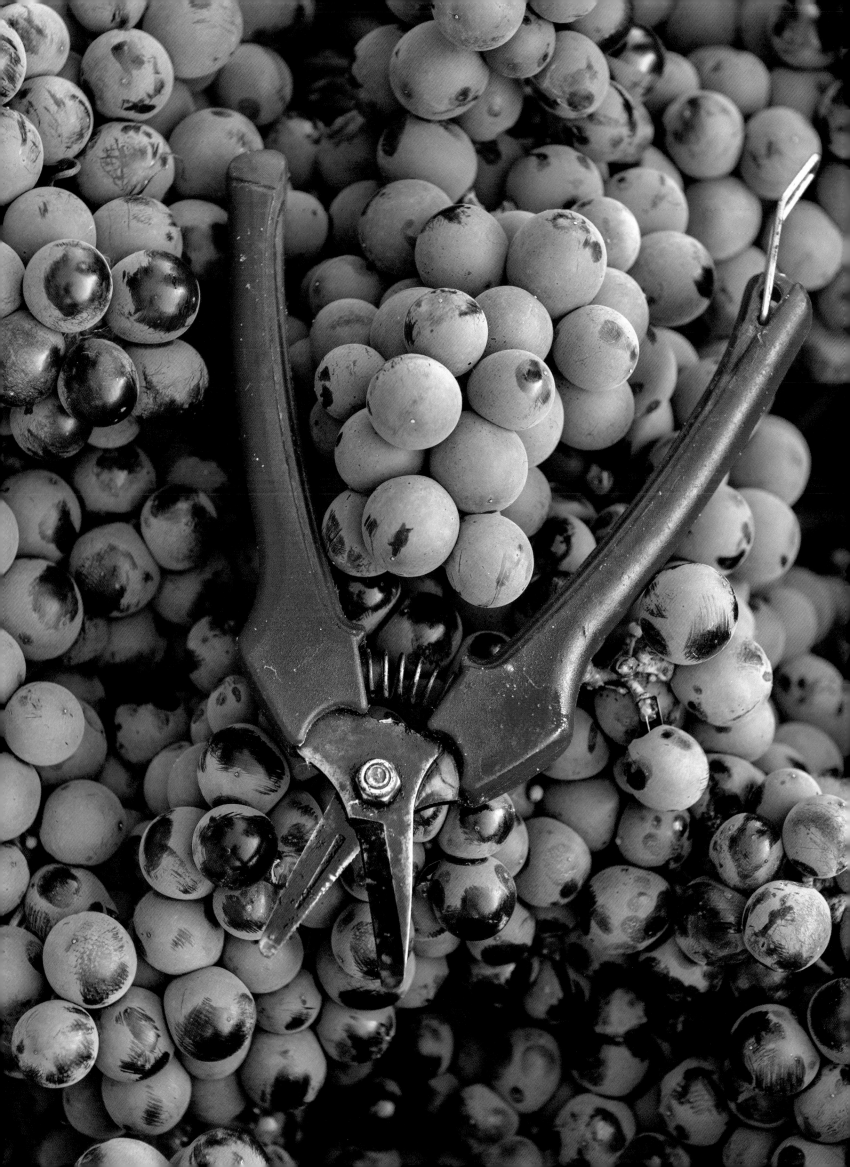

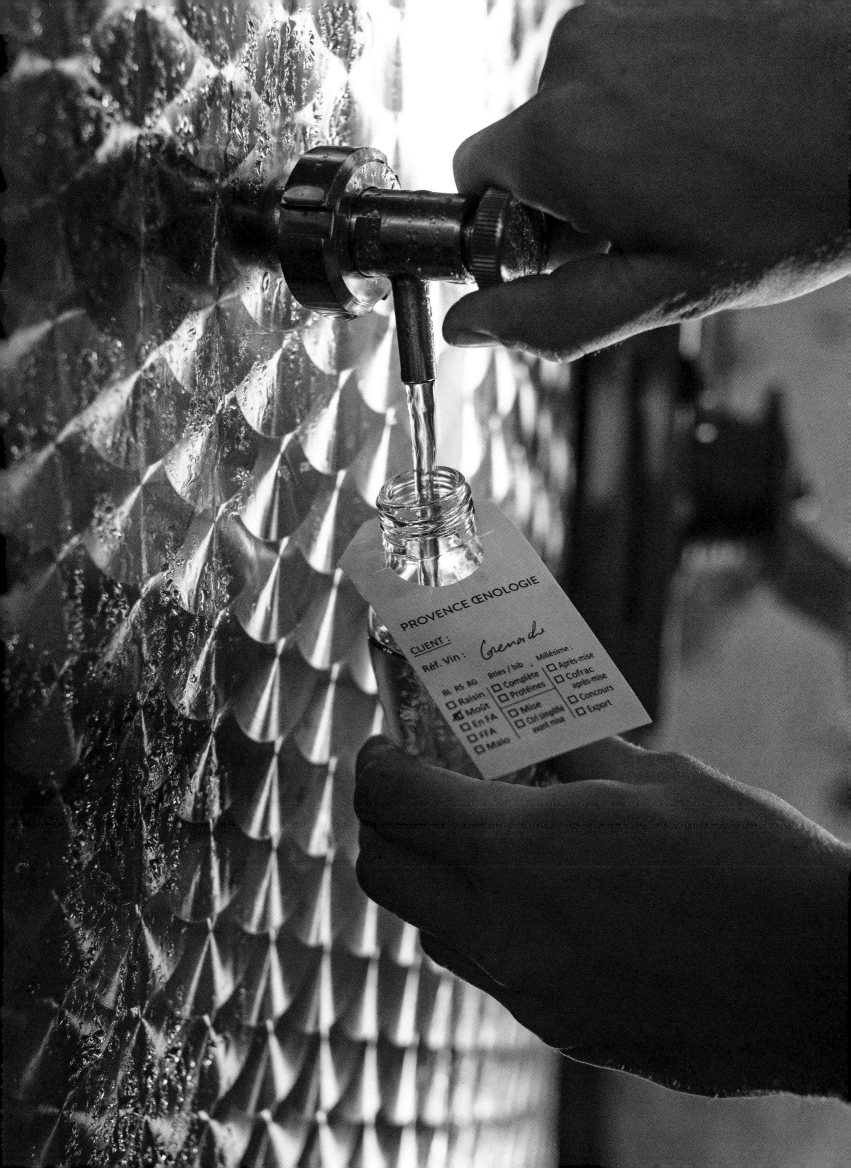

PROVENCE ŒNOLOGIE

CLIENT :

Réf. Vin : Grenache

RL RS RG Btles / bib . Millésime :
☐ Raisin ☐ Complète ☐ Après-mise
☑ Moût ☐ Protéines ☐ Cofrac
☐ En FA ☐ Mise après-mise
☐ FFA ☐ Cpl simplifié ☐ Concours
☐ Malo avant mise ☐ Export

THE DIVERSITY OF THE PROVENÇAL TERROIR

The Provence region covers eight appellations extending from Arles all the way to Nice. Côtes de Provence is the largest and the most famous, producing the bulk of the region's wine from an area covering much of the Var Department and a few areas in the Bouches-du-Rhône Department. Next come the Côteaux Varois and the Coteaux d'Aix-en-Provence, framed by five "small" appellations: Palette, known for its white wines; Bandol renowned for its robust, powerful reds; then Cassis, Bellet and the Baux de Provence.

The diversity of Provençal terroir resides in its soils, geology and vegetation. Limestone Provence, in the west and north supports garrigue vegetation; crystalline Provence in the east and south supports maquis vegetation (both forms of Mediterranean shrubland). A variety of landforms – massifs, plains, valleys and mountain plateaus – meanwhile give rise to as many types of soil whether limestone, argillaceous, schistose or crystalline. The result is a tapestry of terroirs and appellations that give expression to an array of red and white grapes, some of them characteristic of the Provence region. Then of course – the missing piece in this "wine triptych" of ours – there is the climate: hot, dry, sun-drenched (250 days of sunshine per year) and wind-blown. Of all the winds that blow in the Med, the most famous is the Mistral: a cold, dry, north wind that protects the vines from humidity-related disease.

It is these core strengths that make Provence such an ideal candidate for organic farming. Generally speaking, Vins de Provence wines originate in the three major appellations – Côtes de Provence, Coteaux Varois and Coteaux d'Aix-en-Provence – under the banner of the Comité Interprofessionnel de Provence (the cross-trade association responsible for promoting Vins de Provence around the world).

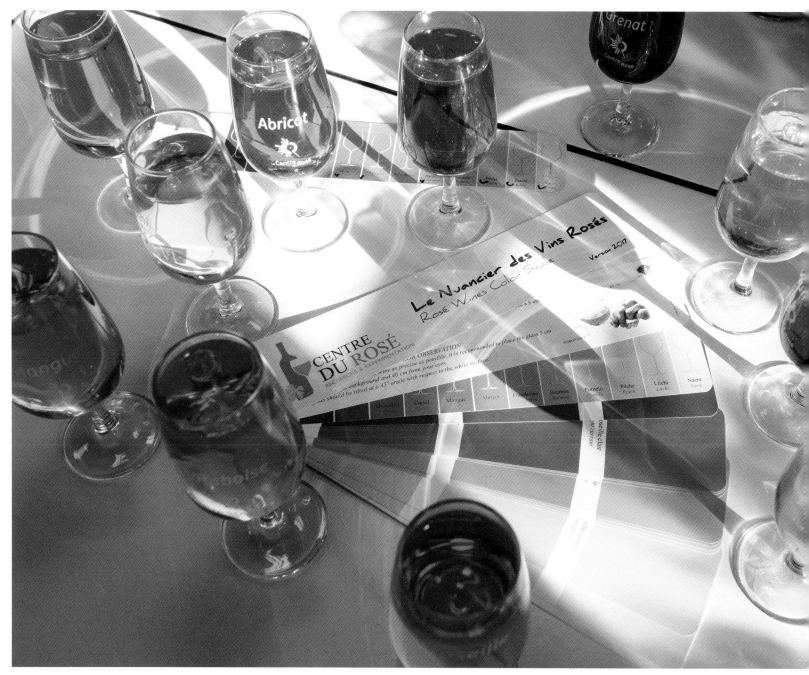

13 SHADES OF PINK

In 1999, with the market now looking increasingly buoyant, the Centre du Rosé came into being: the only research center in the world dedicated to rosé wine. Created entirely from scratch by Var winegrowers, the center is now widely considered an authority in its field and is consulted by local and global players alike.

"Robust scientific method," says Gilles Masson summing up the center's approach in the time since he became director in 1999. "In the beginning, we focused on enology – in-depth research into the special winemaking process required to combine pale color with intensity. The result was a collective effort in response to a very real need on the part of winegrowers." From an enological point of view, rosé metamorphosis depends on three key factors: fermentation at low temperatures, protection against oxidation, and biotechnology, particularly yeast biotechnology. The years that followed would see wineries equipped with all the necessary equipment for state-of-the-art rosé winemaking.

The arrival of pale pink rosé was a turning point says Masson: "Usually, the paler the color, the lighter the wine. Here we were looking for pale color with no loss of structure, finesse or freshness – acidity in other words. Quite a challenge back then." It was this particularity of rosé wine that led the Center to explore color in depth and come up with a visual and semantic reference framework for a broad palette of 13 nuances most typical of rosé wine. It was then the task of the winegrower to extract a color that best conveyed their particular terroir, grape varieties and especially winemaking technique.

These much-needed advances in enology led to a growing awareness of the importance of vineyard management. With the help of research work at the Center, which as Masson points out is still ongoing, "the winning winegrowers were those who made rosé wine for its own sake, with a lot of vineyard work upfront aimed at growing and harvesting impeccable grapes. Top quality fruit is an essential prerequisite for successful winemaking." Choosing the right plots for rosé wine production; matching terroir to grape variety; using specific methods of cultivation – this is exacting work at every level.

Producing a good rosé depends as much on what happens in the vineyard as in the winery. It requires a complex combination of skills that pose special challenges for the winemaker, more so than when making red or white wines, even if it has taken us a long time to understand it and admit it. But that's what it took to make a ravishing 20-year-old Provence rosé that could be rightly proud of its credentials.

Page 98
Wine samples for
color analysis at the
Centre du Rosé.

Opposite page top
The 13 colors most typical
of the world of rosé:
Sand, mother-of-pearl, litchi,
pink grapefruit, raspberry,
peach, salmon, apricot,
mango, coral, redcurrant,
cherry, garnet.

Opposite page bottom
A miniature stainless steel tank
for experimental winemaking
at the Centre du Rosé.

The label approval process varies from country to country as much in terms of product naming as contents. In France, there are three main certifications covering organic agriculture and viticulture, each with its own logo, which features on the label as a seal of approval.

ECO LABELING

HVE: Haute Valeur Environnementale (high environmental value)

HVE certification takes account of biodiversity conservation, plant disease management, fertilizer management and water management. However, unlike organic certification, it does not rule out the use of chemical pesticides and synthetic fertilizers but merely recommends restricting their use. In 2022, ten years after HVE certification was created, the French Ministry of Agriculture tightened the approval criteria to "green up" the label, particularly with respect to the use of chemical treatments.

AB: Agriculture Biologique (organic farming)

Organic farming refers to a method of agricultural production free of synthetic inputs such as pesticides, chemical treatments, artificial fertilizers and GMOs. Organic viticulture likewise puts the environment first, focusing on soil management and the technical aspects of wine grape growing. It takes three years to complete certification, with producers meanwhile being entitled to display the words CAB on their labels (which stands for *conversion en agriculture biologique* or "under conversion to organic farming").

Note that copper is one of the few fungicides that the French government permits in organic farming. It prevents the spread of downy mildew (a common vine disease) and some grapevine trunk diseases (GTDs) and is currently allowed for use up to a limit of 6kg of copper per hectare per year, or 30kg in total spread over five years to allow for more exacting vintages.

Biodynamic viticulture

Biodynamic agriculture takes organic farming one step further, in line with a sustainable, holistic approach based on respect for nature and all life forms. More of a philosophy than a scientific method, biodynamics holds that plant and animal life is intimately bound up with the cosmic forces at work in nature – the light of the sun, the phases of the moon. As you might expect, the requirements for biodynamic certification are more exacting than for organic farming. Crops must be grown in harmony with the lunar calendar, sometimes using horses and mules to work the land instead of tractors. The use of copper is also much more restricted.

There are two main biodynamic labels in the French wine industry: Biodyvins (France) and Demetter (International). First however, producers must meet the requirements of organic farming.

While biodynamic farming is on the rise in France, the difficulties and costs of certification, particularly in terms of vineyard disease management, tend to discourage organic producers from actually getting certified, no matter how great their commitment to biodynamic methods.

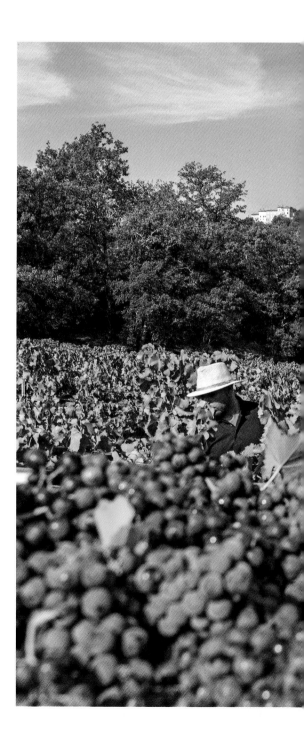

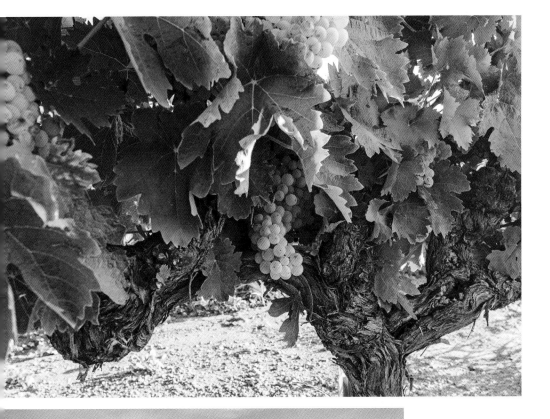

Left
Clusters of rolle: a typically
Mediterranean grape
used by some winegrowers
to add freshness and
fragrance to rosé wine.

Below
The grapes are harvested
at peak ripeness, some
earlier some later
depending on the variety.

More than a dozen grape varieties go
to make Provence wines. Some are the
mainstays of local production; others
are specific to certain appellations being
better adapted to the aspect, altitude
and terroir of the region in question. It
is up to each producer to decide which
grapes to grow and which methods and
planting density should apply.

White grape varieties

Rolle (a close relative of Italian *vermen-
tino*) is a traditional Provence grape vari-
ety sometimes used for rosé production.
Also used but to a much lesser extent are
ugni blanc, clairette, sémillon, grenache
blanc d'Espagne and bourboulenc.

Red (or black) grape varieties
used to make rosé wine

Catalonia grenache and cinsault (native to
Provence) are widely used to make rosé.
Other varieties include syrah, mourvèdre,
tibouren (also native to Provence, found
only in the Var Department), Carignan and
cabernet sauvignon (native to Bordeaux).

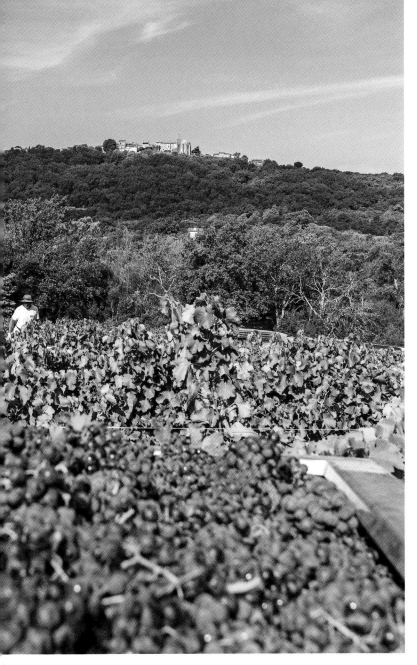

PROVENCE
GRAPE
VARIETIES

CHÂTEAU D'ESCLANS

A PROVENÇAL SUCCESS STORY

When Sacha Lichine became the owner of Château d'Esclans in 2006, he knew exactly what style of rosé he wished to make and where he intended to sell it. And he had the vision and conviction to pull it off. Within 15 years he had turned Whispering Angel into America's best-selling luxury rosé and found a gap in the US market for Provence rosé in general.

Sacha's father was Alexis Lichine: a Russian-born naturalized American nicknamed the "Pope of wine" for having converted the Americans to the cult of Grand Crus Bordeaux and Burgundy in the 1950s. Half a century later his son Sacha likewise became a big name in wine, but under the banner of rosé, and his own rosé in particular – he would be the first to establish Provence rosé as a luxury product. First, however, came a parting of the ways when, in 1999 following his father's death ten years earlier, he sold Château Prieuré-Lichine, the family property in the Margaux appellation, and headed for Provence. "I learned a lot from my father – wine runs in the family – but I couldn't see myself doing what he did."

Sacha Lichine quit university in the US to cut his teeth in sales. He worked as a sommelier in Boston; as a marketing rep for Roederer champagne in the Caribbean; as a winery tour guide; and as a sales representative for America's premier distributor of Californian fine wines. "My father used to say selling was an art. Making good wine is one thing. Selling it is quite another. There aren't many people who can do both."

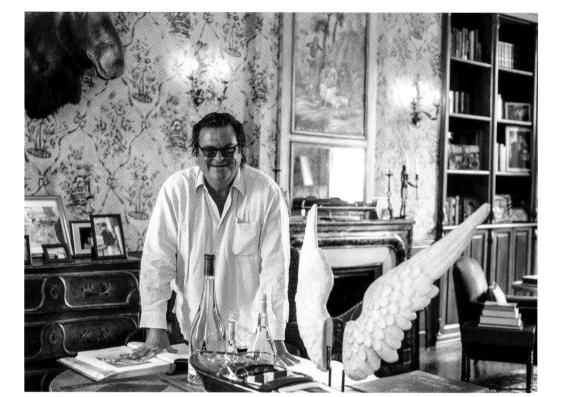

ON THE LOOKOUT FOR TRENDS

On his return to France in 1987, the 27-year-old Sacha took over the running of Château Prieuré-Lichin meanwhile building a side business in new Languedoc and Burgundy wine brands. He also travelled far and wide as befits a tireless go-getter and citizen of the world. He lived in Singapore, London, Paris and a great many big American towns, getting a feel for the market by seeing what was trending. That's what gave him his insight about rosé: "I could see lighter, fruitier wines becoming the thing, sauvignon blanc taking over from chardonnay and pink champagne topping the bill in the luxury category. Particularly with American women – they were huge fans right from the start."

In the mid-1990s he thought of acquiring a property in Provence: "Ten years and 32 property visits later, my eyes fell on Esclans and I took the plunge." The property stands at the entrance to the Gorges de Pennafort, a large, Tuscan-style *bastide* standing in 280 hectares of grounds, with an astonishing variety of soils and aspects, areas of rich, red earth and some old grenache and rolle vines. Over time the vineyard would more than triple in size, expanding from 45 to 140 hectares with the acquisition of the neighboring Grand Esclans holding. For now however, Esclans' new owner concentrated on finding himself a consultant enologist and who better than his father's former associate, Bordeaux native Patrick Léon. Technical director at Mouton Rothschild for 20 years, Patrick Léon was, to quote Sacha, "a gifted wine technician and a man of uncommon kindness." Today his son Bertrand Léon follows in his father's footsteps.

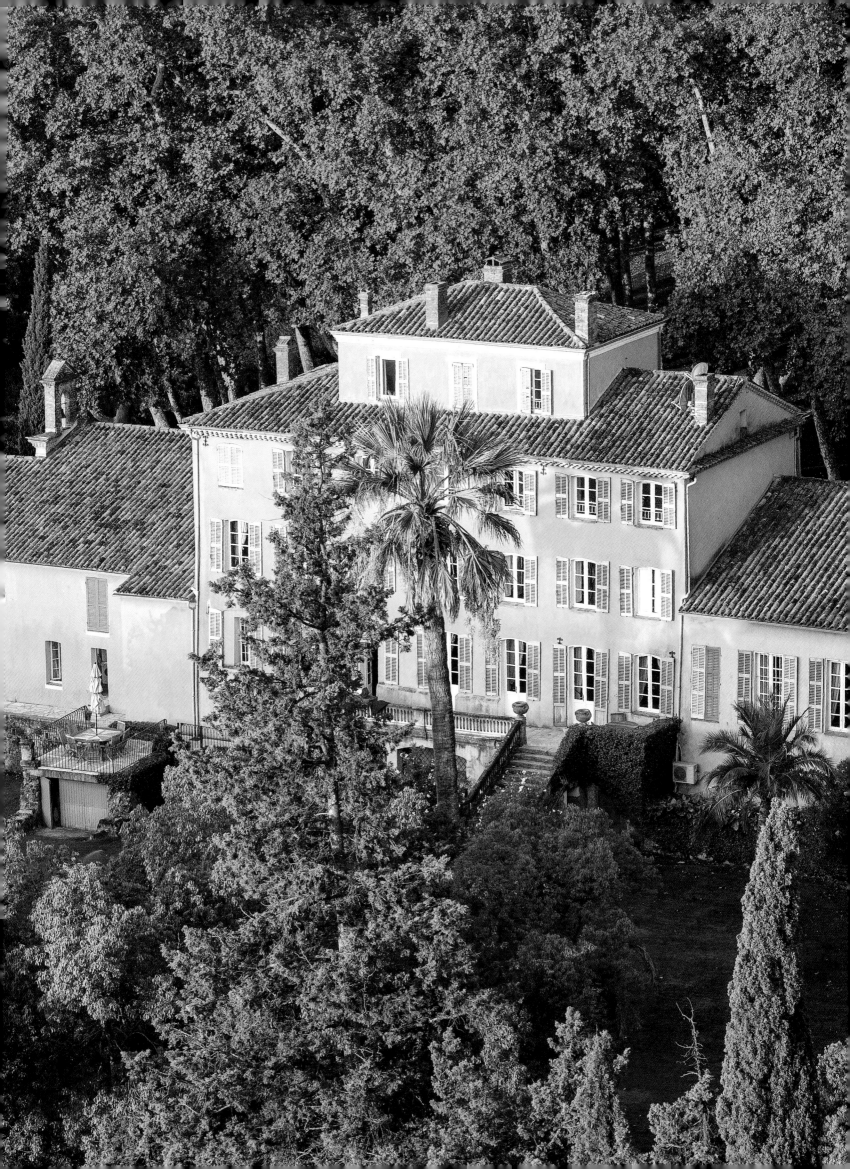

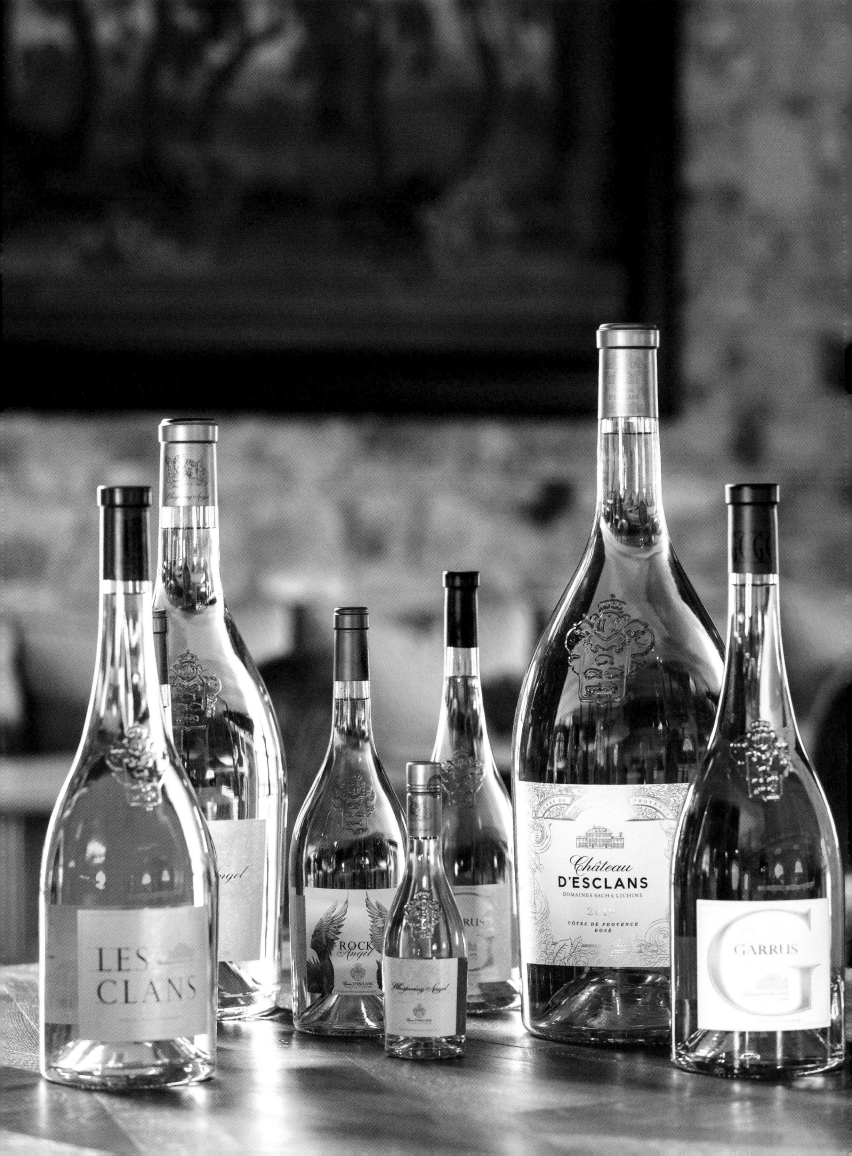

THE WORLD'S
MOST EXPENSIVE ROSÉ

Make rosé for its own sake and focus on quality – every vintage since the very beginning has followed this simple credo. Keep on improving the recipe no matter how much it costs, whether in research, testing or state-of-the-art equipment to control temperature and prevent must oxidation. "I wanted a taut, complex, precision wine, pale-colored needless to say," says Sacha, remembering the advice he once received from a sommelier friend of his – that a rosé when tasted with your eyes closed should resemble a great white wine. Four cuvees were launched with the inaugural 2006 vintage, Whispering Angel, Château d'Esclans, Les Clans and Garrus, all of them equally captivating and consistent in style.

Calling one of the cuvees "Whispering Angel" was Sacha's idea, partly as a tribute to the two cherubs adorning his private chapel and partly for the sake of product storytelling. In the event, the name nailed the US product launch in 2007, as did touting Garrus as the most expensive rosé in the world. Sold at the then unheard-of price of $80 a bottle, Esclans' eye-wateringly expensive rosé certainly caused a stir. Its sister cuvees were equally luxurious, with Whispering Angel retailing at $19.99 – which is pretty daring for a rosé.

The boss of nationwide distributor Southern Wines & Spirits was easily persuaded to carry Sacha's wines, on condition that Sacha himself join the sales team – get an import license and do a two-year stint as a traveling salesman.

Opposite page
The range of Château d'Esclans rosé wines, from the smallest (37.5cl bottles) to the largest (jeroboams).

Above
Garrus, Château d'Esclans' first wine, comes from very old grenache and rolle vines and represents the essence of Sacha Lichine's vision for his estate.

Opposite page
Rock, more complex and structured than Whispering Angel – or as Sacha Lichine put it, "After Whispering Angel, let's Rock."

ROSÉ ALL DAY

He and his family settled in Chicago – not the ideal place to launch rosé wine but he told himself that if he could succeed there, he could succeed anywhere. "After Chicago, I went door to door in every major US city, lugging my bag of bottles around with me." It was what he called his Estée Lauder method: getting into the market by knocking on doors and offering a people a glass of rosé. "I visited every hot spot in town, sometimes coming back through the window after being kicked out through the door, as we say in French!"

He has dined out on the story ever since, enjoying write-ups in the press for his beguiling personality and unconventional sales tactics that worked everywhere from Chicago to New York (Esclans' premier market until 2021) to Miami (now Esclans' top market, with twice the market share of New York). And it didn't stop there. In the years that followed he would launch the same sales offensive in all the playgrounds of the rich and famous: Mustique and St Barts in the Caribbean; Megève and other ski resorts in Switzerland and Italy; Saint-Tropez and the French Riviera; the Greek islands and Ibiza; and London (home of the coolest pubs in the world), Hong Kong and Singapore. Having identified his target markets, he would follow up with a campaign centered on large-format wine bottles and themes such as "all pink" and "rosé all day". Cue a whole string of mind-blowing events, from "Pinknics" in Manhattan, to boat parties on the Hudson River and rosé festivals on South Beach, Miami. Not forgetting event sponsorship and charity dinners galore. With a US-based marketing team harnessing the power of influencers for brand visibility, Esclans saw its reputation rocket.

ROCK
Angel

Château D'ESCLANS
DOMAINES SACHA LICHINE
CÔTES DE PROVENCE ROSÉ 2022

A PYRAMID OF WINES

Whispering Angel continues to enjoy strong growth, with a market presence in around one hundred countries and sales of several million bottles per year. The use of bought-in grapes has increased accordingly, "Everything we make is vinified on the premises, estate-grown and bought-in grapes alike. Our teams are in the vineyards several times a year to monitor quality." The estate now has the facilities to handle the equivalent of a yield from 1,000 hectares of vines at each harvest.

The family of wines has likewise grown, now including Rock Angel and two branded wines released with the 2022 vintage: The Beach by Whispering Angel, and The Pale by Sacha Lichine. Two quaffable rosés to suit the tastes of the English-speaking market, crafted by a visionary winemaker with a talent for spotting business opportunities.

A man of vision certainly, but also a formidable brand builder who took his inspiration from the world of champagne. "I designed the Esclans range as a product pyramid, with an entry level wine at the bottom and at the top a prestige cuvee produced in small quantities and sold at a high price. Marketing really counts with rosé." It's certainly true that the image of champagne, with its glitzy packaging and gala evenings, fits rosé like a glove. Or as Sacha puts it, "Provence is to rosé what Champagne is to bubbles." So says the intuitive entrepreneur who has since ceded 55% of his company to LVMH. There can be no better testimony to Provence's greatest success story.

Opposite page
The Pale, a nod to the custom
in British pubs of asking
for "a glass of pale, please."

Left
Whispering Angel flanked
by giant angel wings.

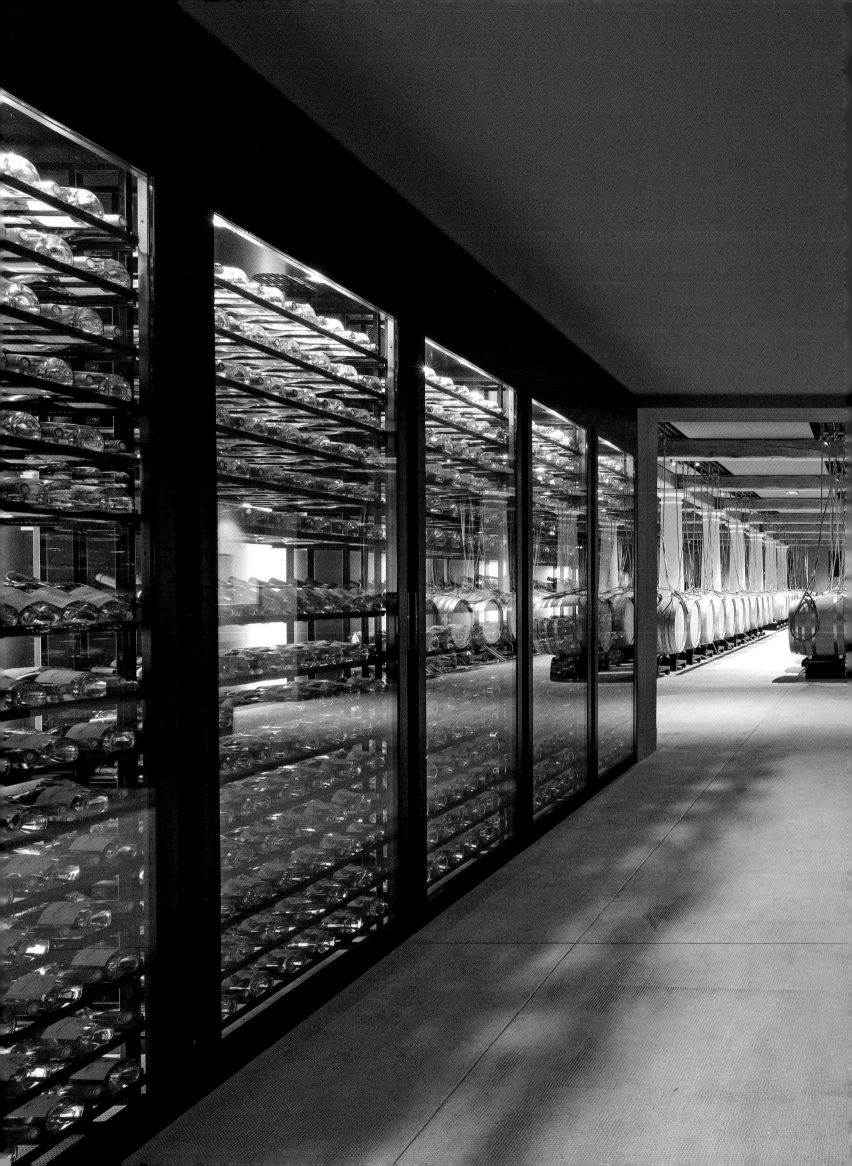

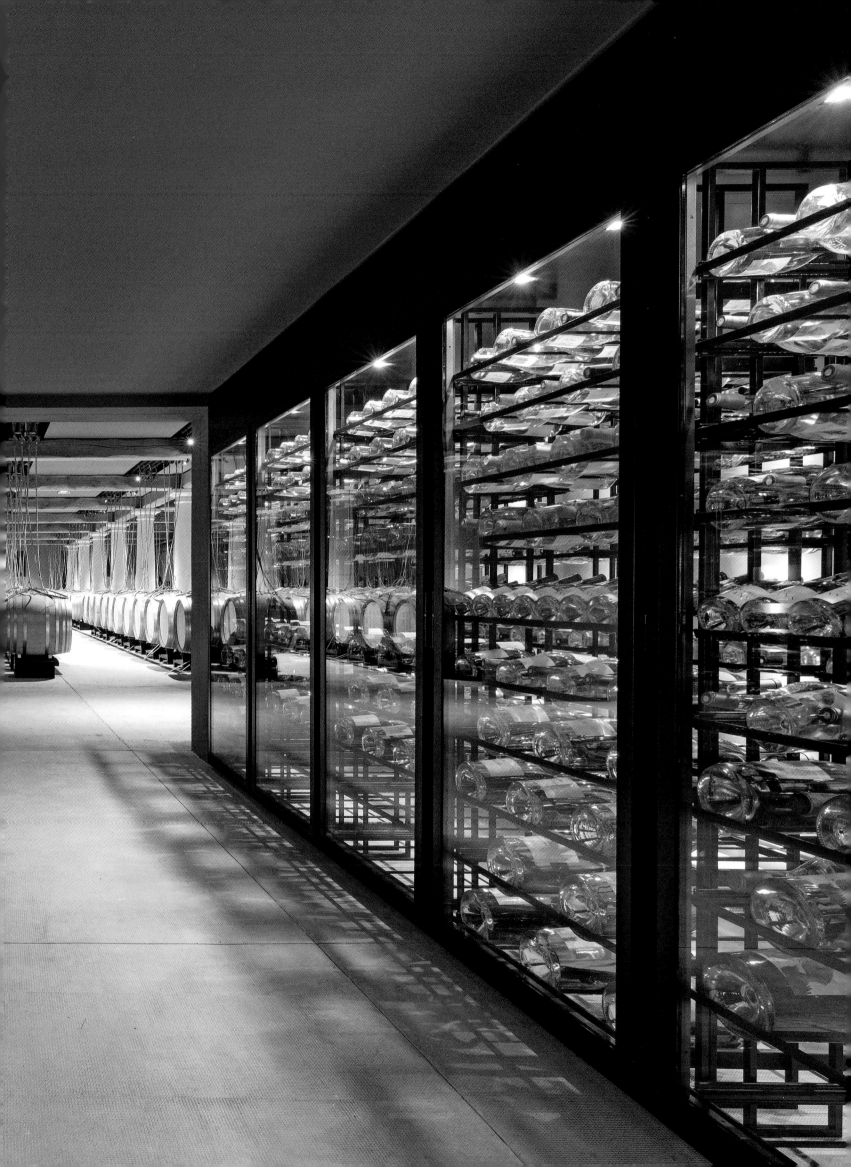

A WINEMAKING TECHNIQUE LIKE NO OTHER

At château d'Esclans, precision wine-making begins with lovingly tended vines seven days a week, 365 days per year, with four of those weeks reserved for painstaking hand-harvesting, usually on the late side and always in early morning.

The crates containing the newly picked grapes are put into cold storage prior to destemming and optical sorting, followed by gentle pressing under nitrogen without maceration to avoid coloring the wine. Fermentation is conducted in *demi muids* (600-liter barrels), some new some old depending on the cuvee and time spent in the barrel, with regular *bâtonnage* (stirring) to amplify contact between the wine and the yeasty lees. A system of cooling coils keeps each individual barrel at the required temperature – usually 11-13° Celsius. The two main cuvees, Garrus and Les Clans, follow this technique to the letter before undergoing 11 months' aging in new oak. Château d'Esclans and Rock Angel are partially barrel fermented and aged for a shorter period of time – a cutting-edge technique that isn't cheap but producing dependably good wines combining structure, elegance and body. D'Esclans' star, Whispering Angel, is fermented in 100% stainless steel tanks.

Left
Grapes on the sorting table prior to scanning by an optical sorter.

Right
Water coils connected to each barrel provide temperature control.

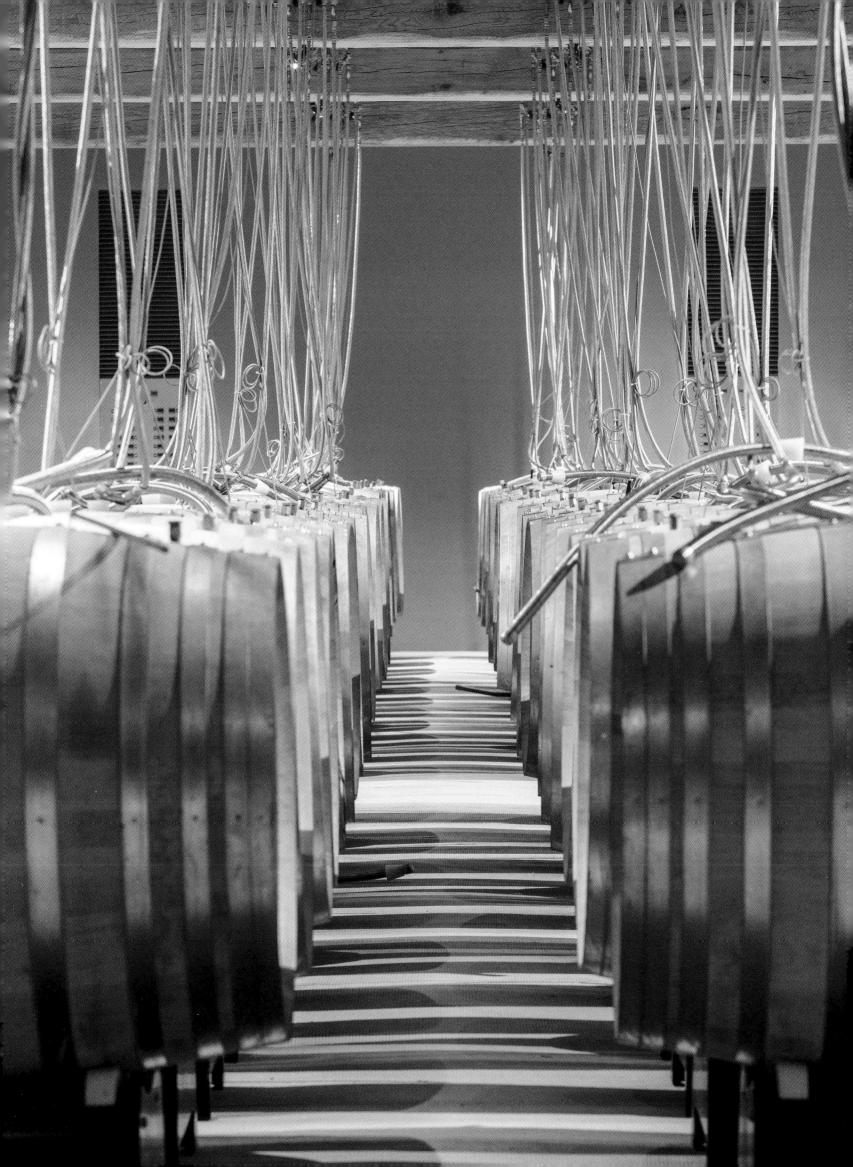

ONCE UPON A TIME...

IN CHÂTEAU MIRAVAL

Quentin Tarantino didn't make this movie and the action isn't set in Hollywood. The setting is Correns, a little village tucked away in the Haut-Var, and in particular a blissful 800-hectare estate flanked by undulating vineyards, trees and regimented rows of lavender. The associate producers are American actor, Brad Pitt and the Perrin family, with Miraval rosé in the leading role. Premiered in 2013 to global acclaim, Miraval has spawned sequels every year since then, with guest appearances by Muse, Studio by Miraval and Fleur de Miraval Pink Champagne.

The stars were aligned when the Perrin family and Brad Pitt met in 2012 through a mutual friend. Pitt, as the new owner of Château Miraval following a three-year tenancy, wanted to increase his wine production but with the focus on quality. The Perrins for their part, who came from five generations of Rhône wine producers famous for their sublime Chateauneuf-du-Pape wine Château de Beaucastel, were now looking to acquire an estate in Provence. "We were struck by the huge potential in Château Miraval," remembers Marc Perrin– so impressed indeed that they quickly reached a deal giving them a 50% stake in the Miraval Provence company, with responsibility for growing the grapes, making the wine and marketing Miraval.

This immense estate (600 hectares at the outset) encompasses a valley extending for four kilometers from east to west, situated at an altitude of 350 meters above sea level (1,150 feet). Perched at this height, the grapes are blessed with warm days and cool nights, basking in the delights of a natural paradise that borders on the Via Aurélia, the Roman road constructed in 241 BC with remnants still visible in places. From the entrance to the estate a narrow track runs along the vineyards then through the woods (about one mile) eventually leading to a pond, buildings, a tower, a chateau and a private chapel. Before you stands a hamlet surrounded by terraced olive groves, trios of Cypress trees, vineyards and lavender fields as far as the eye can see. Idyllic.

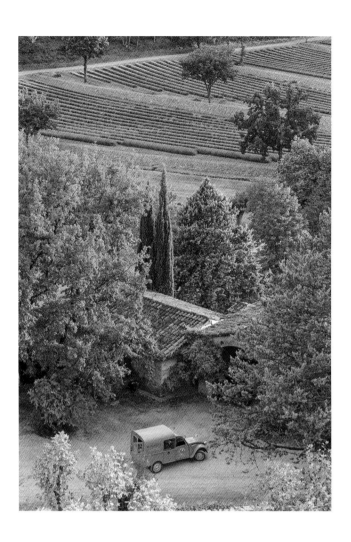

A MOSAIC OF TERROIRS

The first thing the Perrins did on arrival was test the soil to see what kind of terroir they had taken on. The results, says Marc Perrin, revealed important distinctions: "Around a dozen parcels stood out for different soil characteristics that opened up new possibilities for vine training and replanting." He describes Château Miraval as a rich patchwork of terroirs, "some of them very like Burgundy Côte de Nuits" – quite an accolade for wines that are labelled, marketed and sold under the appellations Côtes-de-Provence (the bulk of production) and Côteaux Varois.

Next came a major overhaul powered by ambition and ready money: new plantings and the building of new dry-stone walls to retain warmth on terraced plots and encourage ripening, particularly of syrah grapes. Some years later, the Perrins created a new vineyard out of a four-hectare parcel of stony land in Peyrefuguede, the valley holding they acquired to the north of the estate at a height of 500 meters (1,500 feet). Clearing the land required the use of a mechanical digger, but once completed the Perrins had the makings of what would one day become a *clos* famous for its red wine. Plantings of syrah, mourvèdre and pinot noir moved in alongside the rolle, the mainstay of Miraval's rosé and white wines, a grape that thrives at this altitude.

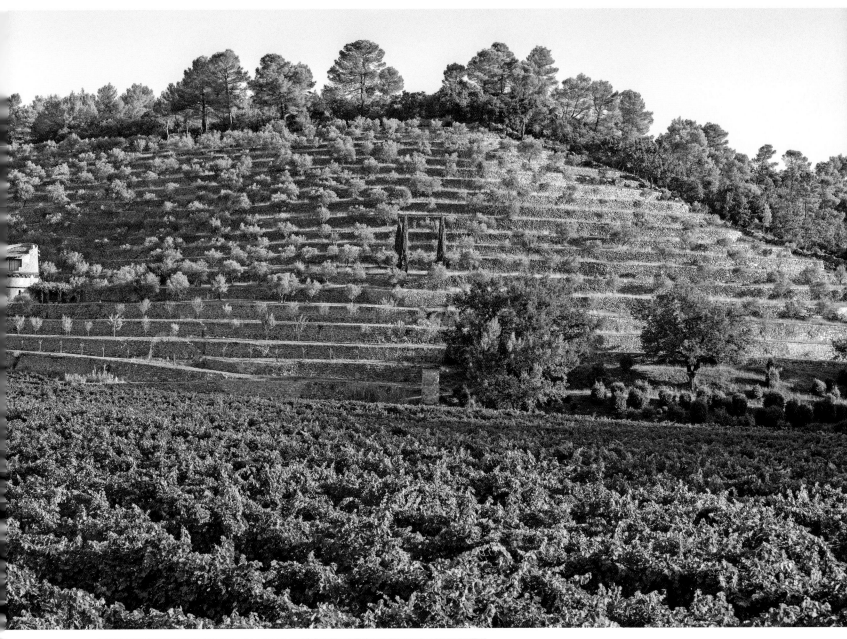

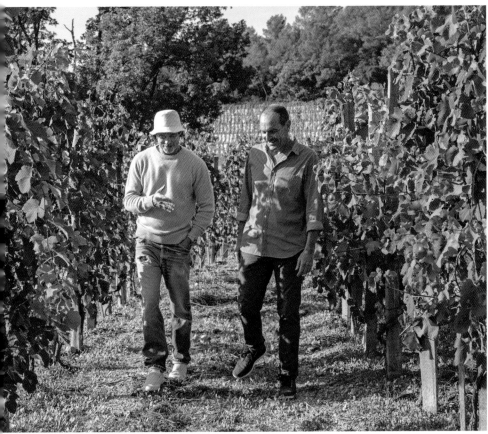

Above
The terraced hillside covered with olive trees and the little tower that appears to stand guard over the entrance to the property.

Left
Brad Pitt and Marc Perrin in the vines.

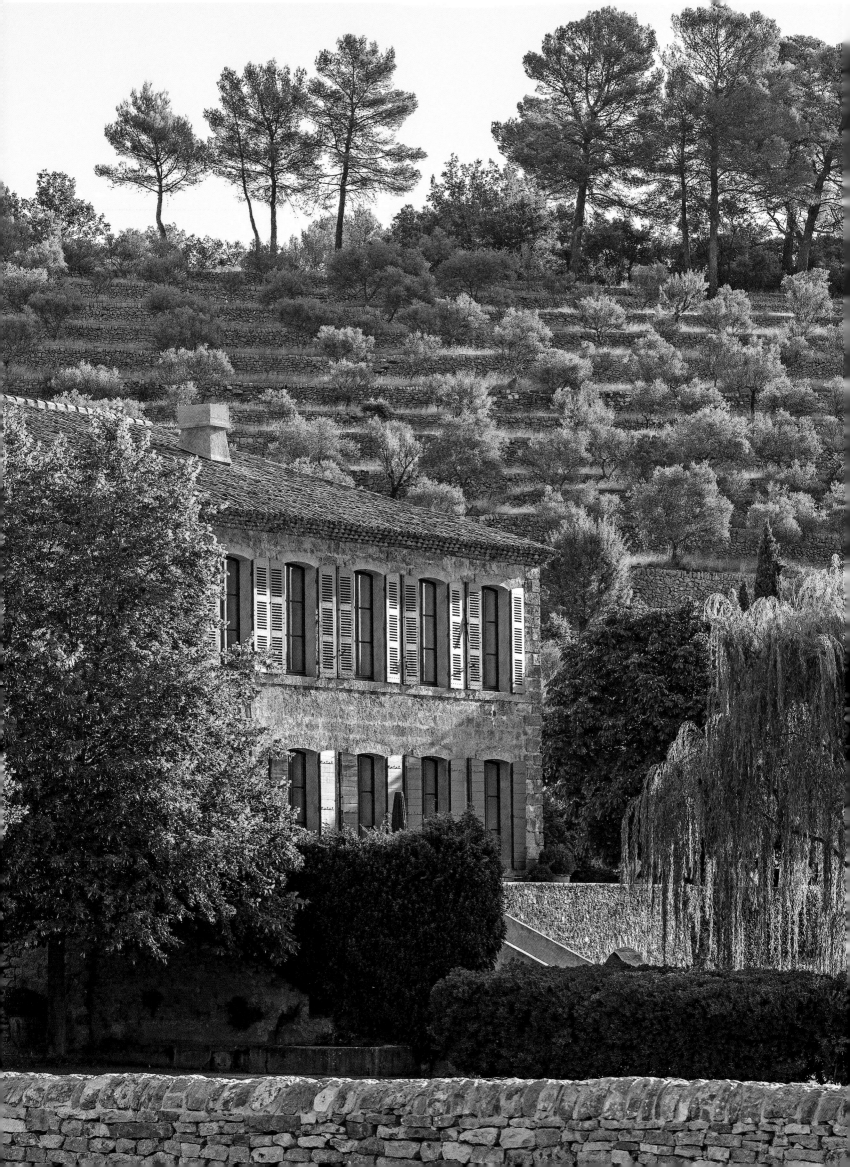

THE FIRST ROSÉ TO RANK AMONG THE TOP 100 WINES IN THE WORLD

For Château Miraval, like so many of its Provençal counterparts, rosé production marked a dramatic shift away from the white wines that then and now underpin its reputation.

Miraval rosé comes in a new, unusually shaped bottle – sober and elegant to match the clean-cut crispness of the Perrins' maiden vintage. For America's wine bible, *Wine Spectator*, this was a wine so memorable that it deserved to rank on the year's list of the world's Top 100 wines. It was the making of a reputation that had salespeople and distributors lining up to represent Miraval's new offering. "Extraordinary really," says Marc, "when you think this was the first-ever rosé to make it onto the list. The 6,000 bottles available on our website sold in half a day." The following year *"Pitt and Perrin, Superstars in Provence"* featured on the *Wine Spectator* cover – a proof of their wine's standing in the eyes of the profession that propelled it to fame on the US market, where to this day it remains the most popular brand. Part of that success, setting aside the winning Pitt-Perrin combination, was due to new food trends championed by the younger generation. Suddenly everyone was cooking with pink.

The passing of the years has seen the estate partner up with other wine growers to ensure a supply of grapes consistent with ever-increasing global demand while maintaining the focus on quality. There is a mounting call for magnums and jeroboams, some of them customized for private beaches and winter sports events held on ski resort terraces. None of them displays the name Brad Pitt to keep Miraval from being seen as a celebrity wine; but that said, his movies increasingly show glimpses of Miraval bottles, as do some Netflix series. Then there are those magnums of Miraval bearing the tagline *Once Upon a Time in Hollywood*, as featured at the 2019 Cannes Film Festival.

Opposite page
The owner's private residence surrounded by nature.

Above
From the opening vintage, Miraval was the first rosé to rank among *Wine Spectator's* Top 100 wines.

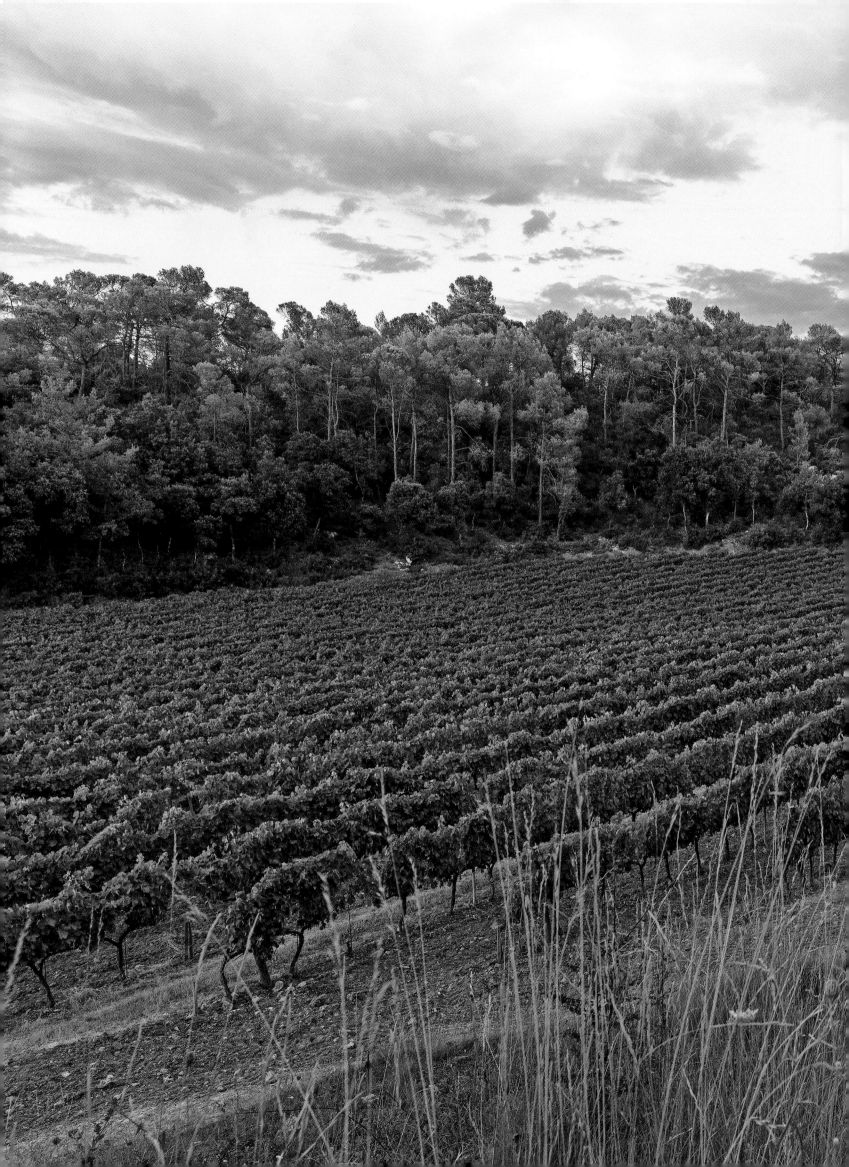

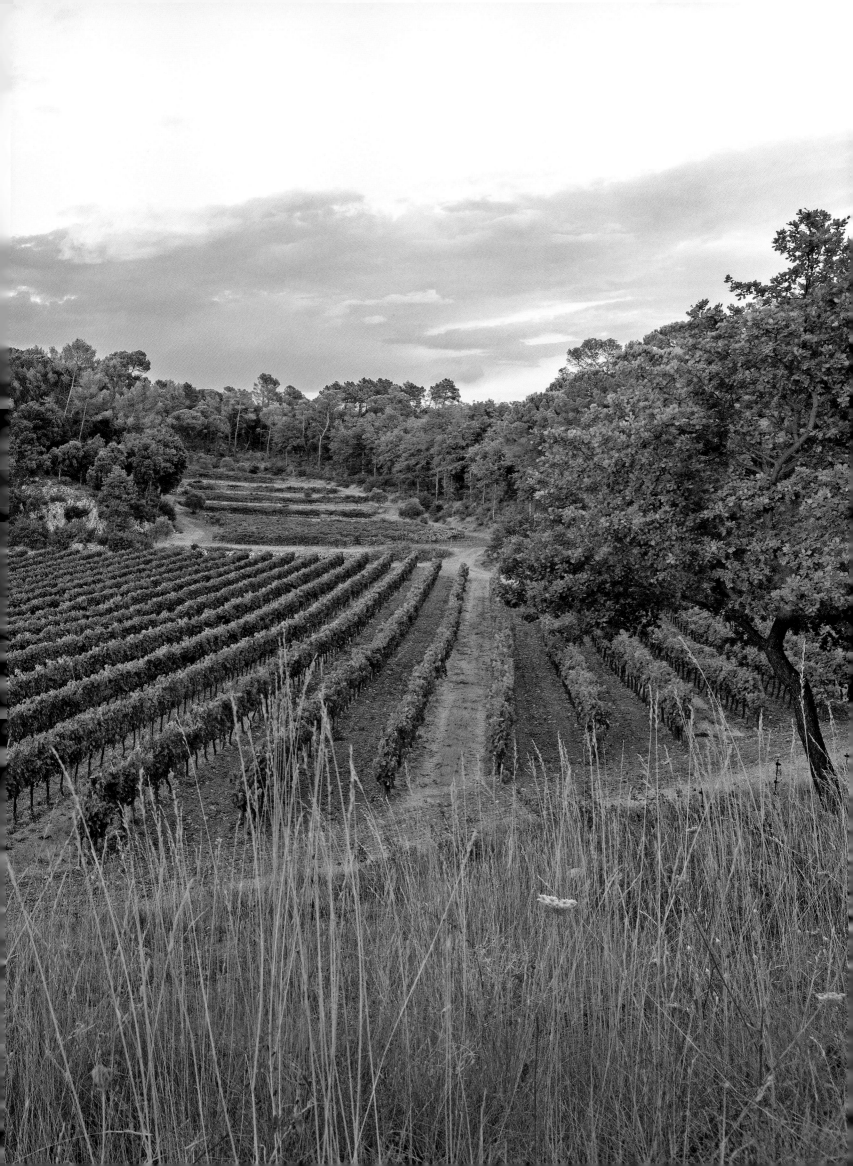

MUSE DE MIRAVAL

Vineyard rebuilding went hand in hand with the refitting of the estate's long, stone-vaulted winery. Egg-shaped concrete tanks moved in among the stone arches, designed to improve the quality of Miraval whites and a new, high-end rosé that debuted with the 2018 vintage: the charmingly complex Muse, produced from two of the estate's finest parcels of grenache and rolle. Maturation in *demi-muids* (600L-capacity oak barrels) does the rest. In the words of its maker, Muse is "an age-worthy rosé that expresses the full potential of Miraval." It is exclusively bottled in magnums and only available as part of a limited edition wine collection, with every magnum from the 2021 vintage onward decorated by an artist commissioned by Brad Pitt, starting with Greek-born Elias Kafouros.

After more than five years of major works, the vineyard is transformed and the estate's wines are now on sale in more than 100 countries. Our winegrowing actor and film producer meanwhile has another project up his sleeve: "I'm passionate about art, painting, sculpture and music and I have a lot of artist friends. I wanted Château Miraval to become a center for creativity offering residencies to international artists – a place where they could draw inspiration from Mother Nature all around them."

Step one was to revive Miraval Studios, the iconic recording studio created in 1977 by Miraval's then owner, pianist-composer Jacques Loussier. Back in the seventies, the studio's divine setting and state-of-the-art equipment attracted all the big rock bands of the time: Téléphone, AC/DC, The Cure, Sting, Indochine, not to mention Pink Floyd who recorded *The Wall* at Miraval. But after standing empty for nearly two decades the whole place needed a rethink, reinterpreting the vernacular to bring the beauty standards of the past into dialogue with present technologies. Today old stones coexist harmoniously with cutting-edge equipment under the baton of French musical prodigy and rising star of the recording industry, Damien Quintard. From this revival came a new cuvee: Studio by Miraval, a quaffable rosé worthy of its proud lineage. Step two was to transform the now redundant former tank room into an immense atelier for artists-in-residence – painters and sculptors who leave a legacy of work behind them.

Château Miraval, styled after the Villa Medici in Rome, came into being. A place where great wines and great works of art are born, created in tribute to the history of a great estate and Provence in all its glory. So says Brad Pitt, the man who fashioned Miraval, his muse.

Above and opposite page
Muse, the Grande Cuvée by Miraval 2021, decorated by Greek artist Elias Kafouros: first of the artists commissioned every year by Brad Pitt to transform Muse into a collectable bottle.

Following pages
The ancient barrel hall, now fully renovated, where the wines are vinified and aged.

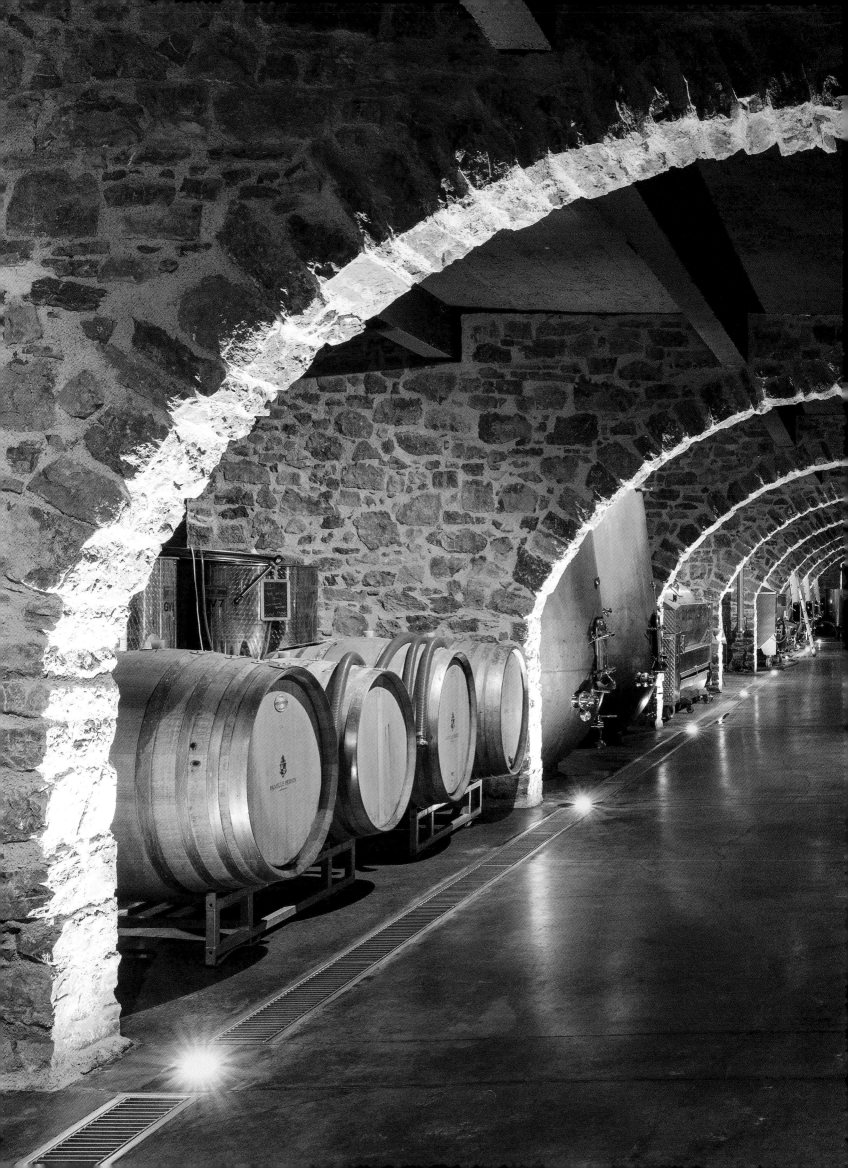

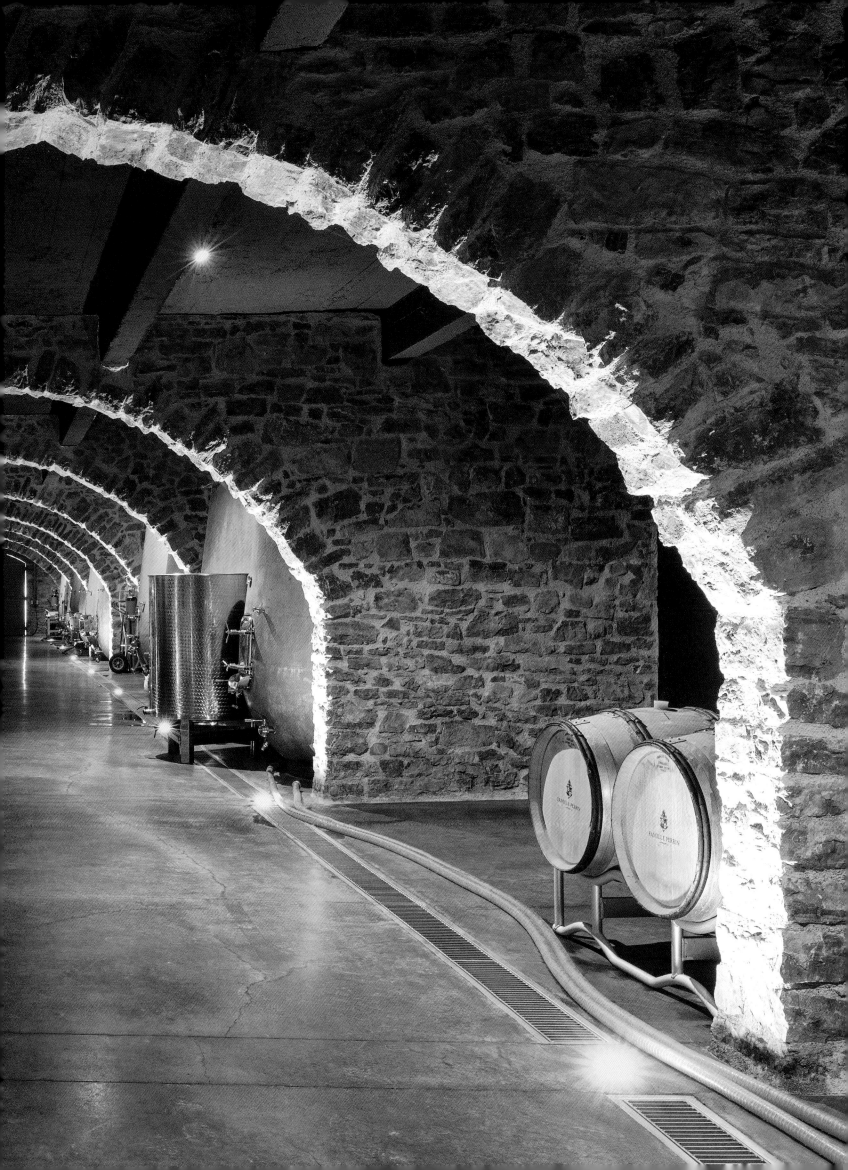

DESPERATELY SEEKING VINE YARDS

THE FIRST DECADE OF THE 2000S MARKED THE ARRIVAL OF A SECOND WAVE OF INVESTORS, TOGETHER WITH KEY COMPANIES IN THE FRENCH WINE MARKET. FIRST ON THE SCENE WAS CHAMPAGNE ROEDERER, WHICH SNAPPED UP DOMAINES OTT*, FOLLOWED BY THE WORLD LEADER IN LUXURY, LVMH. IN 2019 LVMH ACQUIRED CHÂTEAU GALOUPET TOGETHER WITH A MAJORITY SHARE IN CHÂTEAU D'ESCLANS AND ITS FLAGSHIP BRAND WHISPERING ANGEL. FOUR YEARS LATER LVMH'S WINE AND SPIRITS ARM MOËT-HENNESSY TOOK A MAJORITY STAKE IN CHÂTEAU MINUTY, MAKING LVMH A MAJOR PLAYER IN THE INDUSTRY WITH AN ANNUAL OUTPUT OF 25 MILLION BOTTLES. CHANEL OWNERS ALAIN AND GÉRARD WERTHEIMER MEANWHILE CUT THEMSELVES A SLICE OF DOMAINE DE L'ILE ON PORQUEROLLES ISLAND, AND FRENCH GROUP PERNOD RICARD GRABBED CHÂTEAU SAINTE-MARGUERITE. THE 2020S THEN SAW A PLETHORA OF MARKETING CAMPAIGNS AROUND ICONIC CUVEES, REINFORCING A GROUNDBREAKING BRAND STRATEGY THAT TOOK ITS CUE FROM THE CHAMPAGNE INDUSTRY – THE KING OF MARKETING.

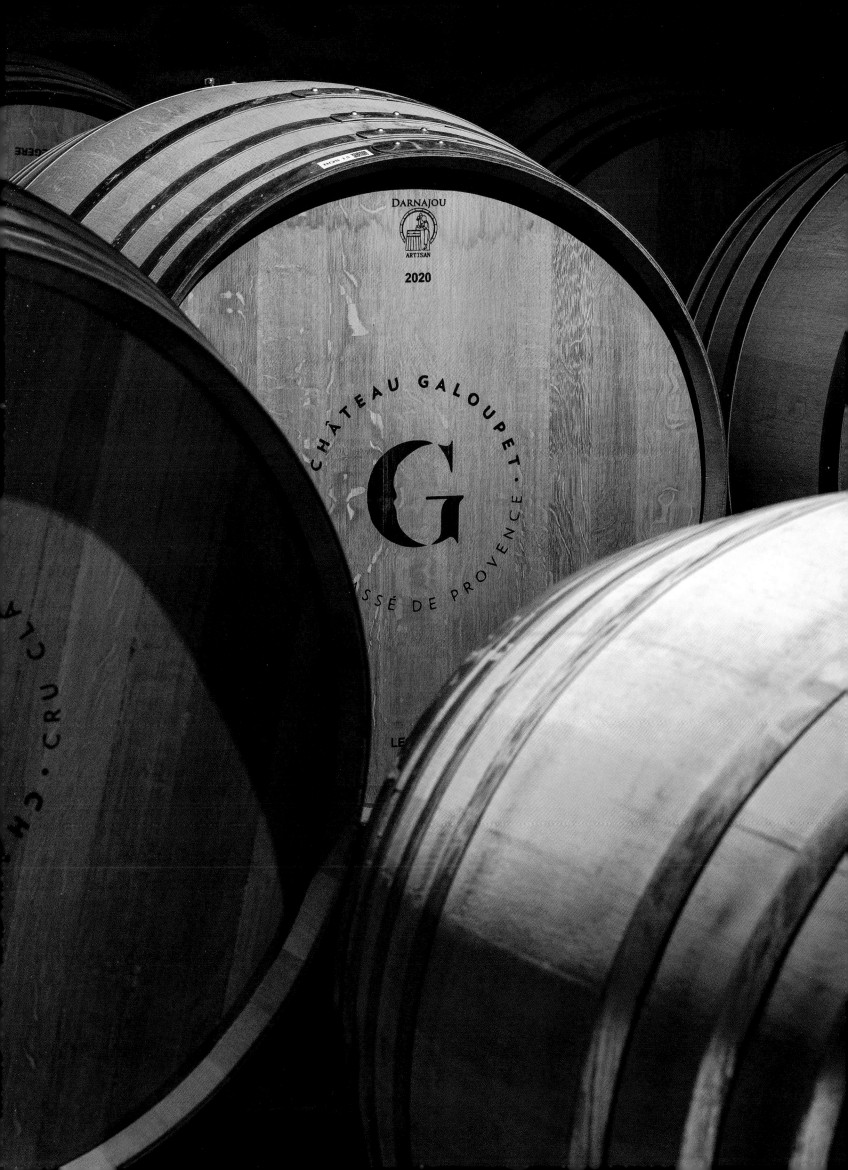

DOMAINES OTT*

JOINS THE ROEDERER COLLECTION

In the 1990s champagne maker Louis Roederer adopted a policy of growth through acquisition. Its targets were famous, family-owned companies – a shrewd move for this independent, family business whose astronomical success over the years was reflected in its brawny balance sheet. Spearheading development was Frédéric Rouzaud who after joining his father in the business in 1996 made acquisitions in Portugal (Ramos Pinto), Champagne and Côtes du Rhône appellations (Deutz & Delas) and in Bordeaux (Château de Pez). Next stop Provence, where the boom in rosé production created a juicy incentive to invest.

Domaines Ott* meanwhile was looking to get acquired: With seven brothers in the third generation and a fourth generation that wanted out, the business had become unwieldy and burdened with inheritance issues. The time was right to merge, and champagne maker Louis Roederer was the perfect fit: a business rooted in the history of French wine, like Ott* itself, with the same commitment to savoir-faire and the pursuit of excellence.

In 2004, Domaines Ott* joined the Roederer portfolio. "We complement each other perfectly," says Jean-François Ott, head of the business. "What the Group brings to the table is marketing and packaging expertise, not to mention its impressive global distribution network. What we bring to the table is our expertise as winemakers and winegrowers." Since he took the helm in 2009, Jean-François has made ever-higher standards of winegrowing his priority. The result today he says is "a painstaking growing process precisely adapted to each parcel, from pruning, to clonal selection, to manuring, to canopy management and every other manual task. We spend as much time in our vineyards as they do in the Bordeaux classified growths – 600 hours of work per hectare per year, carried out by a team of 56 full-time employees working across our three holdings." To this must be added restricting yields, and rigorous winemaking practices ranging from strict, selective sorting, to blending and bespoke aging.

Today each of these three holdings expresses a specific terroir; but common to all of them is a delicate pressing process designed to extract the best of the pulp and the quintessence of the vineyard – a terroir-focused approach that broke with the generic thinking behind Cœur de Grain. Château de Selle rosé is characterized by its finesse, Clos Mireille by its roundness and Romassan by its structure. Together these three rosés account for roughly 85% of output, representing three distinct vineyards covering an area of 231 hectares. With the environment ever more a priority, production has been 100% organic since the 2022 vintage.

Left
Château de Selle's winery:
a modern aesthetic created
by huge stone blocks stacked
in a staggered pattern.

Below
Fourth generation scion
Jean-François Ott.

Opposite page
The Clos Mireille
vineyard bordering
the Mediterranean Sea.

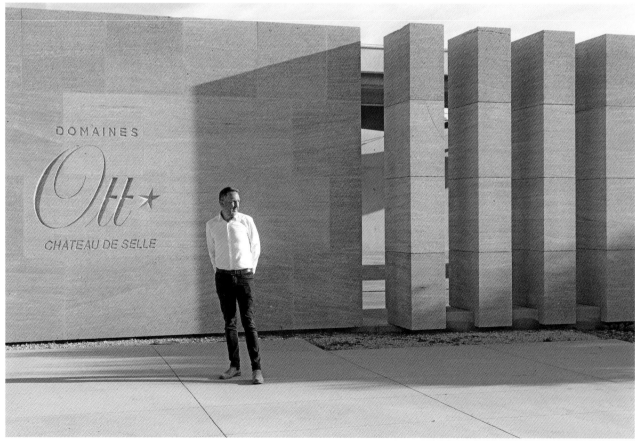

DOMAINES

Ott★

CHÂTEAU DE SELLE

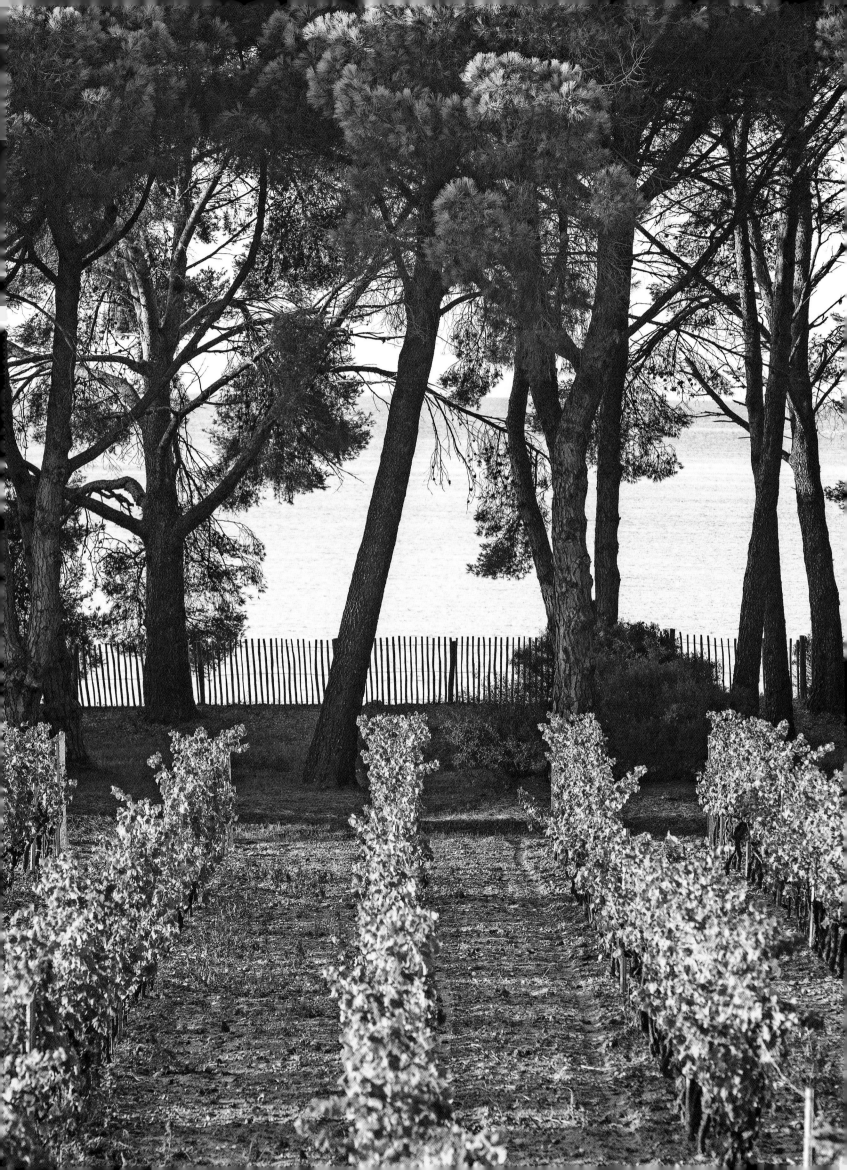

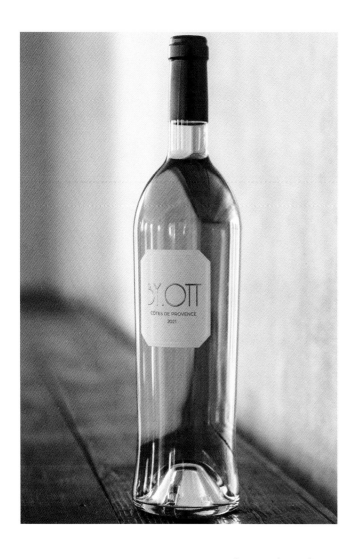

THREE HOLDINGS, A SINGLE UNIQUE BRAND

Faced with mounting competition in a buoyant market, Ott* and Roederer came up with a plan to put their ambitions into practice. They would make the best rosé in the world and the finest wines in Provence – a two-pronged strategy aimed at showcasing Ott*'s long-established position in the rosé market together with the renown attached to its three estates. The message? Three holdings, a single unique brand – Ott*.

By 2016 sales had been rethought around a concerted marketing strategy that bore fruit that year. "By Ott" joined the Ott* portfolio – a predominantly pink Côtes de Provence made from at least 20% estate-grown grapes vinified in a modern winery reserved for Château de Selle production. "A more approachable wine," says Ott, "aimed at our younger customers and made for serving by the glass in restaurants, but bearing a name that is a guarantee of quality and an invitation to discover our more prestigious offerings."

At the other end of the scale and perhaps inspired by champagne, is a prestige cuvee released in 2019 that expresses a vintner's vision. "What we wanted", says Ott, "was to say something different, something entirely new about what makes us special – a reinterpretation of our terroirs that brought out the best in our three vineyards." The result is Etoile: a wine in a class apart, produced from a careful selection of the estate's most characteristics cuvees and custom-aged. Only available in pink and only offered in a limited edition, Etoile takes its place in an "haute couture" wine collection that says "artisan winemaker" loud and clear.

Above
By Ott, the estate's entry level rosé (released in 2016), comes in a different type of bottle and serves as an invitation to discover Ott*'s more prestigious offerings.

Opposite page
Etoile, only available in pink and only offered in a limited edition, brings together the best of Ott*'s three holdings.

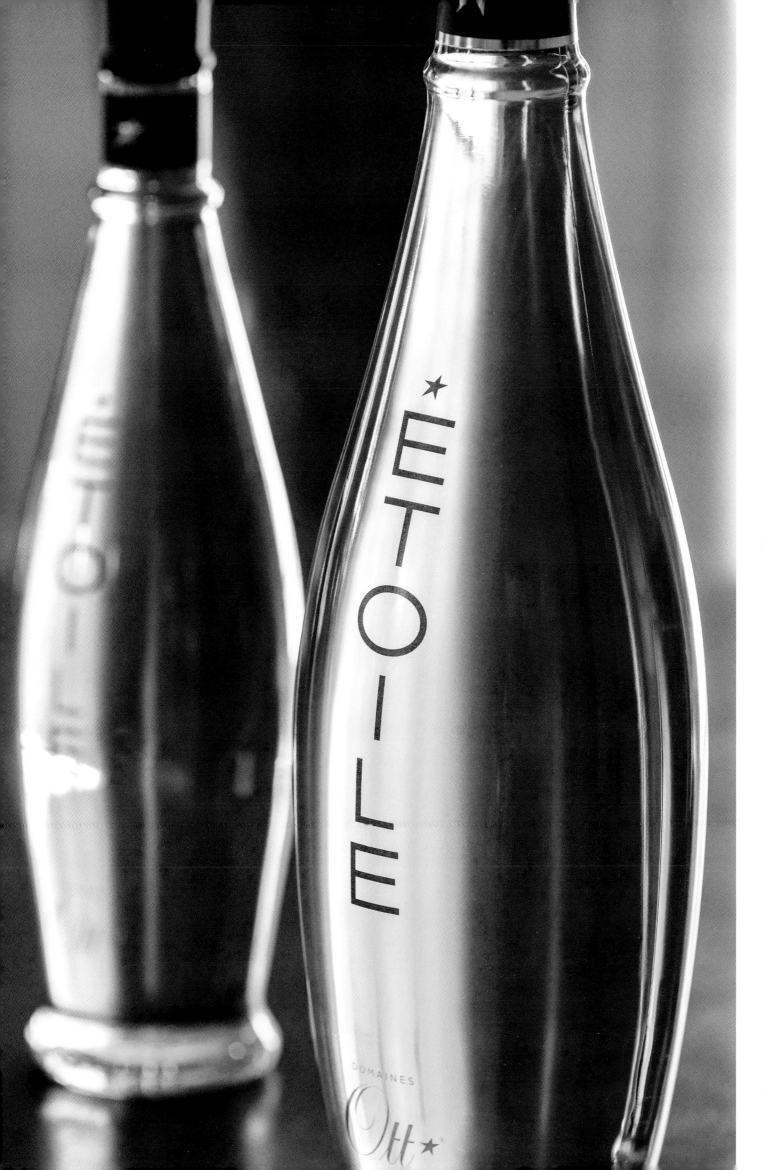

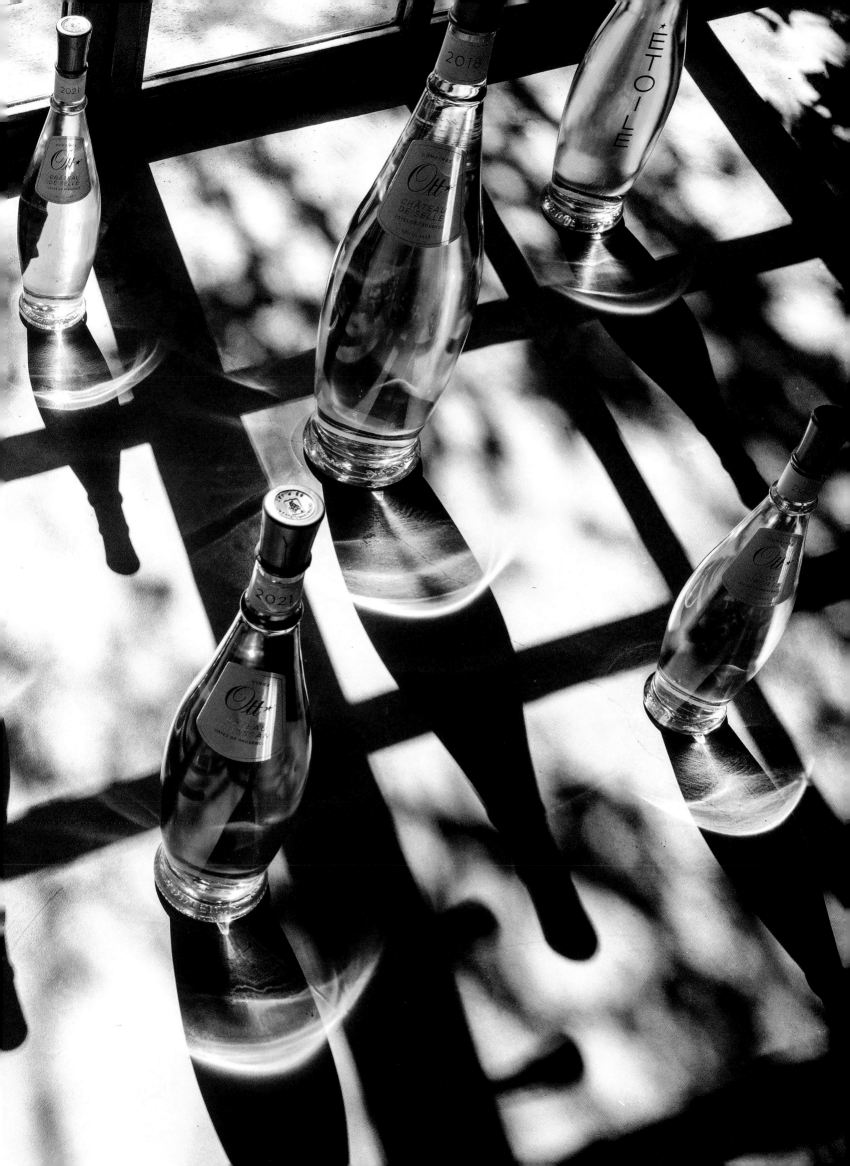

ESCLANS
AND MINUTY

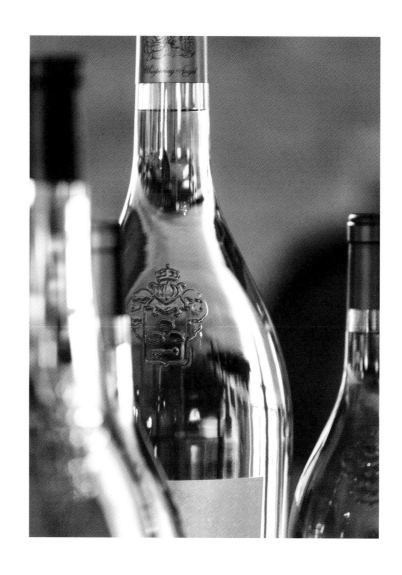

GLOBAL
HORIZONS

When his long-time partner told him he intended to sell his 50% share of the business, Sacha Lichine set out to find a new partner compatible with his vision of the future, in development and financial terms. Among the many groups eager to cut themselves a slice of the action was France's leading luxury group LVMH. The timing couldn't have been better. This was just when LVMH was looking to break into the Provence market and add rosé to its range of fine wines.

"In the beginning I wasn't keen. I said "no" nine times until the day I received a visit from Bernard Arnault. Lunch was a very friendly affair." In December 2019 Sacha said "yes", confident that the future would unfold in line with his wish to take the business global and retain his independence as director. He gave up five per cent of his equity to LVMH which, together with his partner's share, became the majority shareholder.

Wine distribution outside the US henceforth relied on the wine and spirits arm of LVMH, Moët-Hennessy. And with that, new horizons opened up for our visionary achiever – this rocket man who in the end was not displeased to see Garrus and Whispering Angel take their places alongside such hallowed wines as Dom Pérignon, Cloudy Bay and Cheval Blanc.

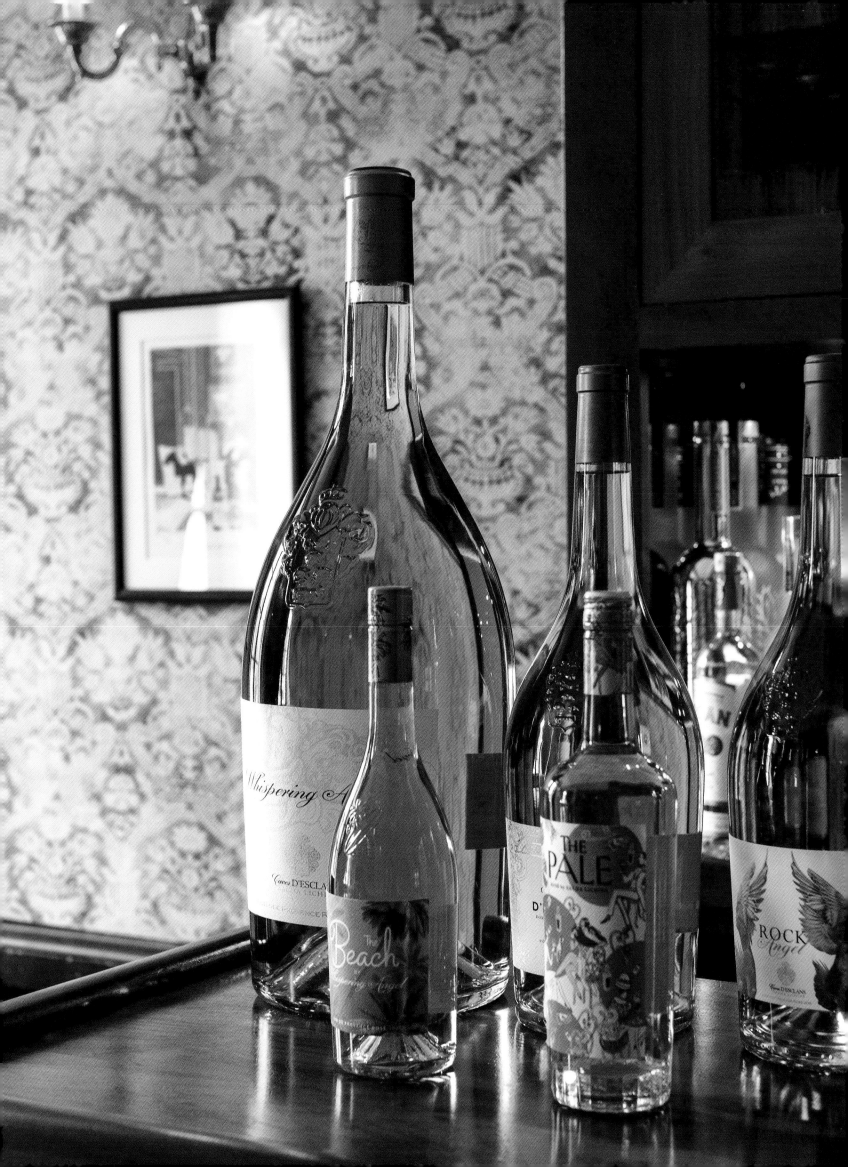

Right
The Château Minuty
winery in the heart
of the Saint-Tropez
Peninsula.

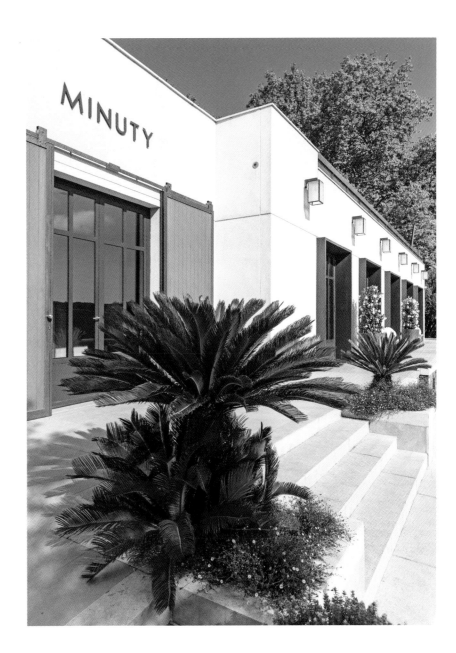

MINUTY IN THE BIG LEAGUE

Early 2023 saw LVMH's wine and spirits arm Moët Hennessy acquire a majority stake in Minuty. Faced with a complex inheritance, the Matton brothers passed the baton after successfully steering the chateau's fortunes for more than 30 years. For LVMH this latest acquisition reaffirmed its interest in pink wine – French market leader Minuty joined Esclans (USA market leader) and Château Galoupet in the LVMH portfolio. Henceforth the group could lay claim to two classified growths and nearly 450 hectares of vines, and the world of Provence rosé could look forward to new horizons.

CHÂTEAU GALOUPET

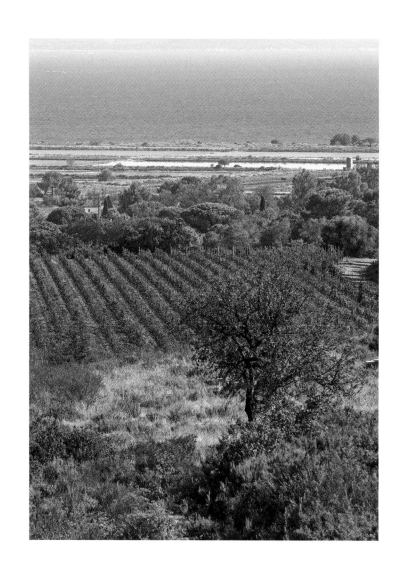

AN ODE TO NATURE

When Jessica Julmy was appointed CEO of LVMH's recently acquired Château Galoupet, it took her just a few months to put the estate on track. Château Galoupet would become a beacon of sustainable development, for the region and for the Group. Four years later, this dynamic thirty-something woman of action smilingly acknowledges that making it happen has been one of her greatest challenges so far. Bringing her bold ideas to fruition has been no mean feat – but then Jessica Julmy is more than equal to the task.

Born in Chicago to Swiss parents, she followed a career path that spoke to her international roots. She studied economics in the US, worked in commercial real estate in Asia and Argentina and earned her MBA in London. Having mastered Mandarin Chinese (her first real challenge) she did a stint with a fine wine importer in Hong Kong who introduced her to the fascinating world of wine – its products and the history and skills surrounding it. That was the turning point. With wine as her new calling, she spent six years with the prestigious House of Krugg (now part of LVMH), mentored by the House's charismatic then-president Maggie Henriquez. Château Galoupet came next, a sleeping beauty despite its *Cru Classé* status, with no clear identity of its own due to a complicated history of ownership spanning 14 successive buyers. Jessica's first priority therefore was to learn as much as possible about the land and its roots. "The only mention I found of the Galope *lieu-dit* was on one of the very first maps of France. That's what decided me to start with the terroir and the soil and I soon realized that everything needed rebuilding from the ground up." The wines' reputation was no exception.

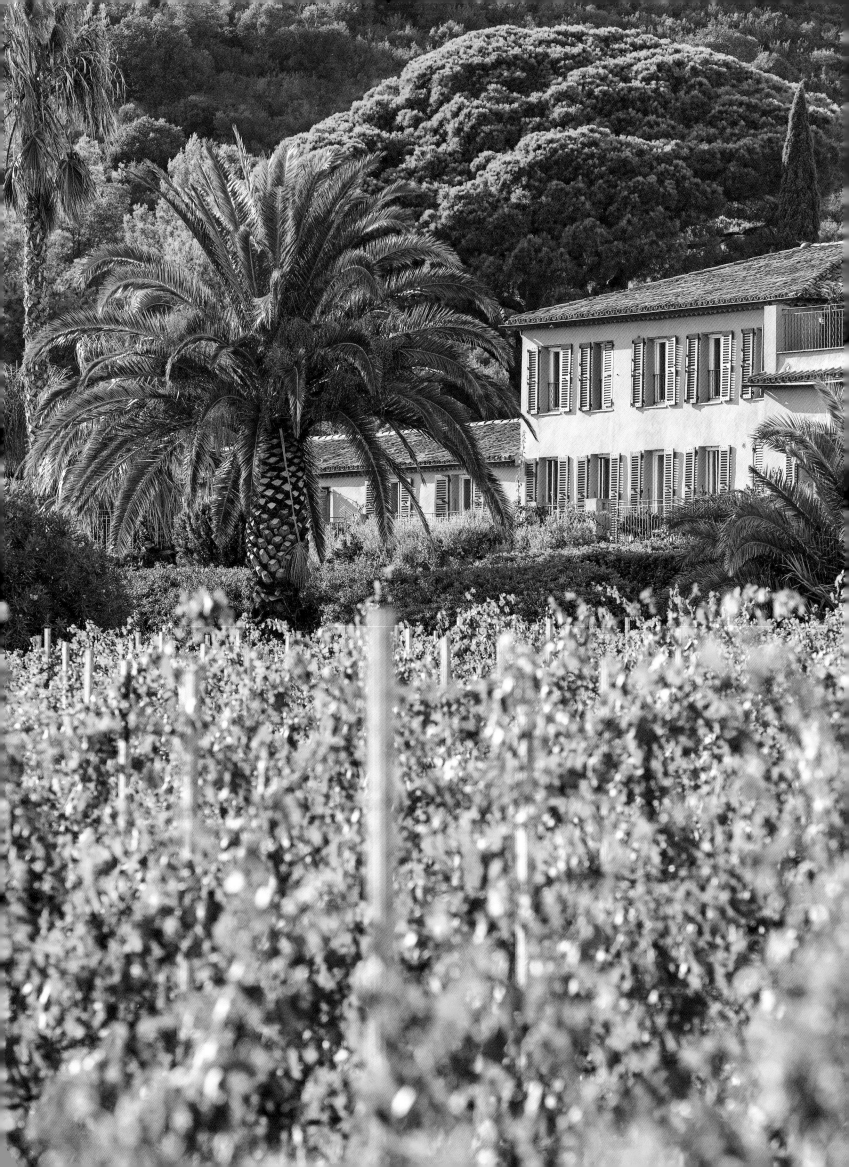

Opposite page
The Provençal-style residence
at the heart of the estate.

Right
A 69-hectare single-block
vineyard, with up to 60%
of vines scheduled
for replacement over
the course of 10 years.

A GREAT WINE IN HARMONY
WITH NATURE

The estate overlooks the Mediterranean and the Isles d'Or,
Porquerolles, Port-Cros and Le Levant: a 69-hectare single-block
vineyard (including four hectares with PGI status) and 77 hectares of
protected woodlands. At the time of purchase, the vineyard was the
worse for lack of money; the winery equipment was outdated and the
main building, with its large terrace area, was mainly used for wed-
dings and evening events.

"We've drawn-up a 20-year organic conversion plan based on an
all-out commitment to biodiversity. Species reintroduction and soil
regeneration depend on forging a connection between the protected
woodlands and the vineyard," says Jessica. The first priority is to test
the soil in preparation for replanting, always matching the plant to
the site (particularly important for tibouren and rolle, the predomi-
nant rosé wine varieties). Sixty per cent of the vineyard is scheduled
for rebuilding over the course of ten years, to include time allowed for
fallow periods. In the meantime, 1.5 hectares of land are now reserved
for planting with resistant grape varieties, with three plots serving as
a test bed for biodynamic preparations– a key issue currently "under
careful consideration".

In partnership with the local branch of the Conservatoire des
Espaces Naturels (nature conservancy) and the Ligue pour la Pro-
tection des Oiseaux (French league for the protection of birds) a sur-
vey is underway to identify the species found in the woodlands and
vineyard and ensure their survival. The effect of honeybees in the
vineyard is also under study with the building of 200 beehives and a
Drone Congregation Area (DCA) where male bees gather and wait for
young queens to visit. Rethinking water use, examining the potential
for growing cork oaks and fruit trees… everything possible is being
done to "produce a great Provence wine in tune with nature." Not
forgetting that the estate is now open to the public in a bid to raise
awareness of an investment in nature-positive land use that enjoys
the backing of two national conservation bodies.

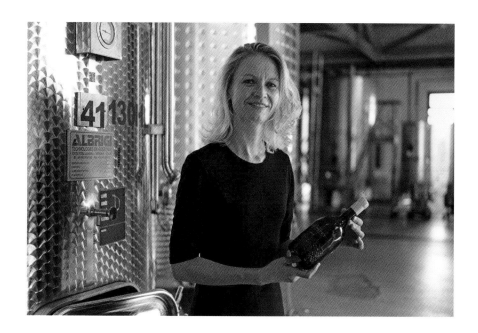

AMBER GLASS...

The 2021 vintage marked the release of the first wine from a vineyard now fully converted to organic production – a rosé to celebrate the end of a long process aimed at bringing out the best in a crystalline terrain with soils developed from schist, sandstone and quartzite. Its red and white counterparts are in the pipeline. Two versions are offered: Château Galoupet Cru Classé, the estate's plot-specific offering; and Nomade, the estate's second wine, a quintessentially Provence organic blend packaged in an ultra-light go-anywhere bottle (hence the name) – a bottle that breaks with convention, as indeed does the amber bottle used for the Cru Classé. Repositioning Galoupet and reinventing its style took some daring; but then Jessica never does things by halves. "Once you embark on the pursuit of sustainability, you soon realize that everything is connected. Packaging accounts for 40% of our carbon footprint and pretending otherwise is just plain hypocritical."

The first wine, Cru Classé status oblige, comes in a glass but near opaque amber bottle that hides the color of the wine. A brave decision for a complex rosé; but as Jessica explains, "this is a bottle weighing less than 500g (that's 271g lighter than a standard rosé bottle), made of 70% recycled glass compared to transparent bottles containing no recycled glass at all." Serigraphy and a pink wax cap tell you this is a pink wine, with the embossed motif nodding to the surrounding vegetation.

... AND A FLAT BOTTLE

The cuvee Nomade goes one step further, as much in terms of shape as materials. Flat and transparent, the bottle is made from recycled plastic collected from coastal areas at risk of ocean plastic pollution. Jessica says it got a very mixed reception "as you might expect when marketing to different generations. But innovation comes in all shapes and sizes and we make it our business to give everything a try – every new product, every new skill."

In 2021 Jessica put her name on the first vintage under her watch and the first chapter in Château Galoupet's sustainability transformation. In the process she and her team enhanced the image of Provence by creating great wines that voice their terroir in all of its magnificent biodiversity.

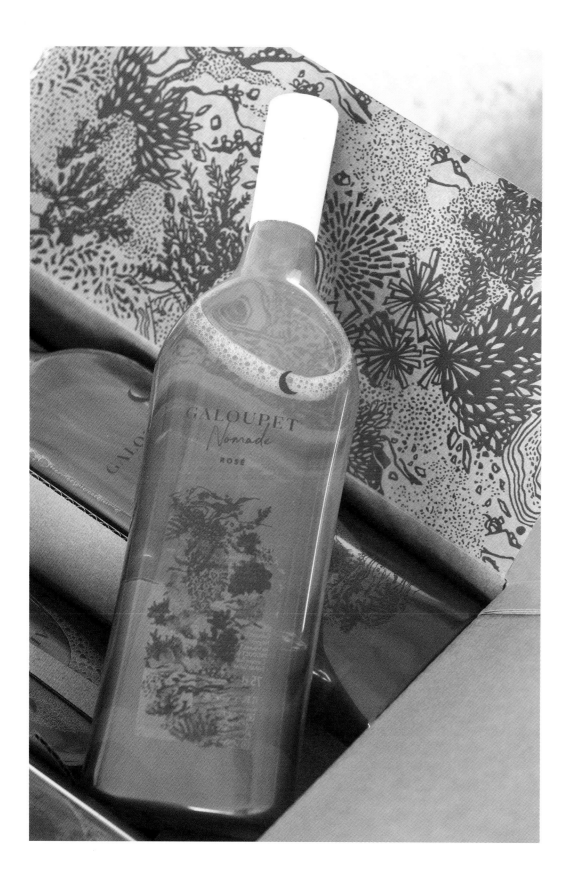

Above
Nomade comes in a
revolutionary bottle made
from recycled plastic
that packs flat when empty.

Opposite page
A very old vine.

CHANEL

AN ISLAND FOR
AN ESTATE

Chanel's arrival in the world of wine is not actually new. But then, whether sashaying into the spotlight or launching its perfumes, the House of Chanel has always remained discreet about a good many of its business activities. Since the nineties the House has been the owner of two large, classified growths, the Rauzan-Ségla Margaux Second Growth and the Château Canon Saint-Emilion First Growth. More recently it added two further properties to its collection: Château Berliquet, another little gem of a St Emilion; and Frenchman Robert Skalli's St-Supéry winery in Napa Valley, famous for its white sauvignon. The approach is identical in every case, focusing on historic wine estates renowned for their terroir and just waiting to take their place in the sun. Domaine de l'Ile on Porquerolles Island, acquired by Chanel in the fall of 2019, is no exception. Unique for its magical location, this is a vineyard without a chateau in sight but all the soul required to "pursue Chanel's journey through Provence," to quote Nicolas Audebert, general director of Chanel holdings in France.

That journey began in 1928 in the hills behind Rocquebrune-Cap-Martin with the building of "La Pausa", the Mediterranean villa designed by Gabrielle Chanel who would spend the next 25 years welcoming artists and writers to her blissful abode before eventually putting it up for sale. In 2015 the property was acquired by Chanel and restored to its original style in tribute to the House's brand heritage and the cultures and values espoused by Coco Chanel, aka *La Grande Mademoiselle*.

The next stop In 1987 was Grasse, home of fifth-generation cultivators, the Mul family, France's largest producers of perfume plants. That year Chanel struck a deal with the family to anchor production of the Grasse jasmine essential to safeguard its famous N°5 Perfume Extract. Once again however, the story leaves out the rest, namely that May Rose, Grasse Jasmine, Rose Geranium, Iris Pallida and Tuberose from the flower fields of Grasse have been the main components of Chanel N°5 since its creation in 1921. Traveling some 50 miles coastwards we come next to Hyères, opposite Porquerolles Island, and the Villa Noailles center for contemporary art of national interest. Chanel is a patron of the center's permanent exhibition and an official partner of the Hyères International Festival of Fashion and Photography.

In addition to its strong footprint in Provence, the famous Maison de la Rue Cambon (the street where Gabrielle Chanel opened her first boutique) also has a solid presence in the field of heritage and arts and crafts conservation. Hence the attraction of Domaine de l'Ile and the Port-Cros national park: one for its Romanesque history and the other for its outstanding natural beauty. No sooner had they moved in than Chanel's new team of enthusiastic young winemakers set to work regenerating the vineyard and learning about the terroir. They planted new vines here and there and introduced new growing methods, but they also sought to look beyond wine to other forms of agriculture – or as one team member puts it "play on the synergy between the estate and the national park". It is this guiding principle that has led to the planting of orchards and hedgerows and the reintroduction of mixed farming (with a community oil mill in the pipeline). Stage two is already underway, upgrading the winery and technical facilities.

FITTING INTO THE ISLAND

In 2019 when Porquerolles winegrowers and farmers Alexis and Cyrille Perzinsky decided it was time to retire, they naturally asked if their neighbor was interested in taking over. It was a unique opportunity to acquire 15 hectares of vines under leasehold tenancy, including certain plots originally planted by Porquerolles' celebrated one-time owners, the Fournier family. Henceforth the property includes 40 hectares of vineyards and as much again in woodlands, and Porquerolles Island boasts two wine estates: Domaine de l'Ile and Domaine La Courtade (housing the Carmignac Foundation).

The classic burgundy bottle remains a key distinguishing feature of the estate, now with a new-look label sporting a map of the island in relief. The wines themselves are currently offered in two colors and two versions, all of them made from organically grown grapes (the vineyard obtained certification in 2015). "We're currently experimenting with red wines but otherwise we're staying true to tradition, so no branded wines, no bought-in grapes," says Nicolas Audebert who is also chief wine-maker for Chanel. Domaine de l'Ile rosé is a fresh, coral-colored wine with good backbone from a blend of five grapes, cinsault, mourvèdre, syrah and tibouren. Five grapes – this is Chanel, after all.

In summer, a visit to the estate shop and restaurant just a stone's throw from the village of Porquerolles will not disappoint – the shop with its selection of wines and olive oil, the restaurant with its *guinguette*-style atmosphere and pine-tree canopy. Wooden tables surrounded by potted lemon trees, 30 place settings (reservation only) and colored fairy lights that twinkle beneath the stars… not so much a restaurant more a little piece of nature. Even the chef is homegrown: a lady born and bred in Porquerolles who specializes in simple fragrant dishes based on local produce and locally caught fish.

Summing up Chanel's adventure on Porquerolles, Nicolas says that the intention has always been to build a global culture in a bid "to understand the island and fit in perfectly". This from a habitué of Porquerolles, with happy childhood memories of Mediterranean escapades under sail… The adventure continues today with the chartering of a sailboat to take part in the island's famous tall ships regatta (the "Porquerolle's Classic"), with the closing dinner held at the Domaine de l'Ile. Music to the ears of Yacht Club president and former estate owner, Sébastien Le Ber.

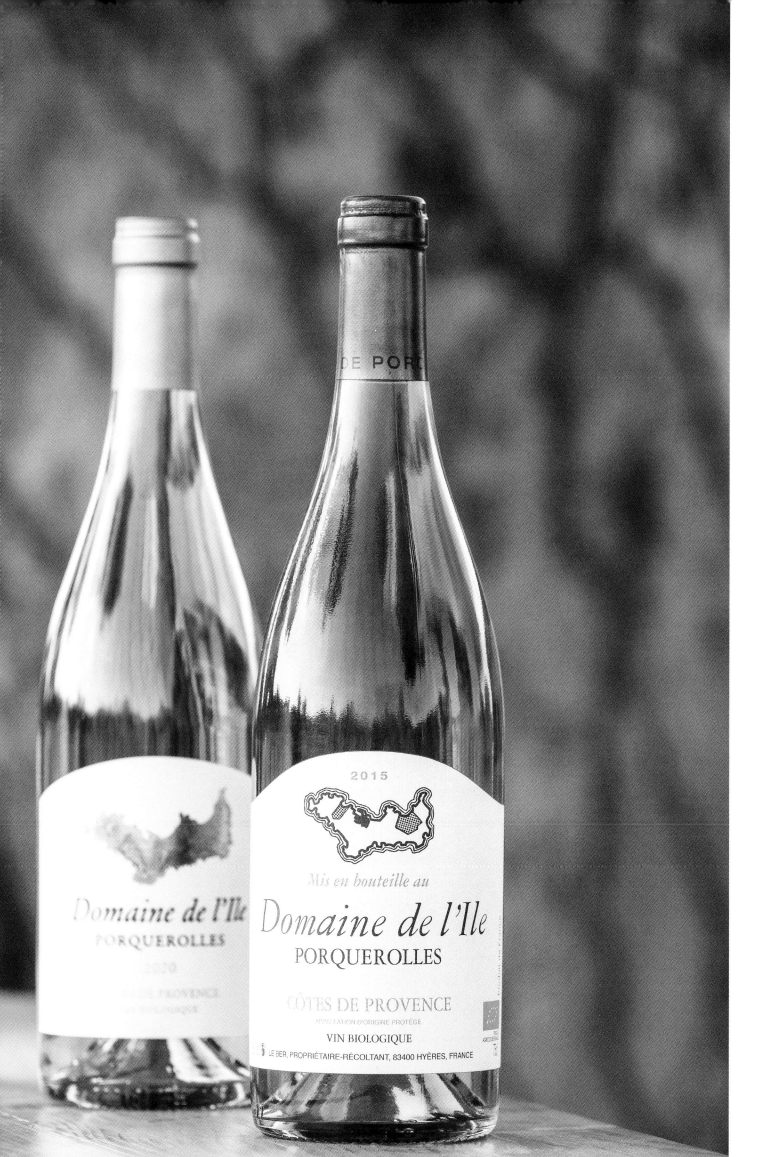

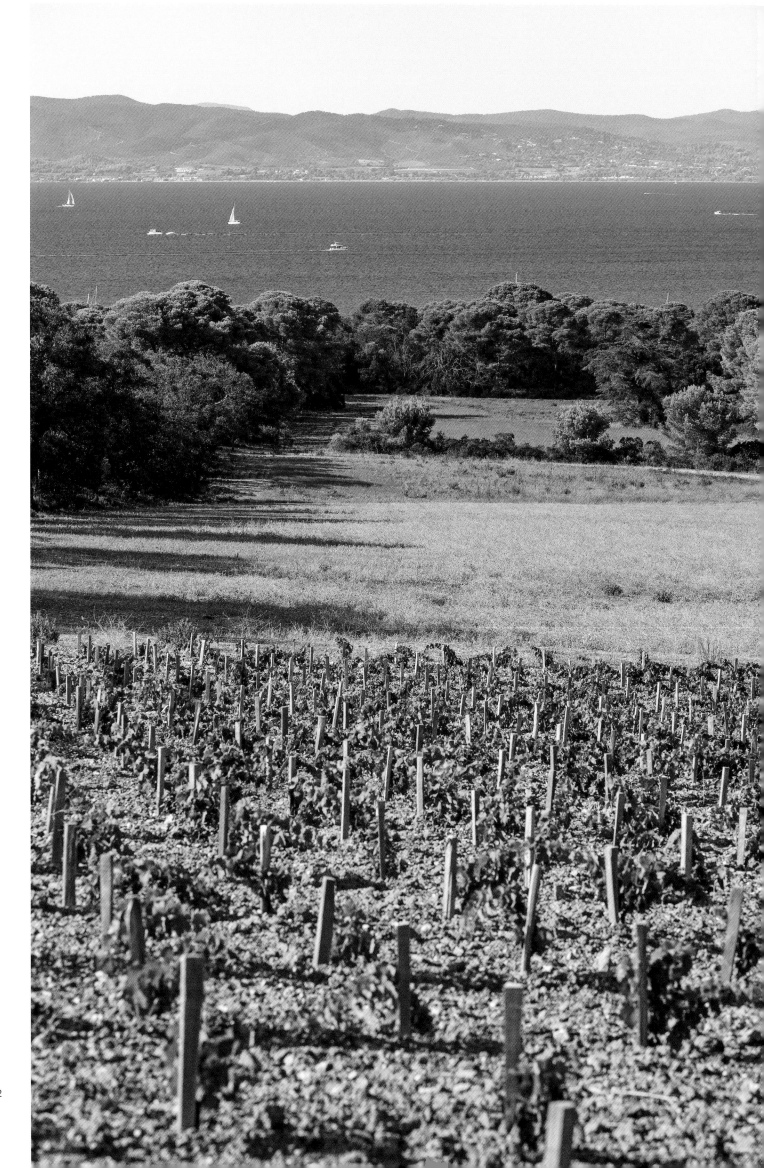

Right
Former owner Sébastien
Le Ber (left) with Nicolas
Audebert, general director
of Chanel holdings in France.

Opposite page
Replanting the vineyard was
a priority for Chanel from
the outset.

Left
The new-look label sports
a map of the island, in relief
for greater visibility.

163

A TRENDSETTING ROSÉ

PROVENCE ROSÉ HAS BEEN A TREND SETTER IN MANY RESPECTS, BRINGING A BREATH OF FRESH AIR AND NEWNESS TO THE SOMEWHAT CORSETED WORLD OF WINE. SHAKING UP THE CODES AND APPEALING TO ALL GENERATIONS, PROVENCE ROSÉ HAS MADE ITS MARK FROM THE PRIVATE BEACHES OF SAINT-TROPEZ AND SWITCHED-ON SHORES AROUND THE WORLD, TO THE "CULT" PLACES OF PROVENCE AND EVEN THE MOST EXCLUSIVE WINTER SPORTS RESORTS. ITS ARRAY OF STRONG BRANDS FEATURE ON THE PAGES OF INTERNATIONAL MAGAZINES AND ARE NOW THE TALK OF THE INTERNET, FAMOUS FOR A LAIDBACK, FESTIVE LOOK THAT HAS ROCKETED PALE PINK TO STARDOM.

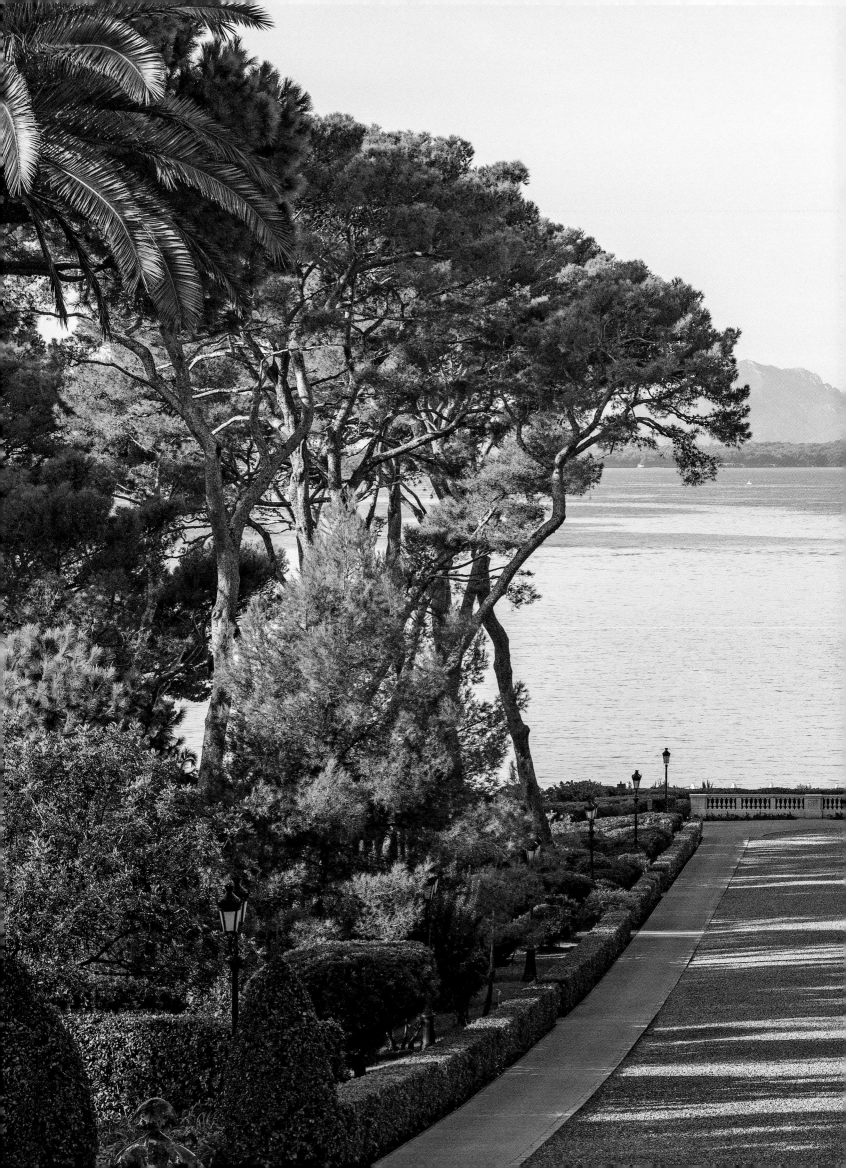

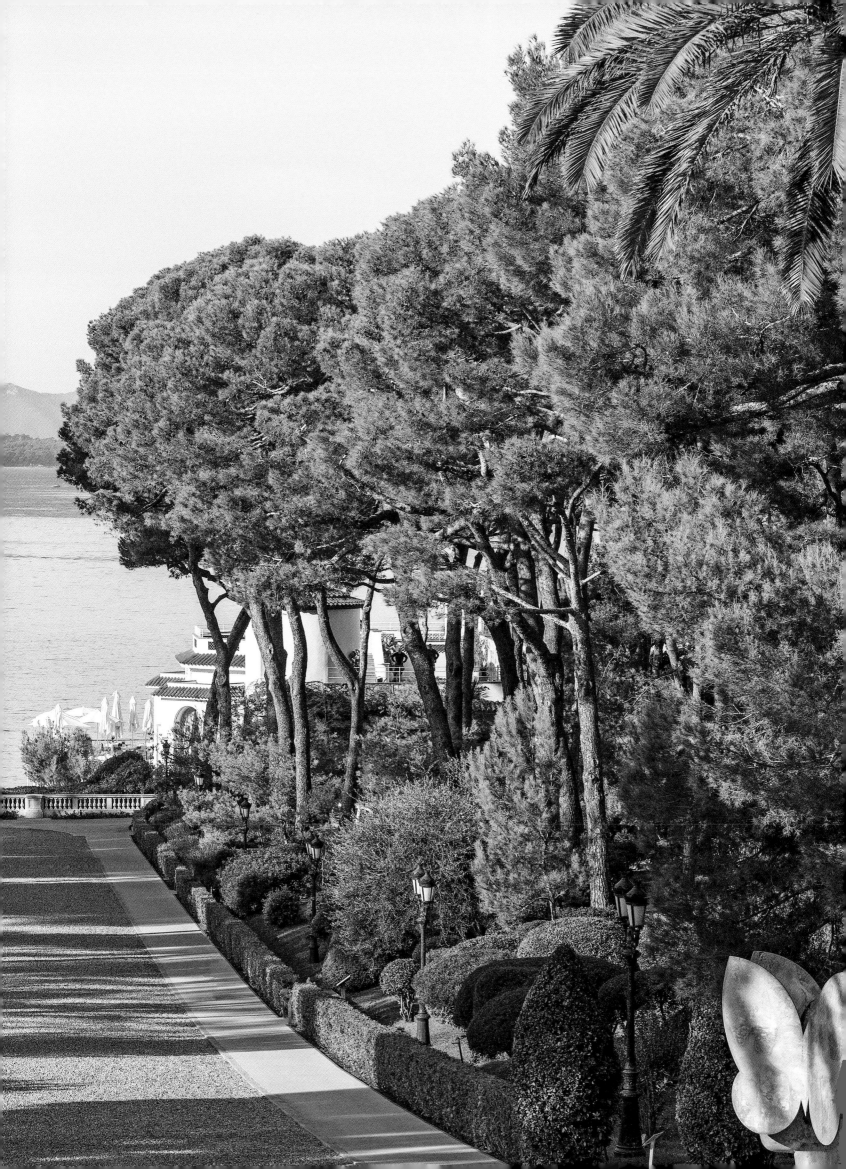

PAMPELONNE AND ITS BEACHES

From pioneers like Tahiti and Club 55, to the most recent newcomers, whatever the style and clientele, each one of Pampelonne's private beaches has added to the exceptional popularity of the Saint-Tropez Peninsula. Located in the municipality of Ramatuelle, the magnificent Bay of Pampelonne extends from Cap du Pinet to Cap Camarat – more than 5km of fine sand bordered by turquoise waters.

Since the 1990s, this oasis has been the favorite daily haunt of celebrities and jetsetters on vacation in the region. Long days lounging in deckchairs, endless lunches and, on some beaches, "afters" under the stars: non-stop partying with champagne flowing like water, served in magnums and jeroboams F1 Grand Prix style to celebrate memorable events. Now it's the turn of pale pink rosé to shine. Together with Saint-Tropez, Pampelonne's trendy beaches provided a fabulous springboard for the success of Provence rosé, in France and across the globe. This is where giant bottles of pink wine first made their entrance, sparking a craze for rose-gold magnums and jeroboams that are now shipped worldwide.

Page 164
Bouquet of magnums on the terrace of the Hôtel Eden-Roc's Grill restaurant.

Opposite page
Pampelonne's legendary beaches.

Pages 166-167
The Hôtel Eden-Roc, with its famous landscaped gardens leading to the restaurants and its swimming pool facing the Mediterranean.

NIKKI BEACH MADNESS

Leading this hymn to laidback living is Nikki Beach: the luxury beach club concept launched in 1998 on Miami Beach by American businessman Jack Penrod. Nikki Beach Miami was the first of its kind in the USA, paving the way for other private beaches around the pools of luxury hotels or down by the sand. Lazing in the sun was never this cool: chic eateries, creative food and countless cocktails served with a smile; blue waves gently lapping white sands; soulful soundtracks in the background. This was the ultimate in fun. "Tell only your best friends" ran the slogan – and so they did because within four years, the world was ready for a second Nikki Beach, this time in Europe and more particularly the Mediterranean. Not in Ibiza, nor in Sardinia but in Saint-Tropez, on Pampelonne Beach, with a never-to-be-forgotten opening night followed by the now iconic summer of 2002.

In less than twenty years, Nikki Beach has planted its flag in elegant outposts all over the world, now with eleven beach clubs to its credit, a fashion division (curated clothing offered by Nikki Beach boutiques) and special events such as the Nikki Beach pop-up venue at the annual Cannes Film Festival and a summer-long pop-up bar and lounge at Porto Cervo Waterfront, Italy. Building on his success, founder Jack Penrod has also now invested in the hotel business with the opening of five resorts in Thailand (Koh Samui), Greece (Porto Heli and Santorini), Dubai and Montenegro.

PRIVATE BEACHES

Miami Beach

Saint-Tropez

St Barts

Marbella

Koh Samui

Mallorca

Ibiza

Monte-Carlo

Dubai

Emerald Coast (Sardinia)

Tivat in Montenegro

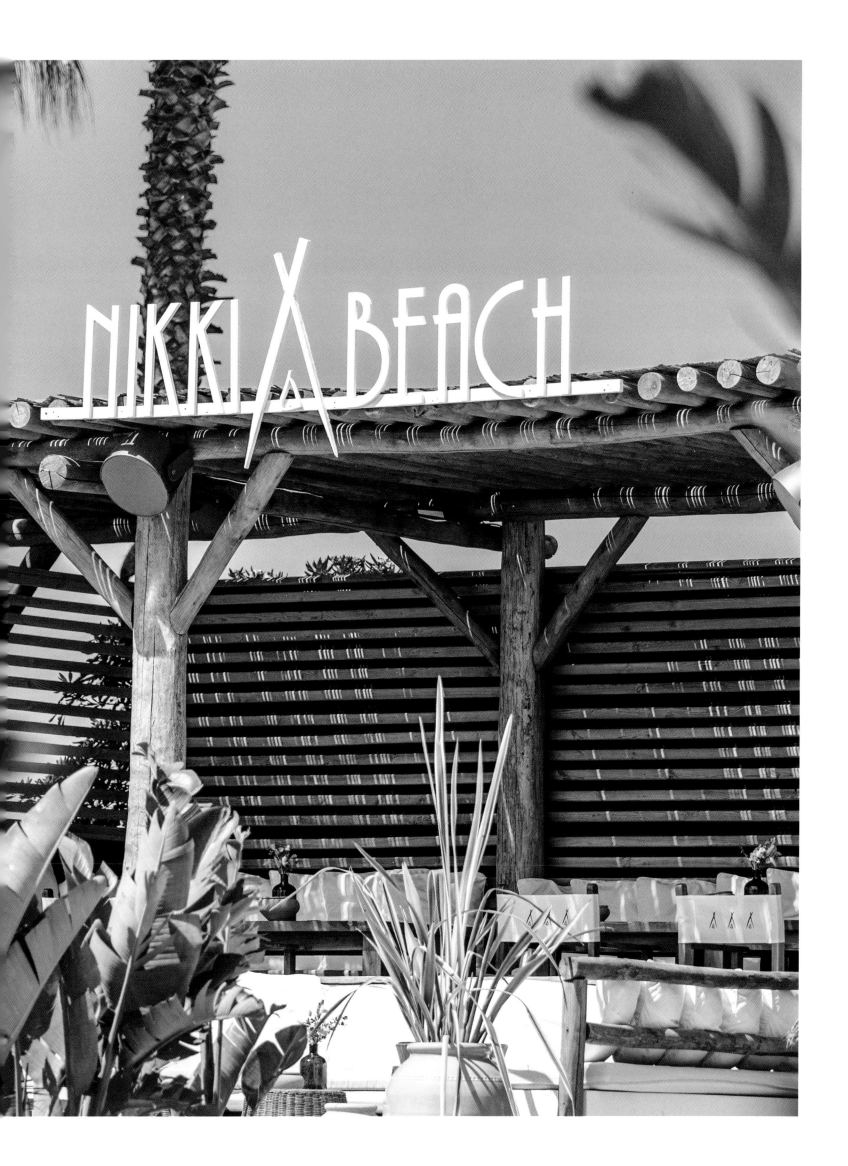

AN ARRAY OF BRANDS

Some properties have always offered blended wines made from bought-in grapes and juice; but the rise of rosé wine brands has been a game changer. Building on their names and reputations, a good many large estates have jumped on the brand bandwagon to meet market demand as part of their product expansion strategy. The thinking is that the brand will recall the name of the "first" wine, albeit destined for a different distribution channel. In keeping with its uninhibited image, the brand aims for unbridled innovation in terms of look and design, further reinforcing the offbeat appeal of Provence rosé itself.

Bottle and label design are equally adventurous. Daring silk-screen prints, original works commissioned from artists, bespoke bottles, limited editions… the more original the bottle the more unmistakable it is.

The name of the estate meanwhile serves as a guarantee of quality for a consumer struggling with too many options, particularly at the level of French supermarkets. Each estate buys grapes from specific vineyards, which are visited regularly to monitor quality. Branded wines are always vinified, blended and bottled on the premises and may include a proportion of the estate's own production. Depending on strategy and the volume of wine produced and exported, they may be labelled AOC Côtes de Provence (the much coveted PDO status), AOC Côteaux Varois or Côteaux d'Aix en Provence, Mediterranean PGI (Protected Geographical Indication) or less commonly, Var PGI (formerly Vin de Pays du Var). Sourcing rules are slightly more relaxed for non-AOC wines but nonetheless governed by very precise quality specifications.

Galoupet Nomade
First released in 2021 under the Côtes de Provence appellation and presented in a flat, ultra-light (63g) recyclable bottle made of recycled POP plastic. Unbreakable!

La Vie en Rose
Released by Château Roubine in 2015 under the AOP Côtes de Provence appellation and, as its name suggests, an exclusively pink wine. Available in organic, conventional and even sparkling versions.

Hippy
Roubine's new brand: a fresh and fruity organic rosé with a Mediterranean PGI label, named in tribute to the summer of love.

Lou
An organic Côtes de Provence for convivial moments – festive, light as a feather and presented in a bottle with an easygoing look.

Les Commandeurs
A refined, organic Côtes de Provence PDO, distinguished by its intense fruitiness.

Love by Léoube
An organic Côtes de Provence made from a blend of traditional grape varieties. An elegant wine in an elegant bottle with all the hallmarks of Léoube mastery.

By.Ott
A Côtes de Provence released in 2016 and made from 20-30% estate-grown grapes. It comes in a different bottle featuring the Ott signature minus the star – usually a magnum or jeroboam for the rosé (90% of the range).

The Pale by Sacha Lichine
A Vin de Pays du Var rosé, with a festive, Roaring Twenties-style label. The name was chosen by Sacha Lichine to recall the custom in British pubs of asking for "a glass of pale, please".

The Beach by Whispering Angel
Whispering Angel's "little sister" features palm trees and a beach. Packaged in a lighter bottle, this is a delicate rosé that showcases the Côteaux d'Aix-en-Provence appellation.

Studio by Miraval
A more accessible Mediterranean PGI released in 2018. The name is a nod to the legendary Miraval Studios now being revived by Brad Pitt, the place where world-class bands once came to record.

Minuty Prestige
The quintessential Provence wine, with Minuty wines accounting for 50% of the blend. First released in the 1990s.

M Minuty
A wine for pleasure, presented in the flute à corset bottle designed in the 1960s by the mother of the current directors. Offered as a limited, high-style edition, with every vintage featuring a globetrotting illustration by an artist from a different country.

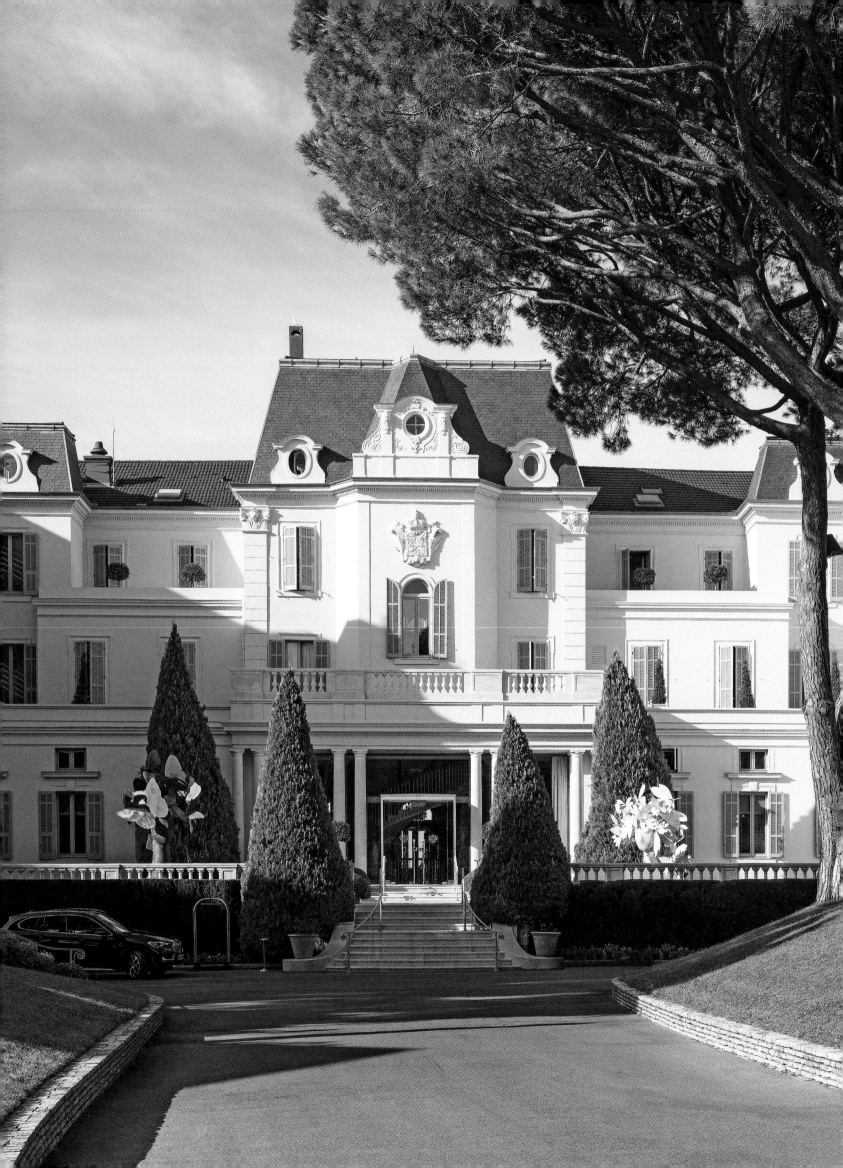

HOTSPOTS OF ROSÉ CULTURE

Presented below are the places where rosé wine forms part of the landscape and history of Provence and the French Riviera – places on the coast and in the hinterland that served as ambassadors for the major rosé brands featured on their wine lists. Some are cult places in their own right. All of them are world-renowned.

HÔTEL DU CAP-EDEN-ROC, ANTIBES

Perched at the tip of Cap d'Antibes, this fabled palace-style hotel on the French Riviera retains all the timeless elegance of its Second Empire architecture. Set in nine hectares of grounds, the Hôtel du Cap-Eden-Roc stands at the vibrant heart of the French Riviera, a favorite venue for high-profile events and private parties, glittering weddings, romantic dinners and idyllic vacations. For some 150 years, it has been welcoming the rich and famous from all over the world, among them many Americans. Regular renovations and embellishments ensure that its 177 guest rooms and suites, including two villas, meet the highest standards of comfort, combining state-of-the-art amenities with refined décor. There are five bars to choose from depending on mood and the time of day; two restaurants including the Grill gourmet eatery; and two sublime terraces overlooking the sea, like the upper deck of a ship.

CHEZ BRUNO, LORGUES

It took a lot of work and no little determination for Clément Bruno to make his name in gastronomy. He started out in 1983 focusing on the hearty, traditional fare his mother and grandmother used to make – food made for sharing. Then along came truffles and suddenly Bruno's life was never the same again. Black and white truffles have been the star attraction at this restaurant ever since, featuring in all kinds of dishes from starter to dessert, with a few iconic dishes offered a la carte. Potatoes, puff pastry, toast… Today it is Bruno's sons Samuel and Benjamin who maintain the tradition, Benjamin adding his own personal touches to mainstay recipes while remaining faithful to the truffle-inspired menu. The family inn offers a limited number of rooms and simply oozes Provençal authenticity. Rustic reception rooms, garden statues and sculptures, a large terrace beneath a shady arbor for eating al fresco in summer… Chez Bruno, nestled in the heart of the Haut-Var vineyards, is an invitation to savor great food in a great setting.

CHEZ MAMO, ANTIBES

Tucked away on a lane in Antibes Old Town, just a stone's throw from the port, this mecca for Italian food has been a staple of the French Riviera since it first opened less than 20 years ago. To judge by the hundreds of often autographed photos that hang on the stone walls, it is also a home-from-home for the Hollywood glitterati, among them some close friends of Mamo's who still come here every year. It was 1991 when he moved into the former warehouses of Domaines Ott* to cook the kind of Italian food he loves: "pasta al forno, pizzas and traditional Italian dishes fragrant with the scent of herbs." The keys to success are the rustic chic of the vaulted dining room, professional service and the presence of the smooth-talking boss himself as he makes the rounds of the tables, always wearing his white jacket even though he sees himself as "a restaurateur and not a chef". The restaurant also got a boost at the outset when the director of the Cap-Eden-Roc confidently recommended Chez Mamo to his clients. Now into his seventies but as active as ever, Mamo is always there for his regulars… and of course the stars.

CAFÉ DE LÉOUBE, PELLEGRIN BEACH

A café in name only, this elegant restaurant stands adjacent to the estate on the edge of the long Pellegrin beach – a high-profile yet discreet address in the heart of a protected area between Bormes-les-Mimosas and Brégançon. Toes-in-the sand dining under the pine trees, wooden tables and large white parasols: The setting plays on the simple elegance of nature. On the menu are Mediterranean dishes that celebrate local fishing and organic produce from the Château's own orchards and vegetable gardens. Homemade tapas and other nibbles are on offer in the restaurant lounge. Tasteful food meets friendly atmosphere, complete with jazz concerts, DJ nights and cinema classics, playing from June to October. A chance to enjoy privileged moments in a bucolic setting far from the tumultuous beaches of the coast.

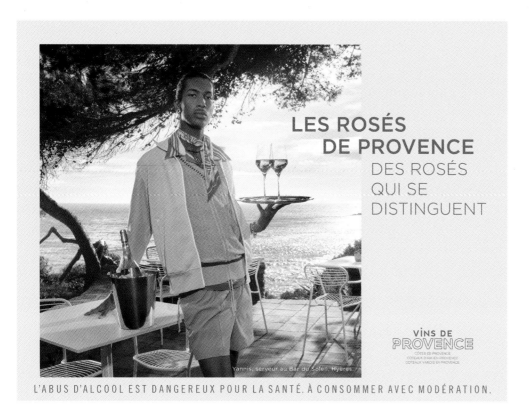

ROSÉ WINES
ON THE
CAMPAIGN TRAIL

Their appearance in glossy magazines is usually the sign that summer is here – time for laidback lunches on the terrace and whiling away warm evenings with friends. Ever since the 2000s, magazine ads featuring pretty pictures of pale-colored Provence rosé have been capturing the imagination of people worldwide.

In France and other countries where marketing is regulated by law (the French Evin law being a good example), advertisers must make creative choices to differentiate their product from the competition: by the design of the bottle, the advertising atmosphere and mood, and sometimes a short positioning statement or tagline. The freshness and originality of these colorful campaigns stands in sharp contrast to the rather more hidebound approach of the major wine regions. The CIVP, the promotional organization for Provence wines, regularly launches advertising campaigns in France and in the main export markets. The visuals and the message have evolved over the years: terroir, territory, heritage, landscapes, conviviality... Generally speaking however, the trump card is the word "Provence", proclaimed loud and clear to maintain the leadership position and enhance the global reputation of the Provence "brand-region."

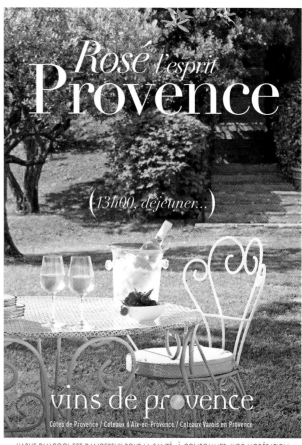

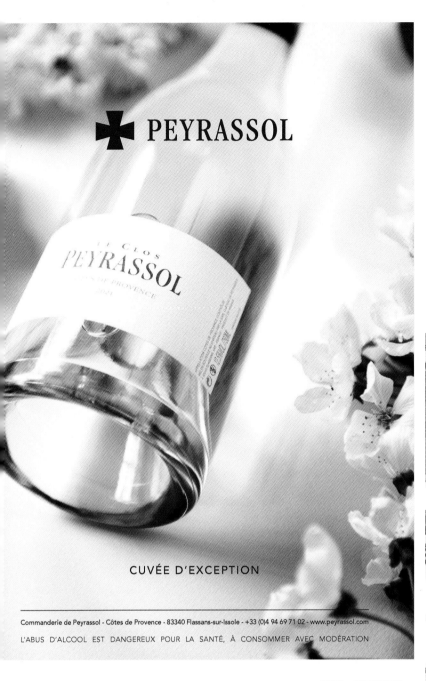

✠ PEYRASSOL

LE CLOS
PEYRASSOL

CUVÉE D'EXCEPTION

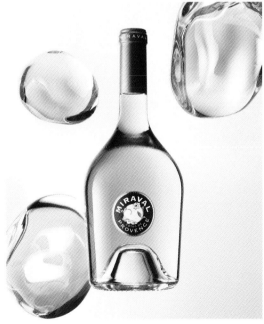

The Art of Rosé

MIRAVAL
PROVENCE

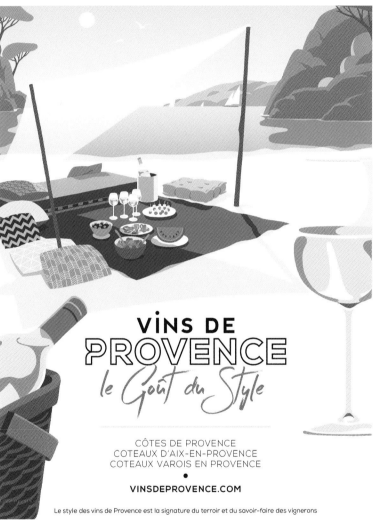

VINS DE
PROVENCE
le Goût du Style

CÔTES DE PROVENCE
COTEAUX D'AIX-EN-PROVENCE
COTEAUX VAROIS EN PROVENCE

•

VINSDEPROVENCE.COM

Le style des vins de Provence est la signature du terroir et du savoir-faire des vignerons

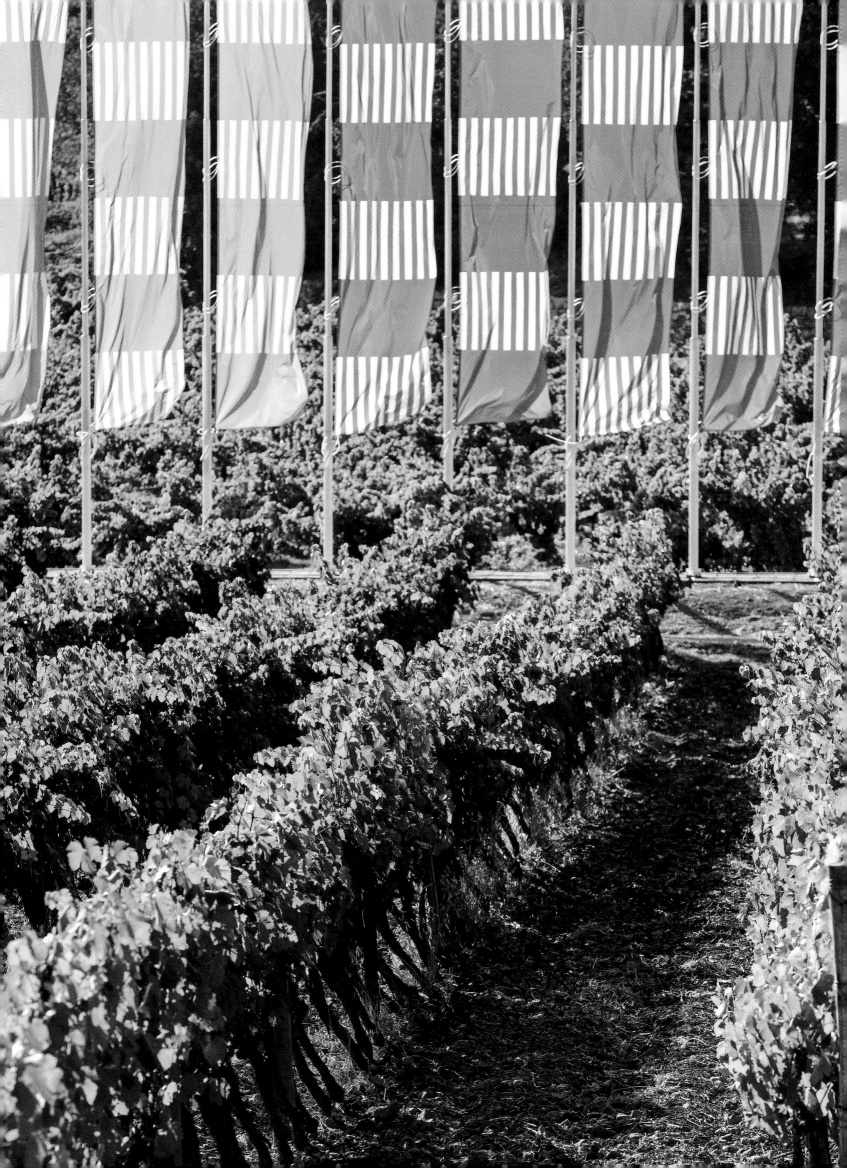

LIVING THE VINEYARD EXPERIENCE

PROVENCE HAS A TRADITION OF HOSPITALITY, ESPECIALLY IN SUMMER. FROM THE SMALL ESTATE THAT OFFERS VISITOR TOURS OF THE VINEYARD FOLLOWED BY A WINE TASTING, TO THE LARGER ONES THAT VIE FOR SUPREMACY IN BESPOKE WINE TOURS, IT'S ALL ABOUT WELCOMING VISITORS TO AN UNFORGETTABLE EXPERIENCE – SHOWING OFF THE SKILLS, THE TERROIR AND THE WINES, OUT AMONG THE VINES AND IN THE CELLARS. WINE WORKSHOPS AND MASTERCLASSES, ART EXHIBITIONS, RESTAURANTS, BED AND BOARD, MUSICAL EVENINGS… WINE TOURISM TAKES MANY FORMS AND IT IS EXPANDING ALL THE TIME.

THE COMMANDERIE DE PEYRASSOL

A SHOWCASE FOR THE ART OF WINEMAKING

In terms of sheer beauty, the Commanderie de Peyrassol ranks alongside that other great Provence wine estate, Château La Coste in the Luberon. Known primarily for the owner's rich art collections, exhibitions and the artists in residence, the Commanderie ranks as a top tourist destination that combines winemaking, gastronomy and art to bewitching effect.

This is a place with soul – a thousand-year-old Templar site patiently transformed over the past twenty years to become a temple of creativity and sensory pleasure. "I am a collector by nature and I became interested in art very early on, through the people I met and my personal preferences. It gives me great pleasure today to invite visitors to the Commanderie to share my fascination with all forms of art and most especially wine, which is my second great passion." So says Philippe Austruy, a lover of fine art and fine wine who lives by the motto: "Pleasing me comes first."

It was a total act of faith. Because despite the glowing reputation of Peyrassol wines, it wasn't going to be easy attracting thousands of visitors to this remote location miles from the coast. A lot would depend on the restoration of the winemaking facilities, the resolutely modern architecture of the art center and the fascination exerted by the *Parc de Sculptures*: a charming private sculpture park bringing together 1,000 years of history, old stones and unspoiled nature, punctuated by a strong architectural statement based on concrete, glass and Corten steel. The result is a place that exudes the grounding force of nature.

The sculpture tour takes visitors on an aesthetic and bucolic journey through the undergrowth and along the paths, following a detailed map that lists the artists. The first works were installed around the historic heart of the Commanderie, gradually followed by other pieces positioned at intervals around a 3-hectare natural park to create a perfect pairing of sculpture and nature. All of them were specifically selected to avoid upstaging nature "with no monumental works likely to disturb the atmosphere" says natural-born landscaper Philippe Austruy. Great names like Frank Stella, Niki de Saint-Phalle, Ugo Rondinone and Sol LeWit rub shoulders with contemporary artists commissioned by the owner to create bespoke sculptures – such as Daniel Buren's stunning multi-colored *Cylindre ouvert et aux couleurs* at the entrance to the property.

Page 182
Daniel Buren's *Le Damier flottant arc-en-ciel.*

Above
Les Génies de Casenuove (Lou), Pascale Marthine Tayou, 2020 – an assemblage of crystal and found objects.

Right
Sculpture P&T, Victor Vasarely, 1978 – made from enameled lava stone and reinforced concrete.

Opposite page
Deux angles 17.5° et 15,5°, Bernar Venet, 2016 – a sculpture in Corten steel.

THE TASTE
OF PEYRASSOL

Faced with a growing number of visitors and tours often lasting half a day, the estate soon extended its offer to include a diverse culinary experience that naturally drew on home grown produce – healthy, high-quality ingredients that reflected the property and its ambitions. This is every chef's dream come true, complete with an organic farm offering seasonal fruits and vegetables, and some thirty hectares reserved for animal-friendly farming. Dining on the terrace of the Chez Jeannette restaurant on a summer evening is a delight, watching the rays of the setting sun flirting with the vines and Daniel Buren's brightly checkered banners blowing in the breeze – a five-color rainbow gradient that nods to the vineyard's modern art collection.

In the kitchen, consultant chef Michel Portos keeps a kindly but expert eye on a stripped-down menu that celebrates modernist cuisine, with the focus on ingredients that flatter the wines and make this eatery a gourmet destination par excellence at any time of year.

Under the hundred-year-old mulberry trees, the Bistrot de Lou meanwhile offers a varied selection of snacks, including dishes to share and a few revisited Provençal specialties. Ideal for an aperitif with friends or a quick break before or after a visit. To complete their tour, visitors can stay overnight (or longer!) in one of the ten or so guest rooms available at La Commanderie and the neighboring property of La Rouvière. Add to this a broad range of wines, wine tastings and wine workshops, plus harvest days, jazz concerts and musical soirees in summer, and you have all the ingredients of a truly idyllic getaway!

Color, life and emotion, under the open sky or in the cool of the cellar… great moments of discovery and sharing. The Commanderie de Peyrassol gives new meaning to the pleasure and art of entertaining.

PROVENCE AND WINE TOURISM

HARVEST FESTIVAL AT CHÂTEAU LÉOUBE

Every four years after the harvest has been brought in and the sails stowed, Château Léoube throws open the doors of the estate for the Harvest Festival: a celebration of summer's end and the olive harvest, packed with activities including a craft market. The festival is one of the many gatherings hosted by the estate to transform wine tourism into an experience in itself, always around the theme of biodiversity.

PORQUEROLLES' BEST KEPT SECRET

La Table du Domaine, Domaine de l'Île's aptly named restaurant, is located just outside the village of Porquerolles and opens for bookings in summer. *Guinguette*-style atmosphere, pine tree canopy, nature all around – this is al fresco eating in all its glory, complete with wooden tables surrounded by potted lemon trees, 30 place settings (reservation only) and colored fairy lights that twinkle beneath the stars. In the kitchens, the local lady chef specializes in simple fragrant dishes based on local produce and locally caught fish that pair perfectly with the estate wines. The secret will out...

BIGGING-UP PINK AT CHATEAU D'ESCLANS

Pink is writ large in the Château d'Esclans' gift store – an endless range of pink-hued magnums, jeroboams and methuselahs lined up alongside boxes on pallets, watched over by framed press articles telling you all about Sacha Lichine himself. On display in the corner are polo shirts and caps featuring the Whispering Angel logo (a nod to the cult brand). Wine tastings are hosted by the house sommelier and may be arranged on request.

THE ROAD
TO TOMOR ROW

Provence rosé continues to forge ahead, driven by sustained growth and an ever-growing global reputation. The arrival of big business and wealthy investors has given new impetus to the region, creating opportunities for progress in the vineyard and winery alike. Better vineyard management, state-of-the-art winemaking, a glamorous name… Provence has notched up some solid achievements, the while protecting its leadership position in the face of spiraling farmland and commodity prices, adapting to climate change and pursuing sustainable development.

As recent experience shows, however, development is not immune to the effects of global economic recession, pandemics and protectionism. Add natural hazards such as frost, drought and hailstorms, and it becomes clear that making and selling wine is a risky business in any year. So the question here is: Can Provence rosé maintain its leadership position, especially in international markets that increase its visibility, without losing its home market through an elitist stance that opens the floodgates to other regions?

Provence, a dreamy name that sells
In a great many countries, to buy a bottle of Provence rosé is to buy the lifestyle that goes with it. Having established itself as the premier producer of rosé wine, Provence fully intends to exploit its competitive advantage by becoming the engine of rosé wine growth. The figures show that Provence sells all of the wine it produces; but with rosé sales now soaring, matching supply to demand matters more than ever. When demand outstrips supply, shortages send prices rocketing and the markets look elsewhere. The producers of Provence rosé have two levers at their disposal: to expand the production area by approving significant new plantings of vines; and to raise the permitted yield in good years when quantity does not come at the expense of quality. Both options have been proposed by producers and are under consideration by the authorities. But neither option is simple, the first because it means finding suitable sites for new plantings, the second because it depends on natural factors beyond man's control.

One thing is certain however: Californian and Chilean producers are already making rosé wine and it won't be long before they launch bestselling brands of their own. That's their game after all. Languedoc is also raring to go. Even Sacha Lichine, the man who converted the US to rosé wine, admits to making an experimental rosé from grapes grown in Santa Barbara, California. He's already decided on the name: Whispering Angeles. The CIVP, the cross-trade association for Provence wines, for its part admits that meeting demand may well be essential to maintain its lead, but promoting the region remains the priority, with the focus on the word Provence and the Provence demarcated area. Indeed, a nomination for the inscription of Provence rosé on the UNESCO World Heritage List is currently under consideration.

Toward a fully organic, HVE certified wine region by 2030

It's the same story at the national level where restoring the balance of trade is essential. French supermarkets account for the bulk of domestic market sales and remain a major outlet for large numbers of wine brokers and producers, albeit for certain wines only. Since 2018 however, supermarket sales have been outstripped by export sales, and that trend continues today.

Languedoc is already well-established in the market and holds plenty of aces where rosé production is concerned. Mediterranean grape varieties, climate, skills, a variety of appellations and enthusiastic winegrowers – little wonder that the Pays d'Oc PGI is the world's leading (non-AOC) producer of rosé wine. It is also well on its way to going organic despite being France's largest wine region, and that says a lot about the commitment of local winegrowers. Provence is likewise accelerating the transition toward organic farming through an ambitious project launched by the CIVP in early 2022. Called EnViProv, the project has three main objectives: to get all local stakeholders to reduce their environmental footprint (especially their CO_2 emissions) without detriment to quality; to achieve collective organic and/or HVE certification (high environmental value) by 2030; and to apply best practice in the vineyard and winery alike. These are

bold goals indeed, but with upwards of 50% of Provence vineyards already certified organic or HVE, more than half the battle is won. Now it only remains to convince a handful of diehards to take the plunge and never mind the cost.

Agroecological research also informs work currently underway at the Centre du Rosé on disease-resistant grape varieties that would eliminate the need for treatments, and drought-resistant varieties that can withstand climate change.

Taking a cue from champagne

Provence rosé borrows from champagne in terms of strong brands and prestige cuvees at stratospheric prices. In fact, the two are not that dissimilar even if they do play in different leagues. Both are wines for celebration and sharing with friends; both have a powerfully evocative name and both have a signature feature – bubbles for champagne and pale color for Provence rosé. But the comparison stops there because while each wine has an unmistakable brand identity, the history behind it could not be more different. Provence is France's oldest wine region; it has been making pink wine for eons and now corners the global market for rosé, reaping the fruits of a winemaking revolution that is barely 40 years old.

In 2022 for the first time in history, champagne exports outstripped domestic sales – the French now drink less bubbly than other nationalities. Provence is not there yet, but with export markets booming courtesy of value-added marketing, that could soon change. The region is more than ever capitalizing on its name to become the market leader in fine rosé wines, riding a wave of enthusiasm for drinking pink and Provence pink in particular. The arrival of the big wine and spirits groups, champagne makers, luxury groups and other major investors speaks volumes about the region's long-term prospects. Savoir-faire, tradition, ambition and adaptability will ensure that Provence is to rosé what champagne is to bubbles.

The right balance

Provence, like other regions, is paying the price of success: Classified vineyards now sell at such inflated prices that only the very wealthy can afford them. Though the land is not as astronomically expensive as in the great growths of Bordeaux and Champagne, prices in Provence have skyrocketed over the past 20 years. Depending on the place, a single hectare can cost anywhere from €100,000 to €150,000, reaching record highs in the Var department and on the coast. That's a two-to-threefold increase in five years – music to the ears of existing owners but a problem for probate and young winegrowers wishing to settle in the area. Côtes de Provence bulk prices, the benchmark used for wine trader and cooperative pricing, have gone from €140 for every hectoliter per hectare to €300 for every hectoliter in 15 years, which is good for growers without their own vineyards, not so good for traders at the mercy of inflation. As for its wines, Provence must find the right balance between wine estates great and small and the international brands. The protection of its PDOs and the Provence brand is a necessary passage to safeguard the heritage and savoir-faire of the region.

Provence rosé is a wine for all occasions, before food, with food, whatever the hour and whatever the season (this is a rosé you can drink all year round). Its trendy millennial pink hue has made it an instant hit with young consumers who willingly pay more for the taste of success – a phenomenal worldwide success, owed to daring, passion, ingenuity and the never-ending pursuit of quality.

The author wishes to thank

All of the vineyard owners and managers
for their welcome and the time
they devoted to me, with special thanks
to Régine Sumeire for her support
from the very outset.

Thank you to: Jean-François and
Jean-Jacques Ott, Pierre-François
de Bernardi, Marie and Edgar Pascaud,
François Matton, Marc Perrin,
Sacha Lichine, Philippe Austruy,
Alban Cacaret, Valérie Rousselle,
Victoria Riboud, Nicolas Audebert,
Sébastien Le Ber, Jessica Julmy
and Romain Ott.

All those people whose precious support
gave impetus to my endeavors and my
story: Rodolphe Moulin-Chabrot, Stéphane
Portier, Bertrand Léon, Jean-Baptiste Terlay,
Marie-Hélène Duroux-Klein, Elise Lavigne,
François Millo, Brice Eymard,
Carole Guinchard, Gilles Masson,
Philippe Perd, Géraldine Léger,
Mégane Fusini, Mamo, Benjamin Bruno,
Jérémy Berthon, Christine Troude,
Mathieu Meyer, Tom Schreckinger,
Marine Guérin, Roland Venturini,
Sébastien Girois, Sarah Griozel
and Alexandre Daligault.

The publisher wishes to thank
Marie-Estelle Rigord for the loan of the
photographs belonging her family.

Bibliography

Stéphanie Des Horts, *Les Heureux
du monde*, Paris, Albin Michel, 2021.

Jean-Richard Fernand et Hervé Fabre,
Nectars du Var, Hyères, Sudarènes Éditions,
collection "Grands Vins de Provence".

Jean-Richard Fernand et Hervé Fabre,
Grands Vins de Provence,
Gémenos, Autres Temps, collection
"Terroir du soleil", 2008.

Geneviève Jamin et Daniel Rey,
Crus classés de Provence, Jarnac,
Les Éditions d'Autils, 2017.

François Millo, *Côtes de Provence*,
Paris, Chêne, 2017.

Graphic Design:
Élisabeth Welter

Photography by Camille Moirenc,
with the exception of:
© Archives patrimoniales
Domaines Ott* page 16
© Famille Rigord page 32 bottom
and page 53 top right
© Archives Léoube page 80
© Photo Philippe Besacier page 81 top
© Giorgio Armani Tennis Classic
– IMG UK page 117
© HLENIE page 125 bottom
© Dorling Kindersley ltd /
Alamy Stock Photo page 168
© Nikki Beach page 171
© Agence Jésus and Gabriel
page 178 top
© GRAPHO-CIVP page 178 bottom
© Christophe Goussard page 179 top
© SOWINE-CIVP page 179 right
© Agence OMEDIA page 179 bottom
© Hervé Fabre page 192 top and bottom
© Adagp, Paris, 2023 for the works of
Valentine De Wain, Pascale Marthine Tayou,
Victor Vasarely, Bernar Venet
© DB - Adagp, Paris, 2023 for the works
of Daniel Buren

ABRAMS The Art of Books
195 Broadway, New York, NY 10007
abramsbooks.com
Photoengraving: SNO

Printed by GPS Group, Slovenia in April 2023
Legal deposit: May 2023
ISBN: 978-1-4197-7035-7

Drinking too much alcohol
is bad for the health. Drink alcohol
only in moderation.